THE
ADVANCED
AIRBRUSH
BOOK

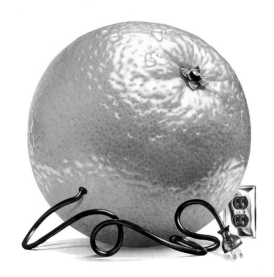

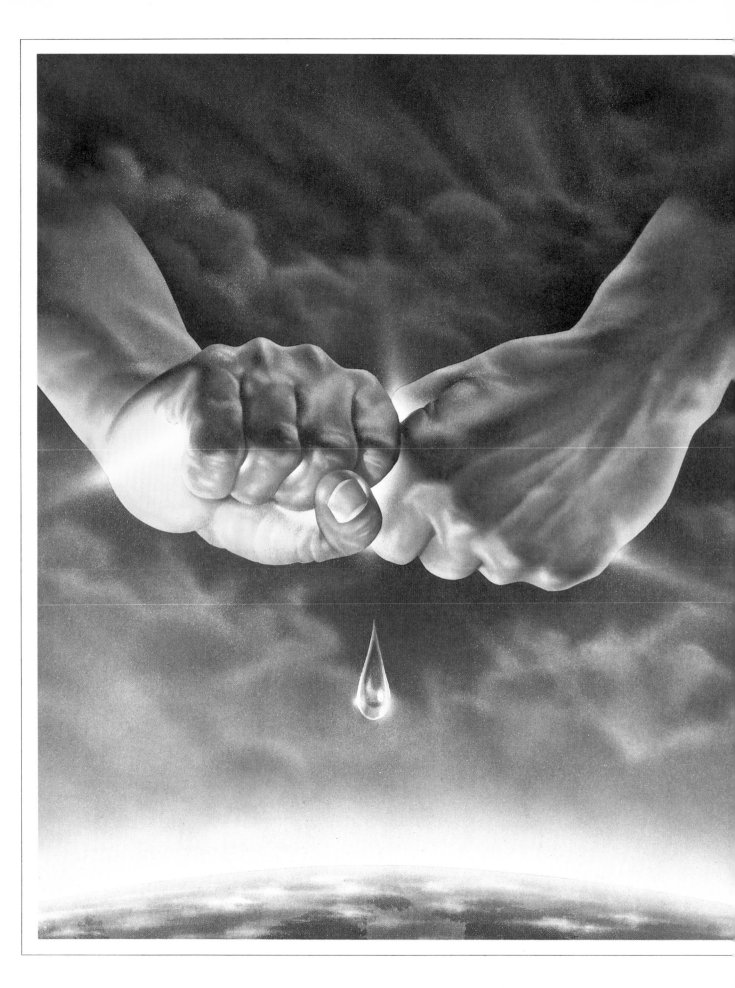

THE
ADVANCED
AIRBRUSH
BOOK

CECIL MISSTEAR
WITH HELEN SCOTT-HARMAN

VNR VAN NOSTRAND REINHOLD COMPANY
NEW YORK CINCINNATI TORONTO LONDON MELBOURNE

Half title
Joe Heiner, USA
Orange and plug (1976)
40.6 × 50.2cm (16 × 19¾in)

Title spread
Bob Norrington, Great Britain
'Light of the World'
53.3 × 106.7cm (21 × 42in)

Copyright © 1984 by Orbis Publishing Limited, London
Library of Congress Catalog Card Number 81-23108
ISBN 0-442-28424-1

Printed in Italy

Published by Van Nostrand Reinhold Company Inc.
135 West 50th Street
New York, New York 10020

16 15 14 13 12 11 10 9 8 7 6 5 4 3 2 1
Library of Congress Cataloging in Publication Data

Misstear, Cecil.
 The advanced airbrush book.

 Airbrush art—Technique. I. Scott-Harman, Helen.
II. Title.
NC915.A35T647 1982 751.4'94 81-23108
ISBN 0-442-28424-1 AACR2

CONTENTS

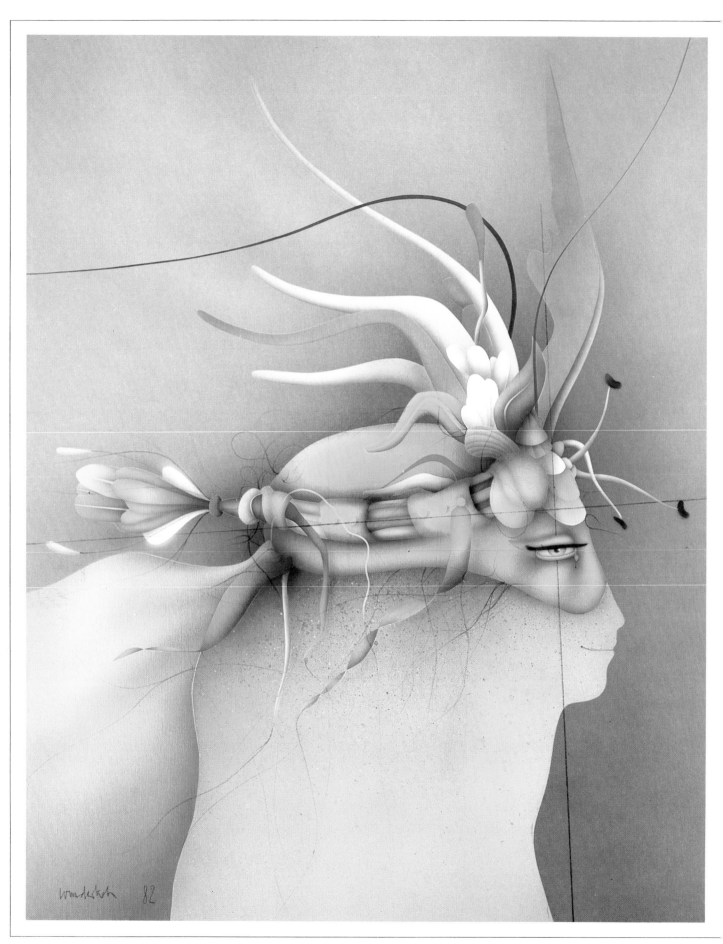

wonderlich 82

INTRODUCTION

This book is primarily a celebration of the remarkable and varied artwork being created these days by airbrush artists all over the world.

In the pages immediately following will be found an eclectic collection of such works, carefully chosen from thousands of pictures airpainted by artists of Britain, the United States, Japan and several European countries.

This period might be seen as the golden age of the airbrush, not only because sales figures for airbrushes are soaring, along with the number of different models and of companies manufacturing them, but even more importantly because of the quality of work that is being turned out. The airbrush has long had a bad reputation in art circles, being regarded as a tool for doing 'slick', surface-only work. Partly to blame is its enormous usefulness for certain requirements of advertising (particularly of cosmetics); many serious art students believe they would be interested in using an airbrush only if they were going to specialize in advertising art. In Europe until recently no gallery would show airbrush art, and it is still not widely accepted outside the commercial world except in the United States. The fine work coming out of Japan—several examples of which will be found in these pages—may be a sign for the future, of how attitudes will change as the airbrush's potential for creating artwork of genuine distinction is taken more seriously.

But the airbrush alone cannot create anything; it is not a magic wand. No degree of skill or technique with

Paul Wunderlich's 'Spring' (97 × 130cm/38 × 51 in, 1982) is one of four seasonal paintings done in acrylics.

the airbrush can overcome bad drawing. The requirement of good drawing for good results is as fundamental with an airbrush as with any other means of putting down tones, such as a paintbrush.

There is a very real reason for the lack of acceptance of the airbrush by people who feel it is a less 'genuine' tool than the paintbrush: on every hand, all around us, in magazines and on billboards, can be seen artwork that is decidedly second-rate, and much of it is rendered by airbrush. It is, of course, absurd to blame the airbrush for this bad work; one could as well blame the scalpel for an inept operation performed by an insufficiently trained medical student. But the onus is there, and the reason is clear: it is because, lamentably, many insufficiently trained artists are commercially successful creating airbrushed artwork of a very low standard. The art schools are not entirely to blame; it is the artists themselves who have not bothered to learn to draw. (Learning to draw is largely a matter of training one's eye, which one must do for oneself.)

How does it happen that these people who never learned to draw are successfully selling sub-standard artwork? It is because they have learned to do slick tricks with the airbrush—to put a shine here or a gleam there or jazzy highlights all over the place. And if something appears new, even if only on the surface, an art director may suspend his critical faculty with a clear conscience; after all, he may assure himself (quite properly), art has no rules that cannot be broken.

And so the airbrush has been given a bad name. That is why, as its secondary function, this book encompasses the subject of how fundamental problems

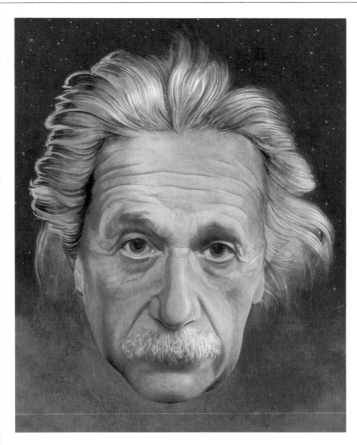

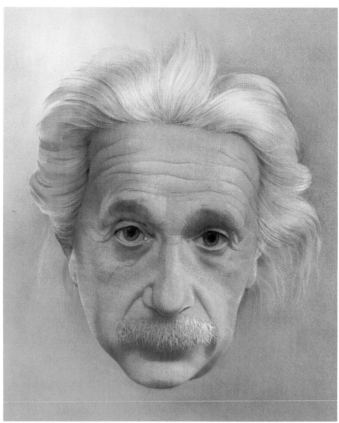

of drawing can be met. It does not and could not attempt to present a complete back-to-school course of instructions, but is intended rather as a quick refresher course, aimed at advanced airbrush artists, and presented with their needs in mind.

Following the 'Gallery' section that opens the book, the 'Workshop and Equipment' chapter deals with the airbrush artist's setting and the things that he/she will need in order to do the best work there. Every stage of the artist's work is covered in the subsequent chapter, 'Materials and Procedures', with emphasis on the ways in which errors in drawing may be avoided or rectified; fundamental principles, such as perspective, are presented in a form that should make for easy reference. The special skills and techniques involved in photographic work are the subject of the 'Photo Retouching' chapter; and 'Airbrushing and the Computer' is about the latest phenomenon in the graphic arts field: a machine with which a picture can be 'painted' directly onto a television screen. Finally, in 'Applications and Accomplishments', examples of work from many fields—fine and commercial art, technical and scientific illustration, collage, lettering, caricature, ceramics, even taxidermy—are shown, along with some step-by-step documentation of how they were created.

So, in the interests of giving the airbrush a good name, this book is dedicated to the hope that professionals, as well as advanced students, will put into

To help dispel the notion that the airbrush is best suited to commercial work of a 'slick' type, and to demonstrate that it is a tool that can produce subtle and detailed effects, these two portraits of Albert Einstein were executed by Richard Ward, one with an airbrush and the other with a sable paintbrush; both were painted with a mixture of water-colours and acrylics. The artist has demonstrably achieved a remarkably similar level of quality. Upon examination, can you tell which was airbrushed? (It is the one at right, which was airpainted with an Aerograph Super 63.)

practice the principles that are covered here; that, for example, the shadows in their pictures won't confuse the viewer (unless eccentric placement of shadows is the point); that the perspective lines in their drawings will recede properly; and that they may feel free to put in reflections to give their pictures sparkle, instead of being afraid to deal with something so difficult; and above all, that they may free themselves of total dependence on photographs to copy from.

Ultimately, however, this book must be dedicated to the sheer pleasure of looking at wonderful pictures, which begins as soon as you turn the page and enter the gallery of fine airbrush art.

GALLERY

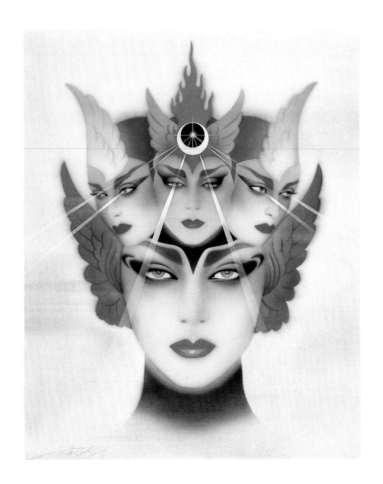

Preceding page
Pater Sato
Japan
'Three Face Lady'
(1981)
61 × 46cm (24 × 18in)
Dr Martin's ink, colour
pencil and pastel
Hohmi Y-1

Above
Terry Gilliam
USA
Untitled still
from an animated film

Left
Syd Brak
Great Britain
'The Dance'
42 × 60cm
(16½ × 23⅝in)
Gouache, dye and
water-colour
DeVilbiss Aerograph
Super 63

Right
Robert Grossman
USA
'Reagan in Choppy
Waters', commis-
sioned by *Time Maga-
zine*
48 × 36cm (19 × 14in)
Winsor & Newton
water-colour and
gouache on
Strathmore board
Thayer and
Chandler A

Audrey Flack
USA
'Invocation' (1982)
163 × 199cm
(64 × 80in)
Acrylic and oil on
canvas
Paasche

Don Eddy
USA
'C/V/A' (1981)
91 × 91 cm (36 × 36in)
Liquitex acrylic on
canvas
Paasche H3

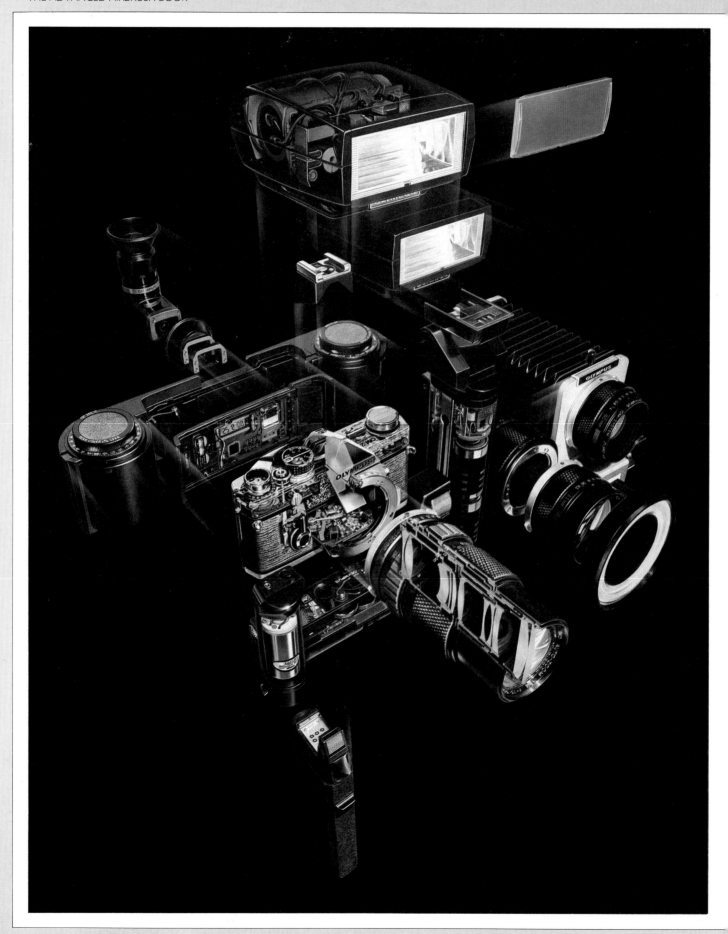

Left
Goro Shimaoka
Japan
Poster and pamphlet
illustration commis-
sioned by Olympus
103 × 72.8cm
(40¾ × 28⅝in)
Liquitex, Animex
Olympos

Right
Ichimatsu Meguro
Japan
An outside view and
inside mechanism of a
planetarium
70 × 50cm
(27½ × 19¾in)
Acrylic and ink
Lumina Type-A

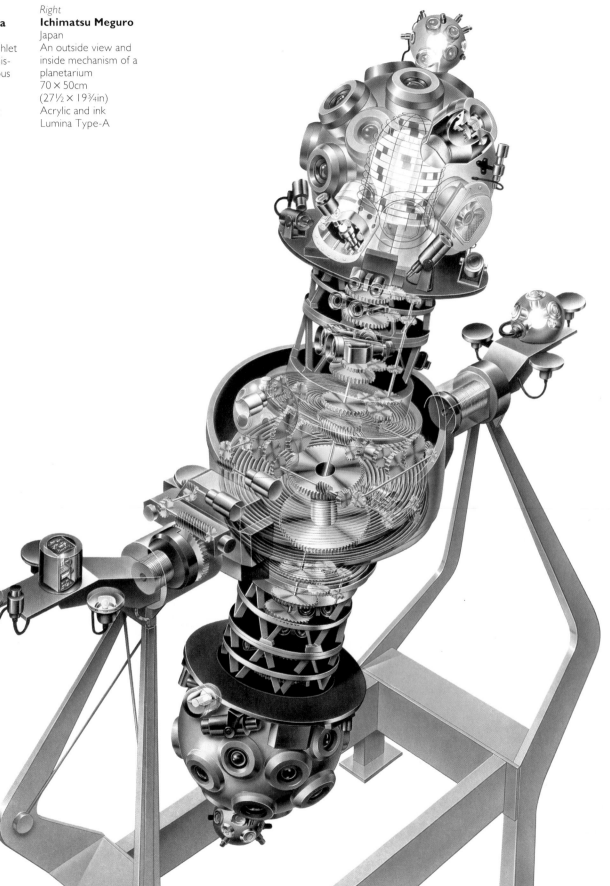

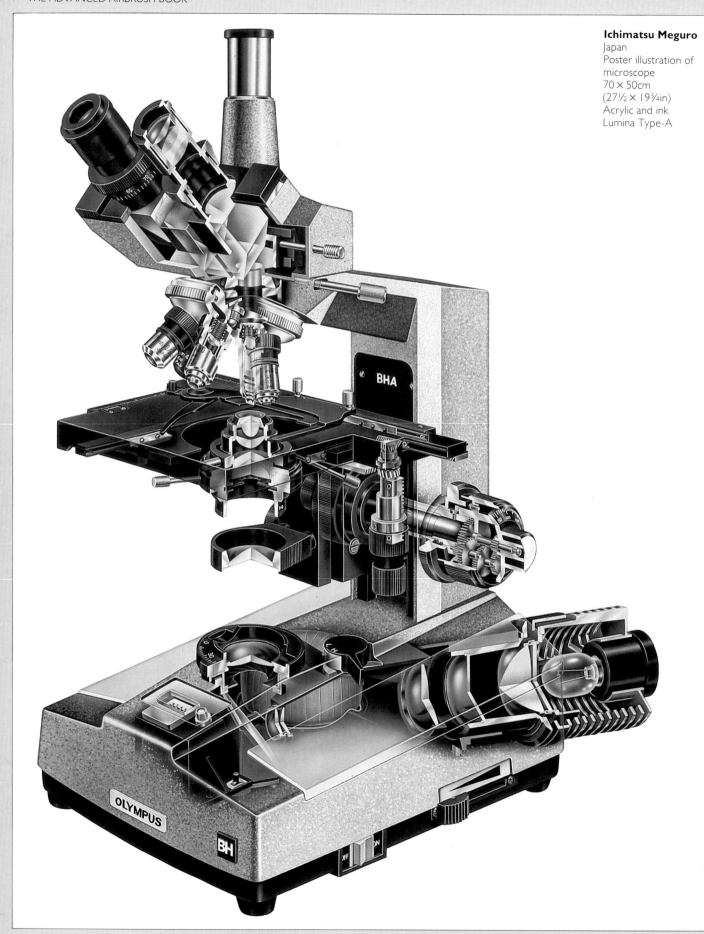

Ichimatsu Meguro
Japan
Poster illustration of
microscope
70 × 50cm
(27½ × 19¾in)
Acrylic and ink
Lumina Type-A

Below
Kazuhisa Ashibe
Japan
Advertisement illustra-
tion of Sony Walkman II
audio-cassette tape
50 × 35.3cm
(19¾ × 14in)
Liquitex
Yaezaki

Right
Kevin Jones
Great Britain
Advertisement illus-
tration of TEAC X-10
tape-recorder
59.4 × 42cm
(23⅜ × 16½in)
Gouache, ink and
pencil
De Vilbiss Aerograph
Super 63

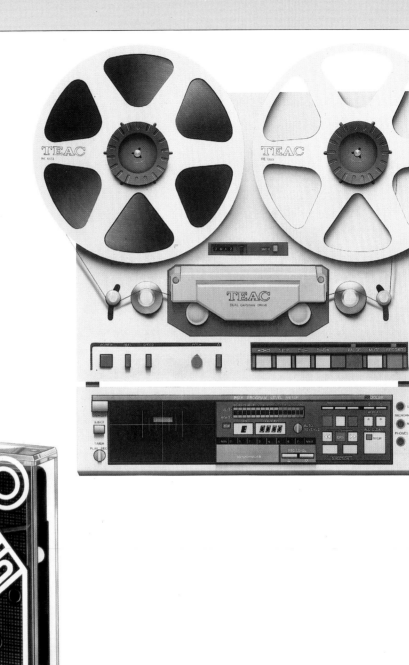

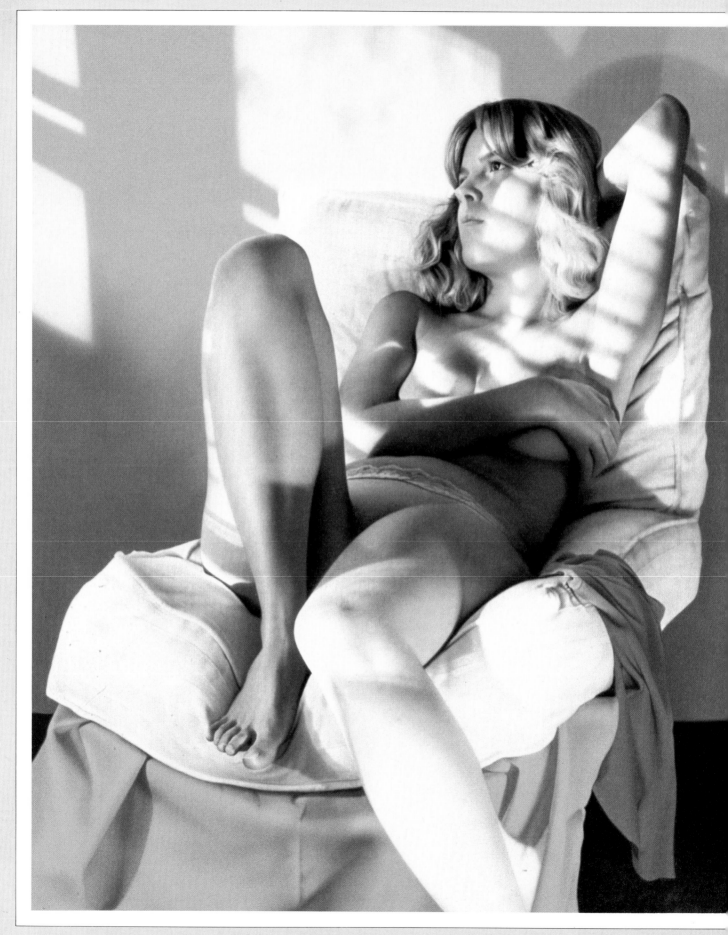

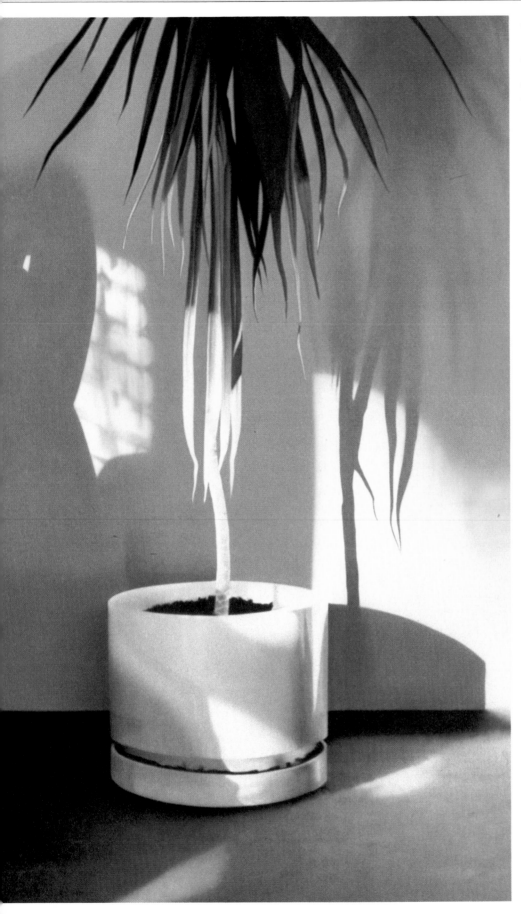

Jerry Ott
USA
Untitled, nude in chair
(1981)
178 × 122cm
(70 × 48in)
Acrylic on canvas
Paasche

**Ramon Gonzalez
Teja**
Spain
'Paris as Seen by the
Illustrator's Work-
shop'
48.3 × 48.3cm
(19 × 19in)
Ink and crayon
Thayer and Chandler

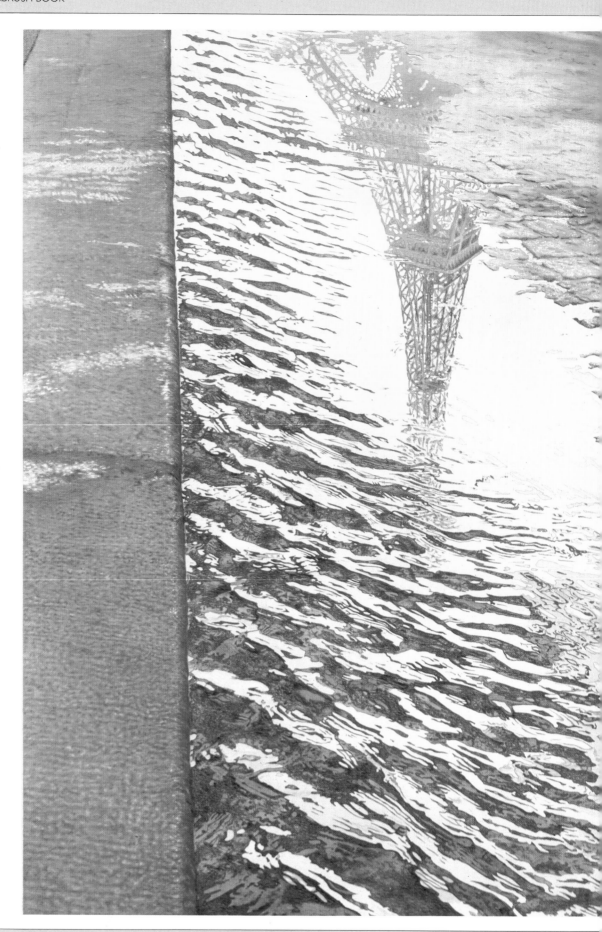

Ri Kaiser
West Germany
'Herbst'
50 × 40cm
(19¾ × 15¾in)
Retouching water-
colour on photo-
graphic paper
Fischer CSX 2001

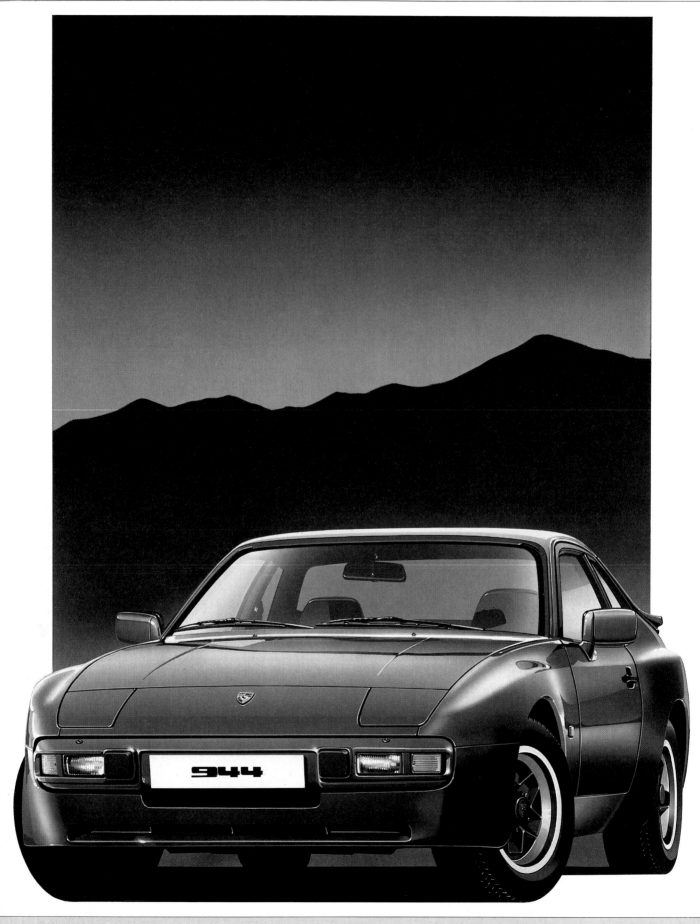

Left
Gavin Macleod
Great Britain
Porsche 944
52 × 35cm
(20½ × 13¾in)
Gouache
Olympos

Above
Hideaki Kodama
Japan
Untitled
40 × 40cm
(15¾ × 15¾in)
Liquitex acrylic and
Holbein drawing ink
Olympos HP-100B,
Holbein Neo-Hohmi
Y-1 and Yaezaki
Baby-Auto

Jean-Luc Falque
France
'Shell' or 'La Vitesse
c'est la Préhistoire'
40 × 60cm
(15¾ × 23⅝in)
Acrylic and ink
Fischer

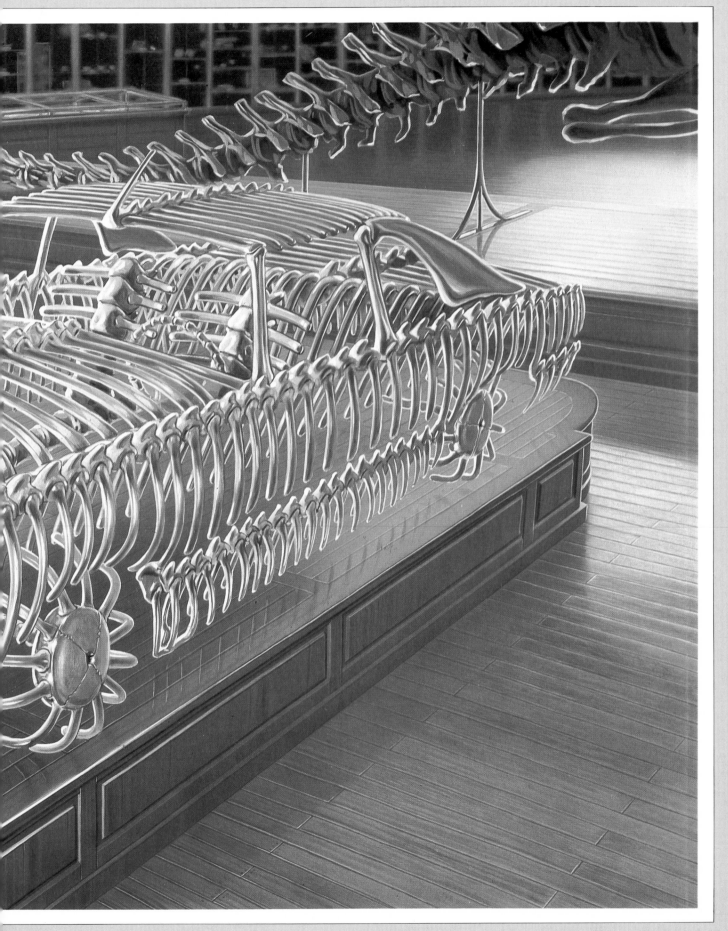

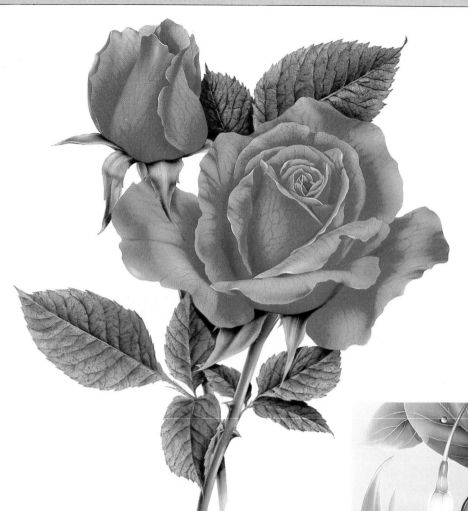

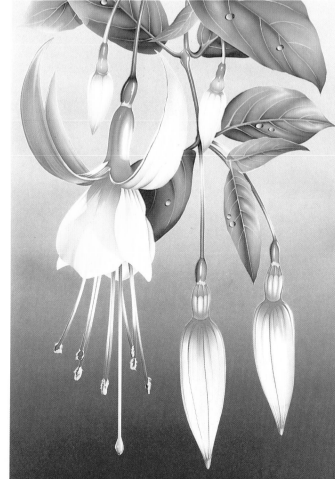

Above
Kurt Jean Lohrum
Finland
Untitled birthday card
and poster
42 × 29cm
(16½ × 11½in)
Schmincke colour
Grafo

Right
Ean Taylor
Great Britain
'Fuchsia' (1982)
50.8 × 40.6cm
(20 × 16in)
Olympos

Opposite
Michael Lye
Great Britain
'Grasping the Nettle'
52 × 40cm
(20½ × 15¾in)
Gouache on water-
colour board
DeVilbiss Aerograph
Super 63 A and B

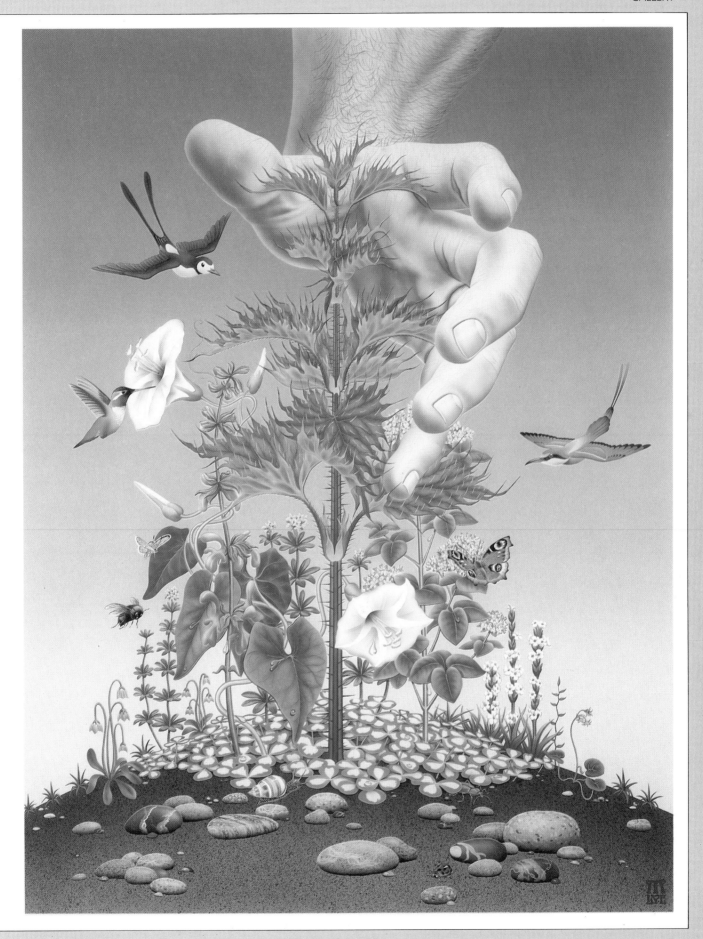

Peter Phillips
Great Britain
'Mediator I' (1979)
135 × 220cm
(53¼ × 86¾in)
Oil on canvas
Grafo type IIB

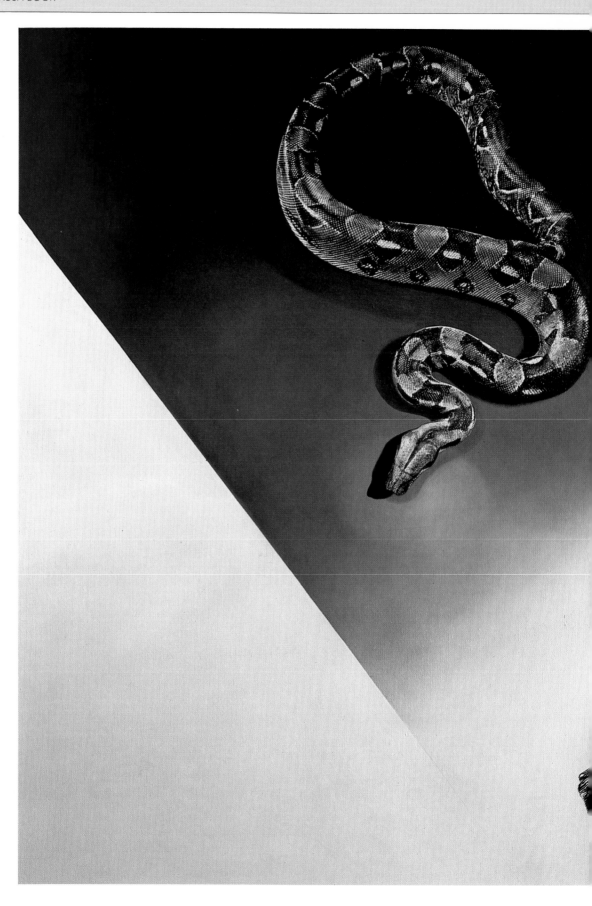

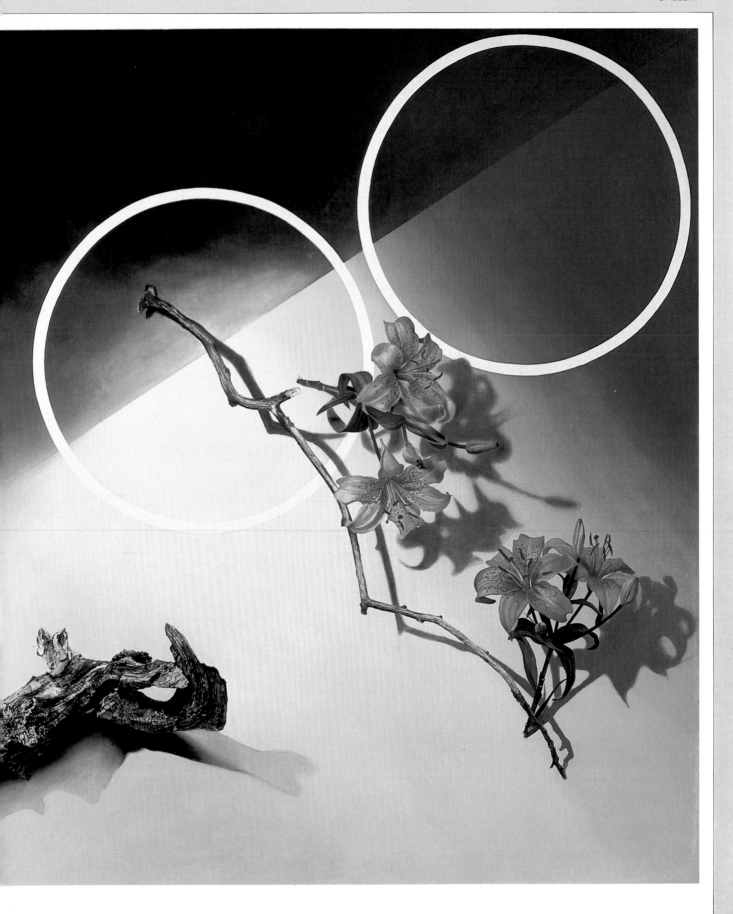

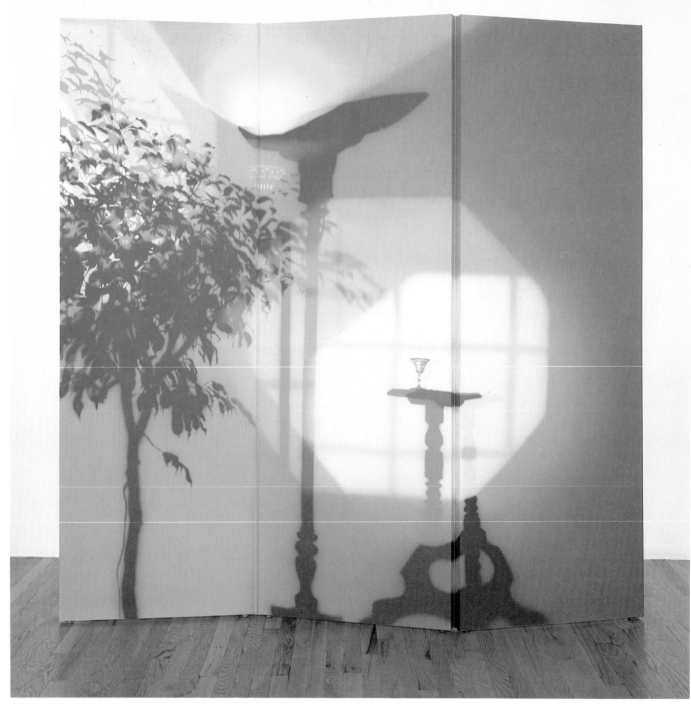

Above
Jack Radetsky
USA
'Lamplight and Moon'
213 × 213cm
(84 × 84in)
Acrylic and canvas on
folding screens
Thayer and Chandler
A and AA, spray guns

Opposite, bottom left
Thomas P. Hubert
USA
'Tilted Bowl'
20.3 × 25.4 × 25.4cm
(8 × 10 × 10in)
Water-based com-
mercial underglazes
on low fire whiteware
Paasche H

Opposite, bottom right
Dan Gunderson
USA
'Target TV'
Diameter 53.3cm
(21in)
Underglaze colour
and matt transparent
overglaze on bisqued
ceramic ware
Paasche and Badger

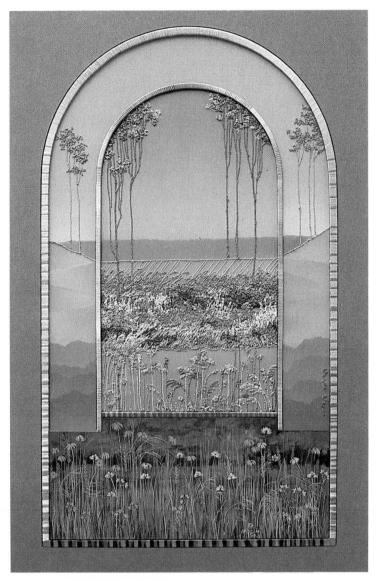

Verina Warren
Great Britain
'Harebells and Daisies
in a Moon Garden
Grew'
26 × 16cm
(10¼ × 6¼in)
Hand and machine
embroidery on
sprayed fabric back-
ground with painted
card mounts and silk-
bound borders
Badger

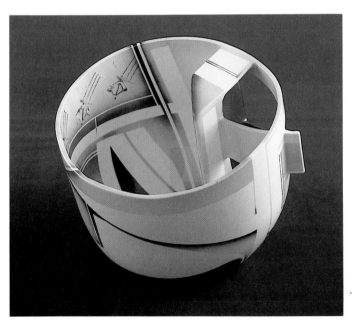

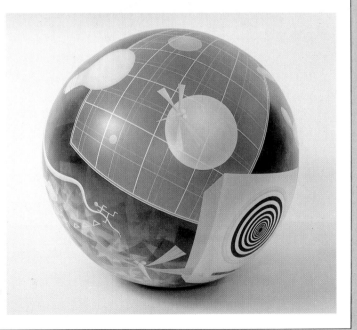

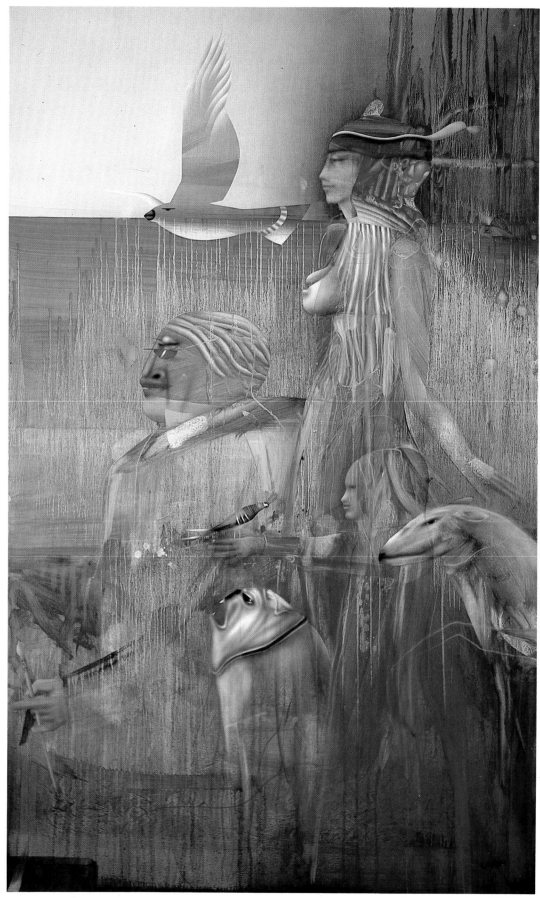

Left
Paul Wunderlich
Germany
'Familie mit Tieren'
(Family with animals)
(1981)
170 × 105cm
(67 × 41¼in)
Oil
Efbe and Sata

Right
Pater Sato
Japan
'Venus II' (1981)
46 × 31cm (18 × 12in)
Dr Martin's ink, colour
pencil and pastel
Hohmi Y-1

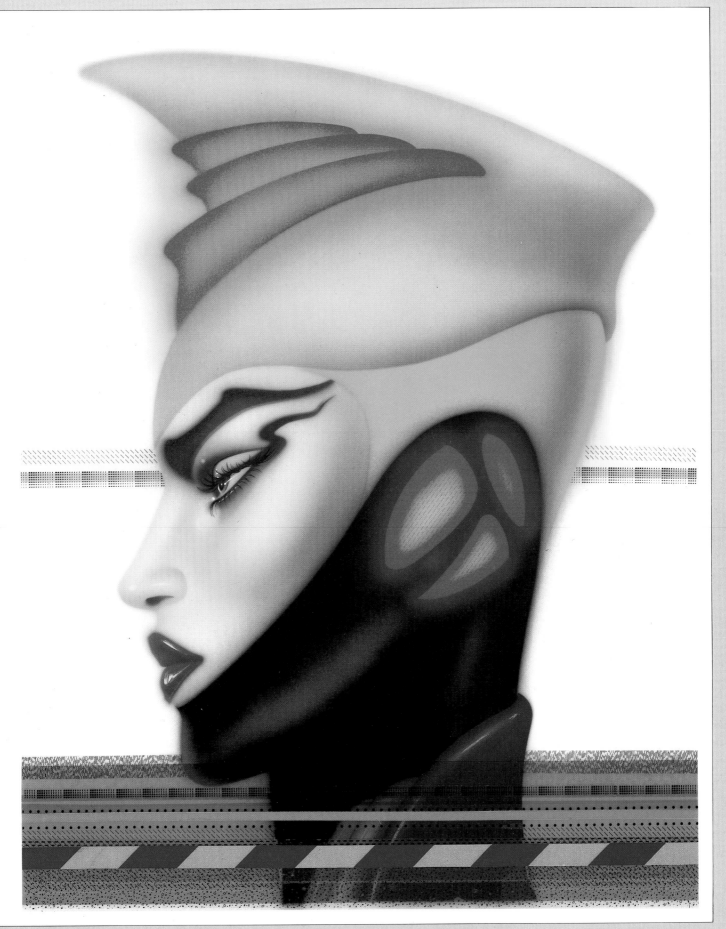

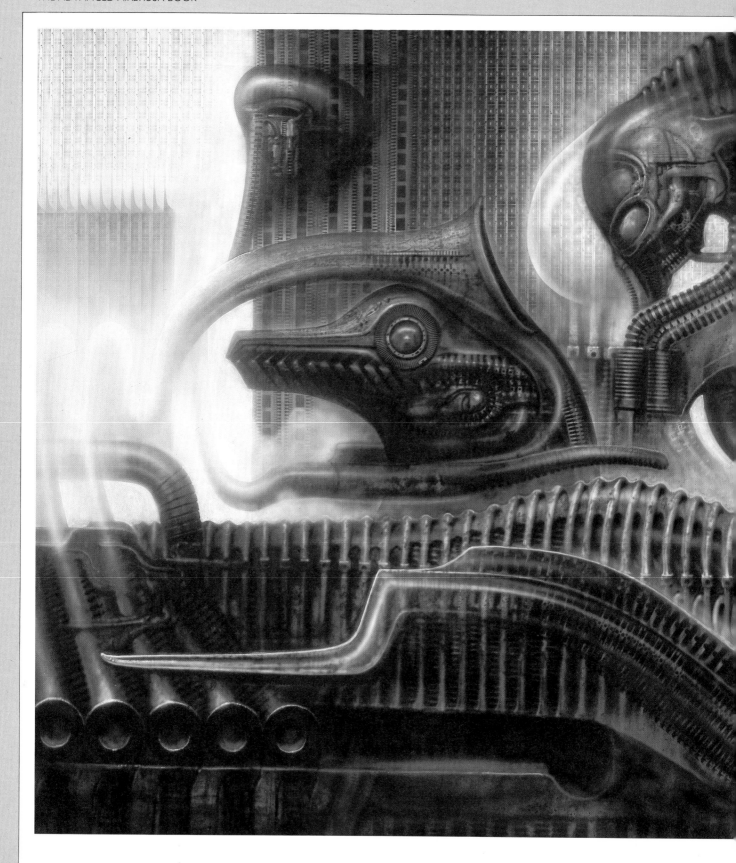

Left
H.R.Giger
Switzerland
'N. Y. City II -
Lovecraft over
New York' (1980/1)
100 × 140cm
(39½ × 55¼in)
Acrylic and ink
Efbe 15mm

Above
Norman Catherine
South Africa
Untitled
72 × 65cm
(28¼ × 25⅝in)
Rowney acrylics
Thayer and
Chandler A

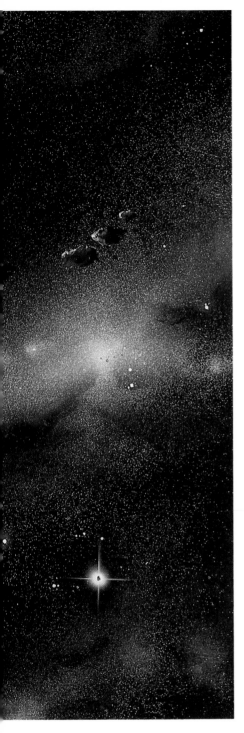

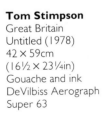

Tom Stimpson
Great Britain
Untitled (1978)
42 × 59cm
(16½ × 23¼in)
Gouache and ink
DeVilbiss Aerograph
Super 63

Chris Moore
Great Britain
'Secrets of our
Spaceship Moon',
book-cover
illustration
38 × 22cm
(15 × 8⅝in)
Acrylic and ink
Conopois

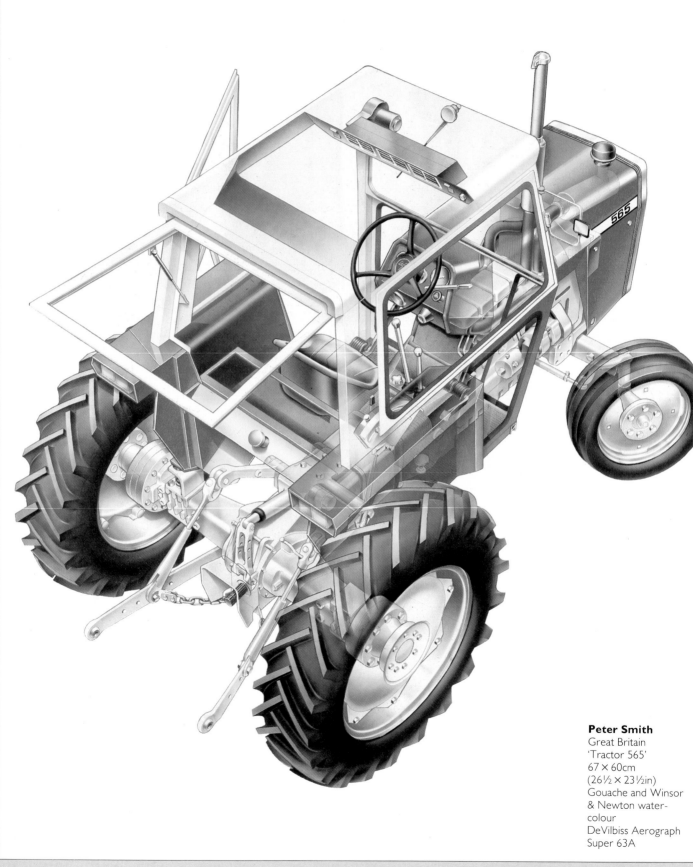

Peter Smith
Great Britain
'Tractor 565'
67 × 60cm
(26½ × 23½in)
Gouache and Winsor
& Newton water-
colour
DeVilbiss Aerograph
Super 63A

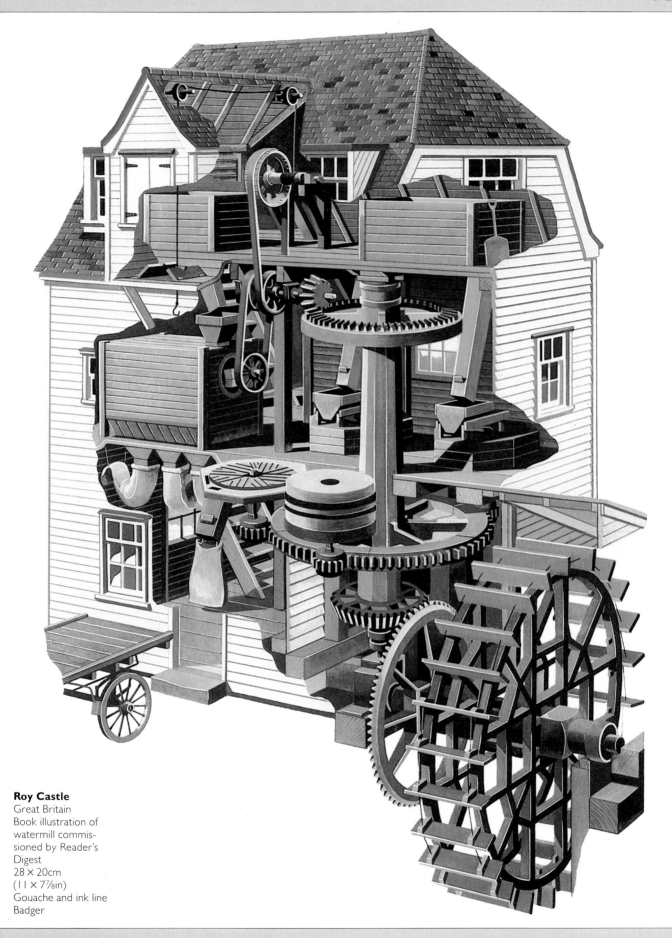

Roy Castle
Great Britain
Book illustration of
watermill commis-
sioned by Reader's
Digest
28 × 20cm
(11 × 7⅞in)
Gouache and ink line
Badger

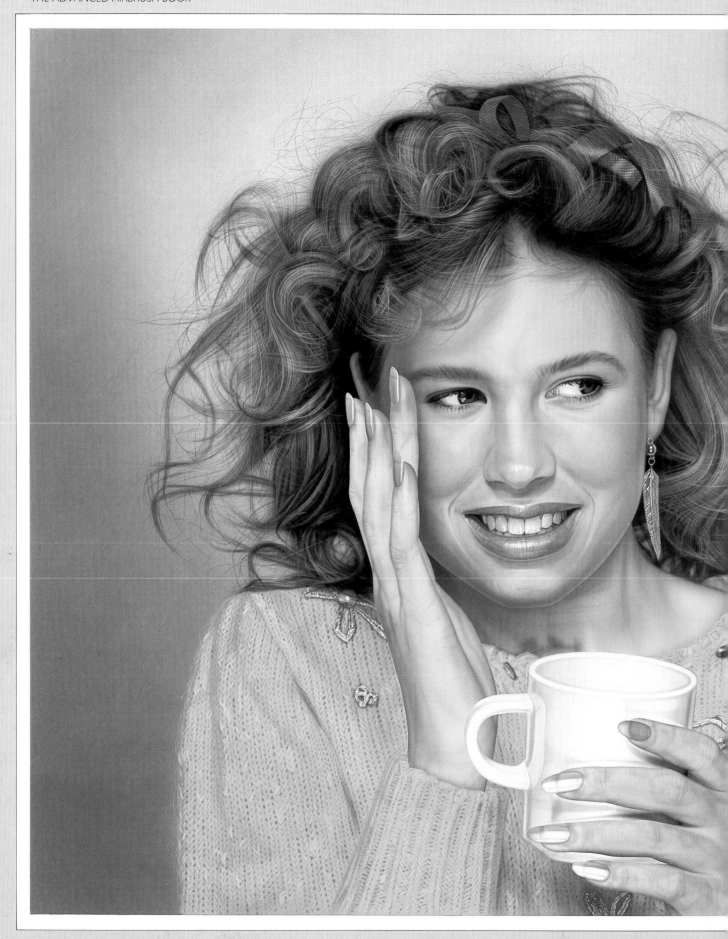

Toshikuni Ohkubo
Japan
Calendar illustration
51.5 × 72.8cm
(20¼ × 28⅝in)
Acrylic, gouache and
ink
Yaezaki

Left
Jane Kleinman
USA
'La Nouvelle Russe'
(1982)
127 × 102cm
(50 × 40in)
Spray paint, pastel,
lipstick and rouge

Right
Shiro Nishiguchi
Japan
'Science of Women'
40 × 40cm
(15¾ × 15¾in)
Acrylic Liquitex
Holbein Toricon Y-2

Top left
Guerrino Boatto
Italy
Untitled commission
for travel company
90 × 60cm
(35½ × 23⅝in)
Acrylic
Paasche

Right
Joe Ovies
USA
Promotional illustra-
tion commissioned by
MacDonalds
76.2 × 76.2cm
(30 × 30in)
Gouache
Iwata

Top right
Otto and Chris
Australia
'More'
76.2 × 50.8cm
(30 × 20in)
Inks
Thayer and Chandler

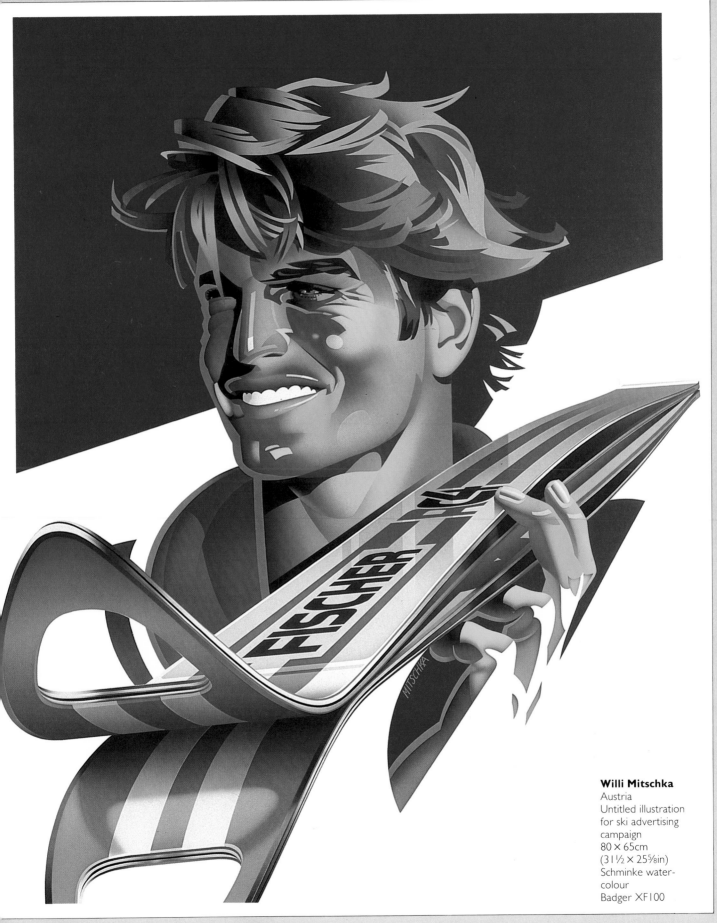

Willi Mitschka
Austria
Untitled illustration
for ski advertising
campaign
80 × 65cm
(31½ × 25⅝in)
Schminke water-
colour
Badger XF100

Left
Kirk Q. Brown
USA
'The Cats' (1983)
30.5 × 30.5cm
(12 × 12in)
Water-colour
Paasche VI

Below
Gerry Preston
Great Britain
'Signal Toothpaste'
38 × 51cm (15 × 20in)
Dye
DeVilbiss Aerograph
Super 63

Above
Chuck Schmidt
USA
'I Love Leather'
(1979)
38 × 51cm (15 × 20in)
Liquitex acrylic and
Pelikan coloured inks
Thayer and Chandler A
and Paasche AB

Right
Chuck Schmidt
USA
'Bank' (1983)
25.4 × 30.5cm
(10 × 12in)
Badger Air Opaque
acrylics on photo
Iwata HP-C and
Paasche AB

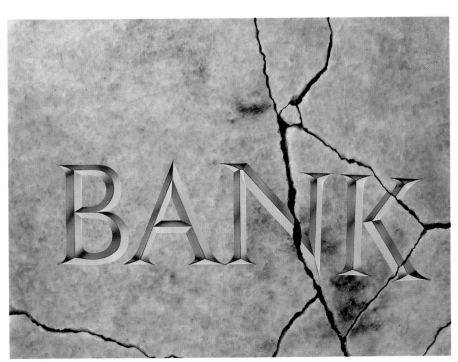

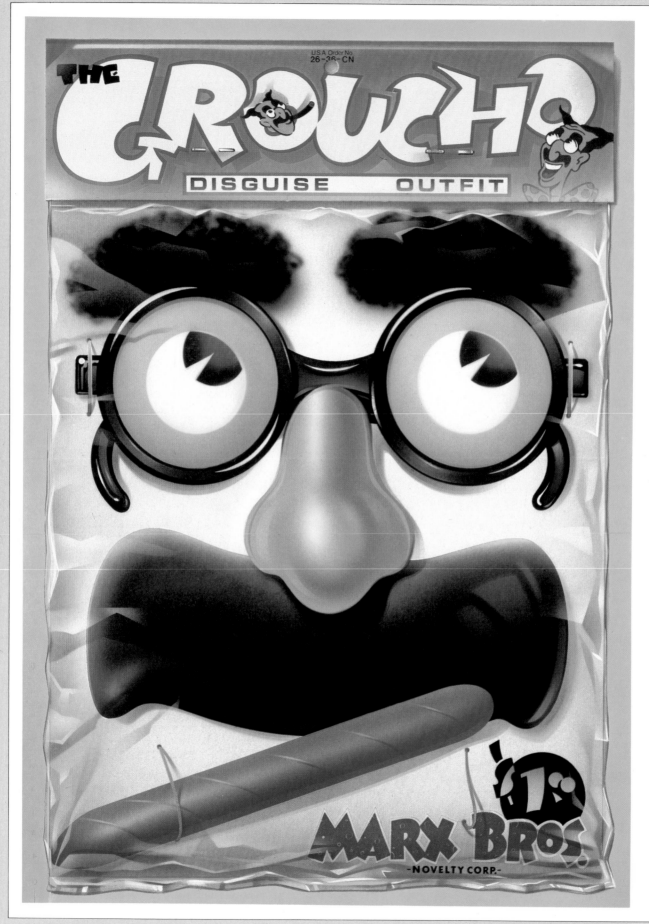

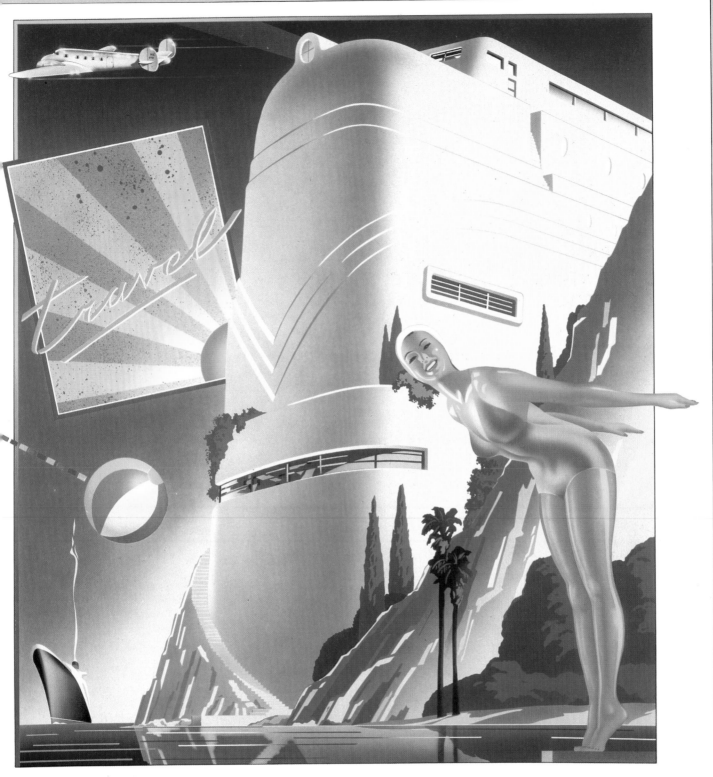

Left
Mick Brownfield
Great Britain
'Groucho'
30.5 × 22.9cm
(12 × 9in)
Gouache and ink on
CS10 card
DeVilbiss

Above
David Juniper
Great Britain
'Travel' (1981)
57.2 × 52.1cm
(22½ × 20½)
Gouache and ink
Conopois

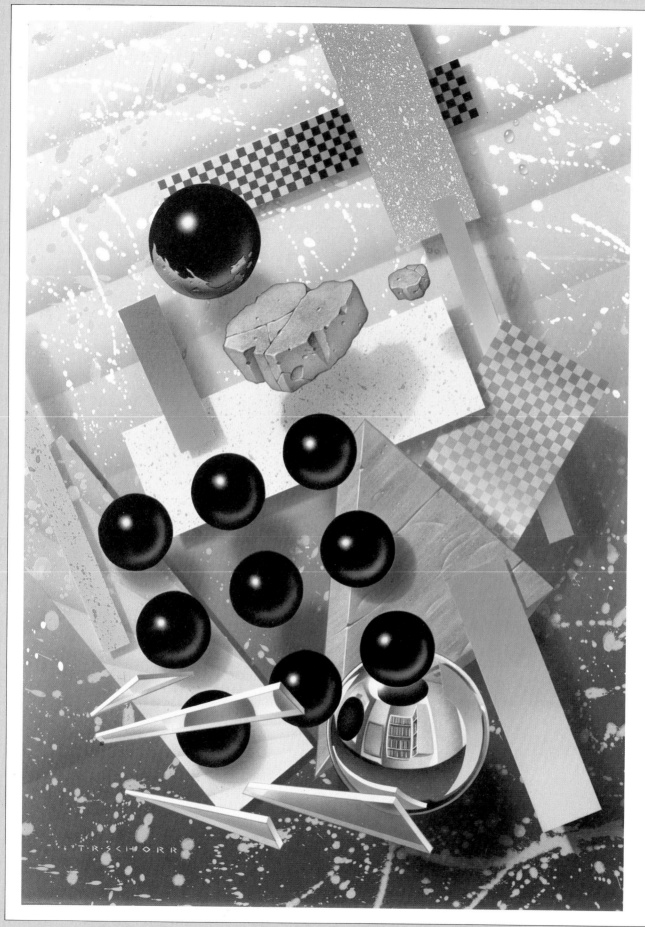

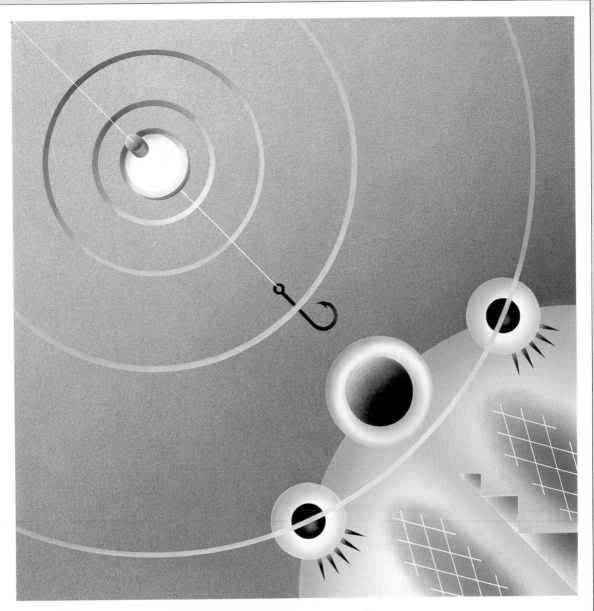

Left
Todd Schorr
USA
'Black Spheres'
50.8 × 40.6cm
(20 × 16in)
Gouache and dyes on
illustration board
Thayer and Chandler

Top right
Jose Cruz
USA
'Nippon Fish' (1982)
33 × 33cm (13 × 13in)
Acrylic
Paasche AB and H

Bottom right
Ben Lustenhouwer
The Netherlands
'Sunday Afternoon'
35 × 34.4cm (13¾ ×
13½in)
Schmincke-diafoto,
AD marker-aqua-dye
water-colour and ink
on board
Conopois

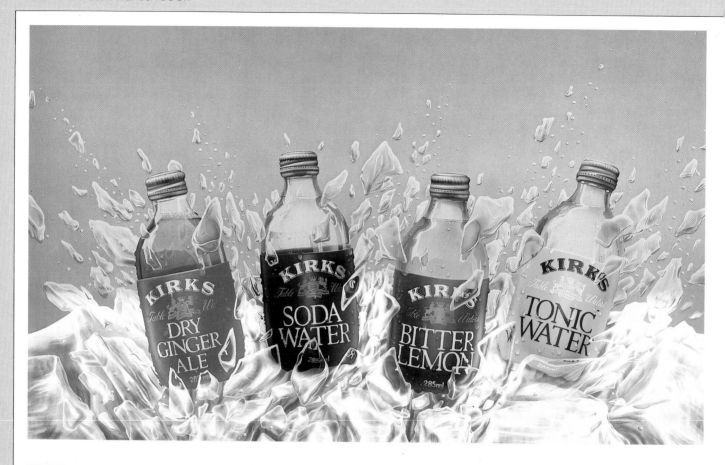

Left
Jean-Jacques Maquaire
Belgium
'Frozen Trout' (1982)
50 × 40cm
(19¾ × 15¾in)
Mecanorma and Dr Martin's water-colour
Fischer 03

Above
Mark Salwowski
Australia
Advertisement for Kirks products (1982)
40.6 × 50.8cm
(16 × 20in)
Rotring opaque ink and gouache
Thayer and Chandler, and Paasche AA

Right
Masao Saito
Japan
Strawberries for book illustration
41 × 32cm
(16¼ × 12⅝in)
Capesulecon No 4

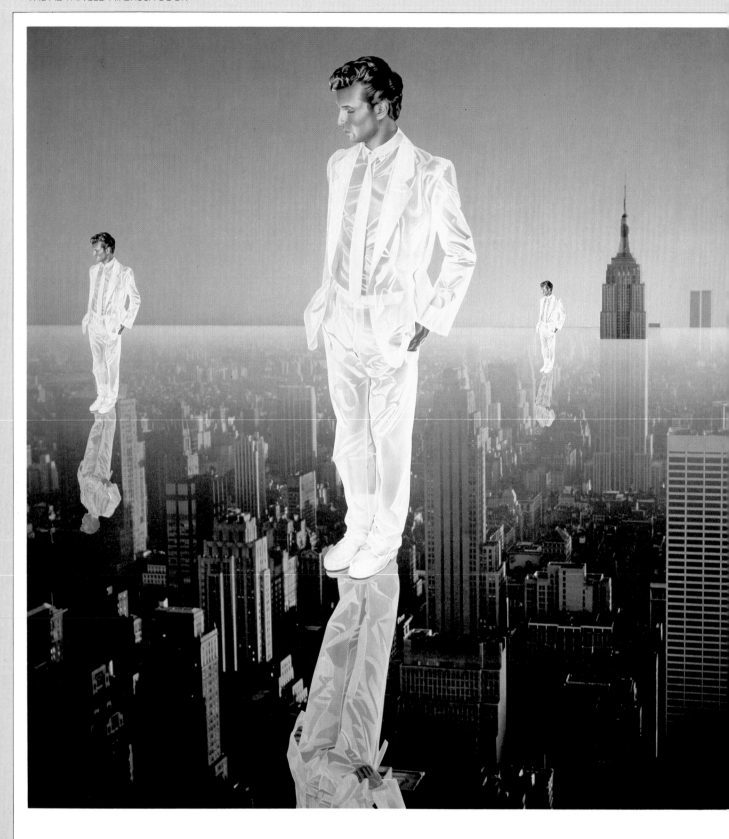

Left
Ryoko Ishioka
Japan
Illustration for outer
wall surface
71 × 103cm
(28 × 40½in)
Liquitex acrylic

Above
Philip Castle
Great Britain
'Disassembly Line'
(1982)
106.7 × 78.7cm
(42 × 31in)
Gouache
DeVilbiss Aerograph
Super 63

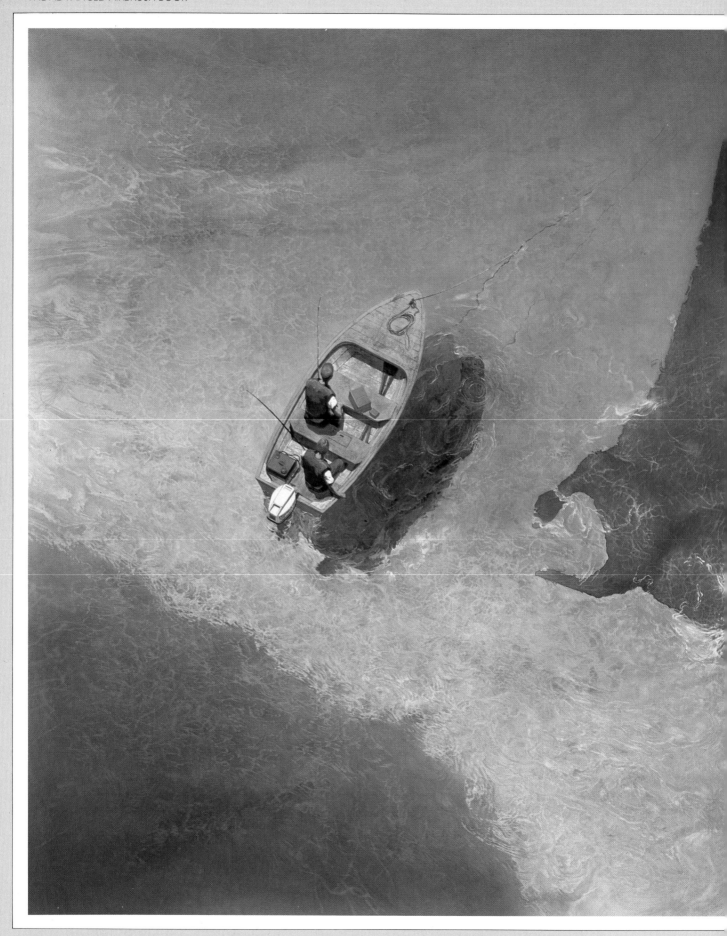

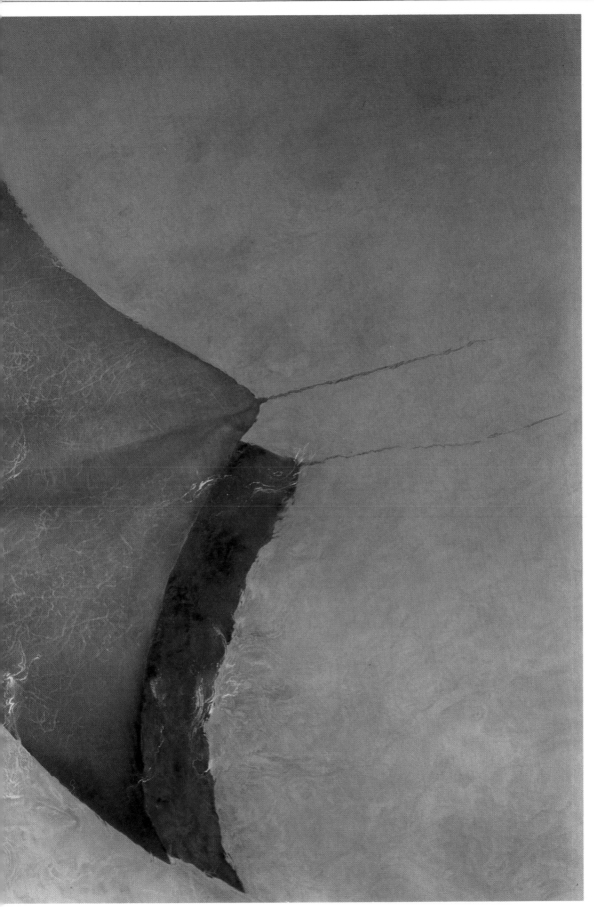

Akira Yokoyama
Japan
Poster design for
Honda outboard
motors (1979)
47.3 × 73.2cm
(18⅖ × 28⅘in)
Water-colours. Li-
quitex and gouache
Hohmi Y-2

Above
Hilo Chen
USA
'Beach 100' (1982)
98.4 × 142.2cm
(38 × 56in)
Oil on canvas
Paasche

Right
Joe Nicastri
USA
'Barbara in the Studio'
(1981)
101.6 × 81.3cm
(40 × 32in)
Acrylic plaster on
board
Paasche AB

Ben Johnson
Great Britain
'Street Scene,
Minorca'
(1980)
152.4 × 229cm
(60 × 90in)
Acrylic on canvas
DeVilbiss MP and MPS

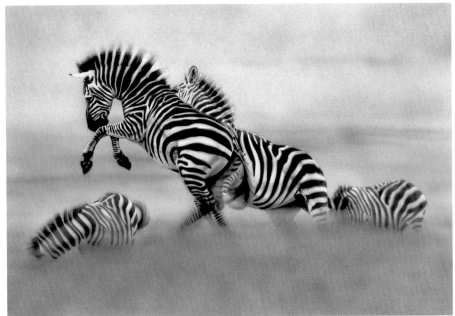

Left
Jan Verberk
The Netherlands
'Exhibition Hall'
50 × 70cm
(19¾ × 27½in)
Gouache
DeVilbiss Aerograph

Above
Jon Rogers
Great Britain
'Zebras'
30.5 × 43.2cm
(12 × 17in)
Ink and gouache
DeVilbiss Aerograph
Super 63A

Above
Peter Sedgley
Great Britain
'Spring Fever' (1981)
120 × 120cm
(47¼ × 47¼in)
Acrylic on linen
DeVilbiss MP

Right
George Green
USA
'Mia Comet' (1981)
137.2 × 106.7cm
(54 × 42in)
Acrylic on canvas
Paasche

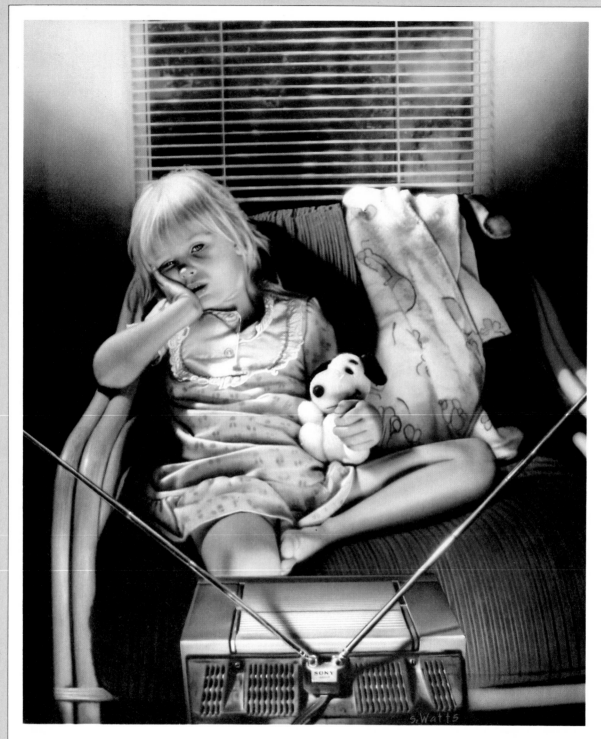

Above
Stan Watts
USA
'TV Boredom', cover
illustration commis-
sioned by Emmu
Magazine
50.8 × 61cm
(20 × 24in)
Acrylic and ink
Iwata HPB

Right
Gottfried Helnwein
Austria
'Angel', cover illustra-
tion commissioned by
Kronebunt (1981)
37 × 29cm
(14⅝ × 11½in)
Water-colour on
paper
Grafo, Efbe and Binks,
Wren-B

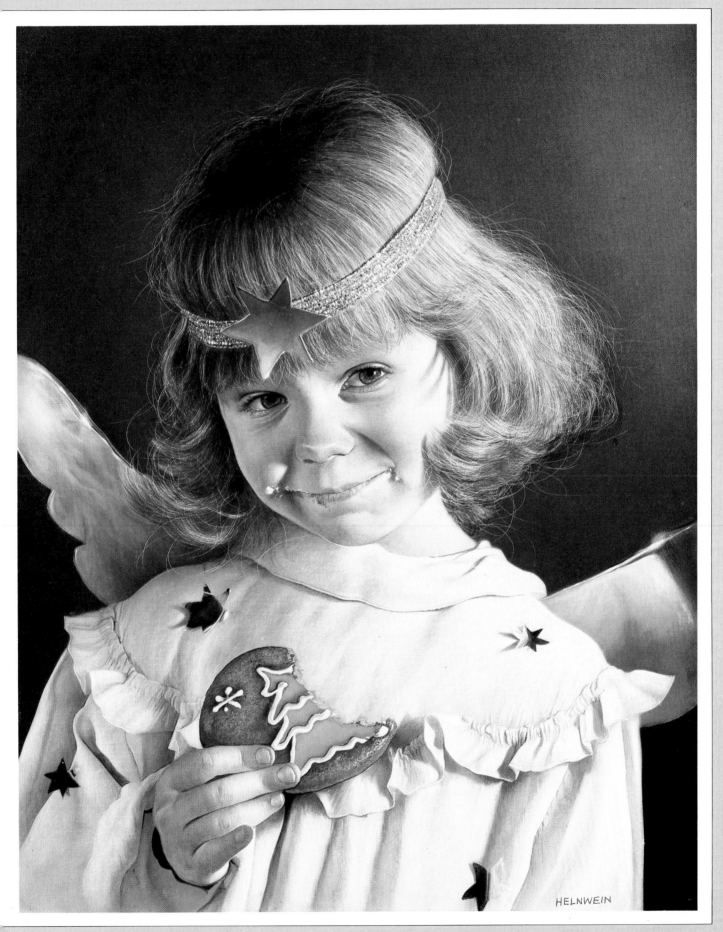

HELNWEIN

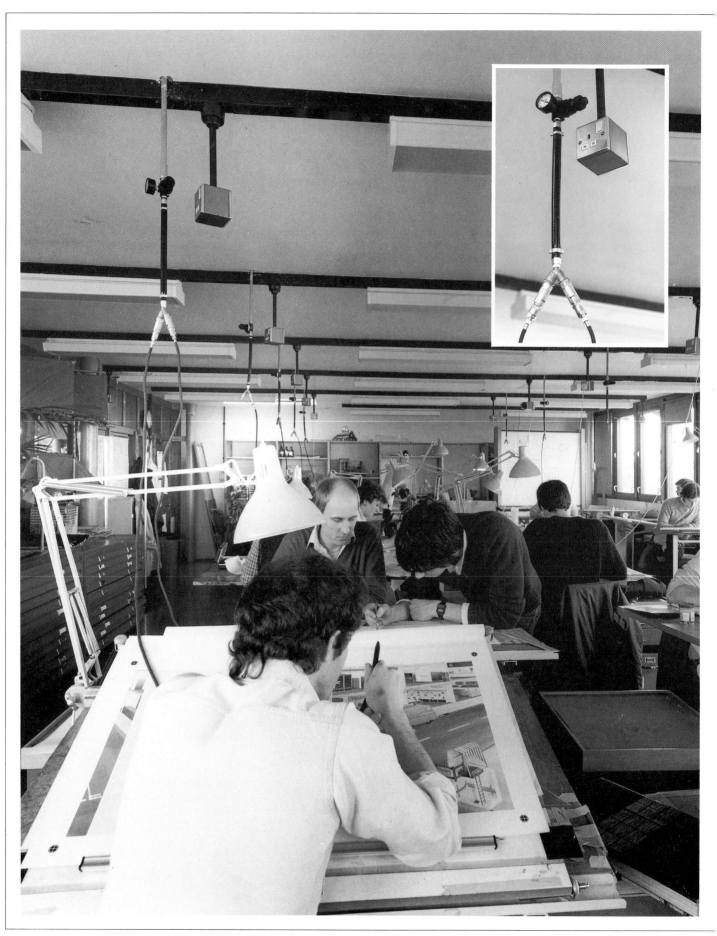

WORKSHOP, EQUIPMENT
AND
SUPPLIES

The professional airbrush artist and even the advanced student will doubtless have a specific idea of what their ideal work space should be like, and precisely what equipment and supplies it should include. In fact, if they are lucky they have it all already. But for those who don't yet have a workshop set up or even a clear idea of its requirements, it seems worth considering the essential tools of the trade.

THE WORKSHOP

An airbrush artist's workshop is likely to be either a work space for one person working alone or a studio of considerable size in which several airbrush artists work together.

In the workshop for one person, which is often a room in his or her own home, the compressed-air supply requirement is for only one airbrush even if the artist has several airbrushes to use for different jobs. In the larger workshops, of the sort found in art schools, design departments of large industrial concerns, and graphic arts studios, the question of the air supply is more complicated. Frequently a single compressor is employed, but in some cases it is found that

Graphic design students at work in the airbrush studio of a London art school. There are 12 pairs of ceiling-suspended outlets (see inset) which are joined to the artists' air hoses by self-locking quick-release couplings. Each pair has its own pressure control regulator and electric outlet.

several smaller two-outlet compressors make more sense, despite the added expense.

Space

Whatever the size of workshop, the amount of space needed by each individual airbrush artist is a minimum of 4 sq m (4 sq yards); no smaller area should be considered feasible even where it is expected that only close work, such as photo retouching or minutely detailed art work, is to be carried out. This is in order to ensure good air circulation, and also because the fine colour dust produced by the airbrush will inevitably settle in a larger area than one intends. In estimating space needs, bear in mind that, in general, the greater the air pressure the larger will be the area of residual paint spray. If a studio installation is being contemplated for a building with an air-conditioning system, plans for the workshop will need to include an added extraction device to carry away the spray-laden air.

Lighting

Good lighting, while of course a basic requirement for all artists, is of particular importance in airbrush work and should not be skimped. The ideal light is from a north-facing skylight, but whether or not such a good daytime light source is available, it must be assumed that work may need to be done at any time of the day or night, so artificial lighting is required. This should give good general light to the entire room.

To direct light to the work itself, a lamp, preferably of the flexible-arm type, should be placed in a position where no shadow will be cast, the light for right-handed artists coming from the left and for left-handed artists from the right. There is a tendency among artists to use bulbs of higher wattage than they need. Forty-watt bulbs are best.

Temperature and Ventilation

The temperature in the workroom should be kept at a comfortable but fairly cool level, as higher temperatures increase the problem of moisture in the air flow. Intake of fresh air and good air circulation are absolutely essential, in order to minimize the inhaling of fine particles of colour mist. The possibility of inhaling not only paint spray but even more noxious fumes must also be kept in mind when using certain synthetic mediums, such as cellulose paint, even when a mask is worn. For this work, extra ventilation facilities will probably be needed if there is no window nearby that can be opened wide.

Work Surface

To minimize glare, the area of white within the artist's sights should be as limited as possible, unless a special non-glare white paint is used. It is probably best to surround the art work, itself likely to be on a white ground, with a non-reflecting surface in a medium-pale colour such as beige. The kind of adjustable tilted drawing table commonly in use is ideal in this respect; and in other

The Airbrush Studio

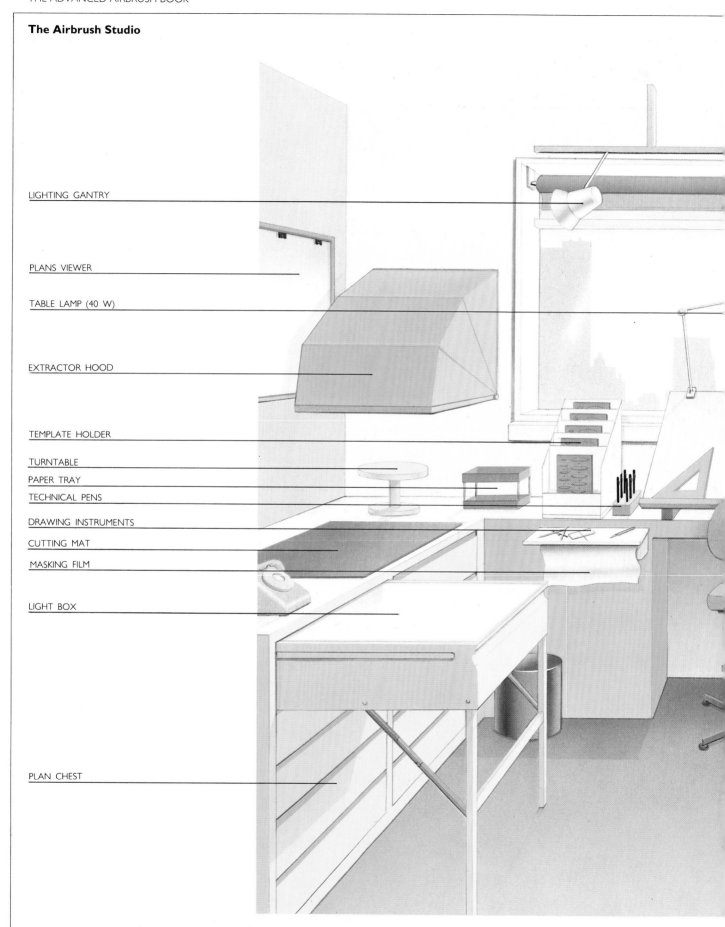

LIGHTING GANTRY

PLANS VIEWER

TABLE LAMP (40 W)

EXTRACTOR HOOD

TEMPLATE HOLDER

TURNTABLE

PAPER TRAY

TECHNICAL PENS

DRAWING INSTRUMENTS

CUTTING MAT

MASKING FILM

LIGHT BOX

PLAN CHEST

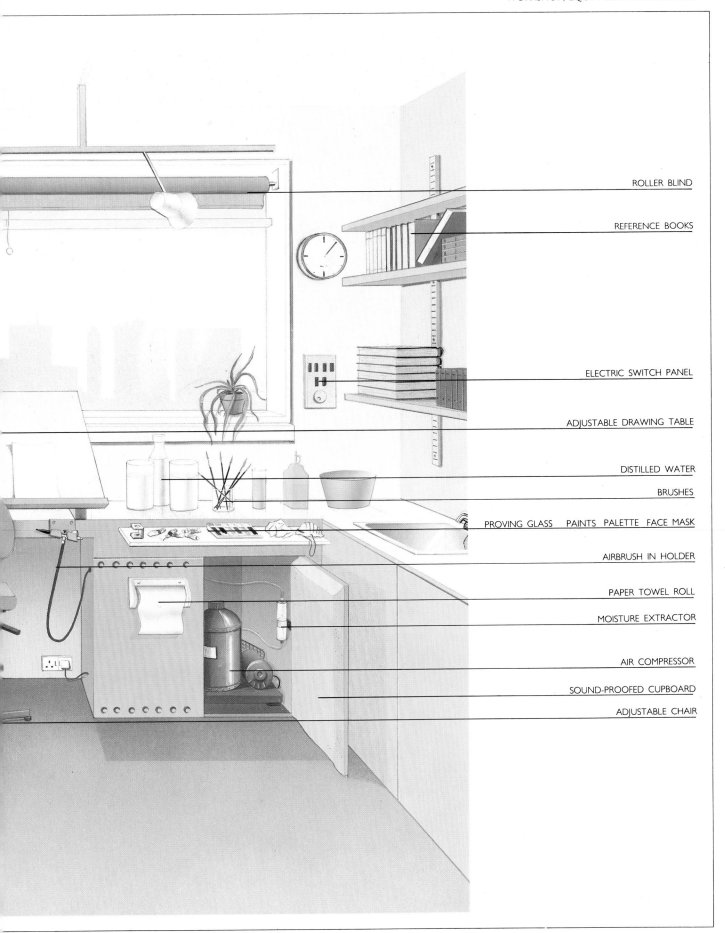

ROLLER BLIND

REFERENCE BOOKS

ELECTRIC SWITCH PANEL

ADJUSTABLE DRAWING TABLE

DISTILLED WATER

BRUSHES

PROVING GLASS PAINTS PALETTE FACE MASK

AIRBRUSH IN HOLDER

PAPER TOWEL ROLL

MOISTURE EXTRACTOR

AIR COMPRESSOR

SOUND-PROOFED CUPBOARD

ADJUSTABLE CHAIR

AIRBRUSH CHOICE

Four successful airbrush artists give their highly personal appreciation of airbrushes.

Cecil Misstear

'I was first introduced to an early DeVilbiss Aerograph model and later on to the Super 63; after much practice I became familiar with the idiosyncracies of this model. A great many artists tend to have a love-hate relationship with their airbrushes. In my case, preferring the devil I know to the one I don't, I have remained faithful ever since to the Super 63, a real thoroughbred. Of other airbrushes I have been most impressed by the German-made Grafo.'

Pater Sato

'I use the Hohmi Y-1 for all phases of airbrushing. I like it because it is both light and small.'

Robert Grossman

'I've got about twenty airbrushes but I almost always use a Thayer and Chandler. Of course, they are all wretched things; they all clog up. It is just a tool, after all!.'

Gottfried Helnwein

'I use three different airbrushes: Grafo, Efbe and Binks Wren-B. I have used the Grafo since the beginning of my career. It is stable, easy to use and indestructible. It is perhaps not the most delicate but it is the most hard-wearing.

'The Efbe is the smoothie among airbrushes, a filigree charmer that is usually very precise and fine. However, it can't be called a long-distance runner.

'The Binks Wren-B is the Elvis Presley among airbrushes. It has the biggest glass bottle and its sphere of action is greater than that of the others. I only use it for really large performances (surfaces). It is the king.'

Aerograph Super 63A, DeVilbiss, Great Britain

Hohmi Y-1, Yaezaki Iron Works Co. Ltd, Japan

Thayer and Chandler Model A, H.H. Pratt, USA

Grafo Type 11, Grafo Fein Mechanik GmbH, West Germany

L. Fischer Type G183, Zeichen Technik, West Germany

Conopois Model F, Conopois Instruments Ltd, Great Britain

Efbe Type 52, Friedrich Boldt, West Germany

Paasche Type VJR, Paasche Airbrush Co., USA

Binks Raven, Binks Manufacturing Co., USA

Olympos HP 1008, Olympos Co. Ltd, Japan

ways as well it is probably the best work surface. The type that can be raised and lowered as well as tilted is especially recommended.

Surrounding Surfaces

The flat areas to either side of the drawing table should also have non-white surfaces, even though these may be scarcely visible when covered by paint pots and other materials. The walls as well should ideally be of some pale colour rather than white.

Seating

The best seating for the artist at work is a swivel chair. Choose one for stability as well as ease of movement. It is a sensible precaution to find out in advance any relevant safety regulations.

Storage Space

Plenty of open shelving will be needed for supplies and reference materials. Closed cupboard space is another requisite, for the storage of art boards, which can fade or discolour in the light.

EQUIPMENT AND SUPPLIES

The various items required for the airbrush artist's workshop include a great many which are needed by graphics artists in general, and a rather shorter list of specialized equipment and supplies peculiar to airbrushing.

A single glance at any art supplies catalogue will give a good idea of how vast is the range of equipment and supplies available to the artist today. The items listed below should all be considered indispensable, while the choice as to which additional non-essential items to acquire is left to the individual artist's personal tastes and inclinations. (Of course, any one of those so-called non-essentials could in time come to seem as indispensable as anything on this list.) The question of whether or not to purchase, for example, a waxing device to apply a coat of pressure-sensitive wax to the back of materials that are to be fixed down is a matter for the artist himself—or his employer—to decide.

The Airbrush

All airbrushes are similar in principle to the very first one, invented in England in the 1890s, but there are many variations on the theme. There are also larger-scale variants, such as spray guns, that employ the same basic principle. Some of these spray guns are becoming quite sophisticated, but although useful for carrying out certain jobs, they are not the fine tools dealt with in this book.

Airbrushes are of either the single-action or double-action type, and have either gravity feed or suction feed. Unless otherwise specified, it is assumed in this book that the artist is using a double-action airbrush with an integral open reservoir above for gravity feed. Single-action airbrushes are suitable for beginners but not versatile enough for advanced work, and the suction-feed types are best reserved for large-scale work where the greater capacity of a jar-type reservoir is required. One type of airbrush not to be recommended is the sort with several cups supplied as accessories; the idea is to have the various colours that are to be airbrushed all ready to hand in separate reservoirs. This is not the good idea it may seem, since it is always best to use freshly poured paint or dye rather than any that has been exposed to the air.

The Airbrush Holder

Most of the holders on the market have extremely unsatisfactory features. Before buying one, examine it critically and ask yourself the following questions:
Is the airbrush held securely and in a stable position?
Is the airbrush held at an angle that will reliably prevent any liquid from the reservoir getting into the mechanism?

The author's own airbrush holder, in soft plastic (kinder to the airbrush than metal), holds the tool securely, yet it is easily removed and replaced.

Is the material of the holder soft enough? (Many clips on the market are extremely hard and eventually could wear away the thin metal surface of the airbrush as metal rubs against metal.)

If you are not satisfied on these points, an improvised holder, similar to the one made by Cecil Misstear, shown here, may be the best answer.

The Compressor

In the choice of a compressor, there are several factors to consider, such as capacity required, steadiness of air flow, moisture extraction, noise and vibration.

The size of the ideal compressor for you will depend on the capacity needed—whether one airbrush is to be supplied, or several. In any case, it is advisable to have approximately 25 per cent greater capacity than you expect ever to need; this is because the compressor's working life will be considerably shortened if it is used constantly to full capacity.

The airbrush can only atomize the pigment smoothly and evenly if it is receiving an absolutely constant flow of air at a predetermined pressure, with no pulsation whatever. The choice of which compressor to buy, once the required capacity is determined, should rest primarily on this consideration. Moisture extraction elements should also be examined closely. Noisiness of operation can, in some cases, be mitigated by placing the compressor in a soundproof enclosure—making sure the housing is well vented—or by placing it in another room. Vibration can also be reduced by placing the compressor on rubber mounts.

A large studio's requirements can best be met by a high-speed turbine compressor; this is the most efficient air-supply system. The high capital outlay is offset to some

COMPRESSORS

Bulky turbine compressor (top) that will accommodate a large number of artists, 35 airbrushes or more. (Below) A silent-type portable compressor and air receiver; these are designed for either 2 or 4 airbrushes. (Bottom centre) A piston-driven compressor suitable for a single airbrush artist; these compressors tend to pulsate. (Right) Refillable gas cylinder that can be used in place of a compressor, for one airbrush, or possibly 2.

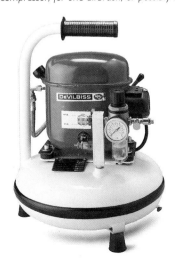

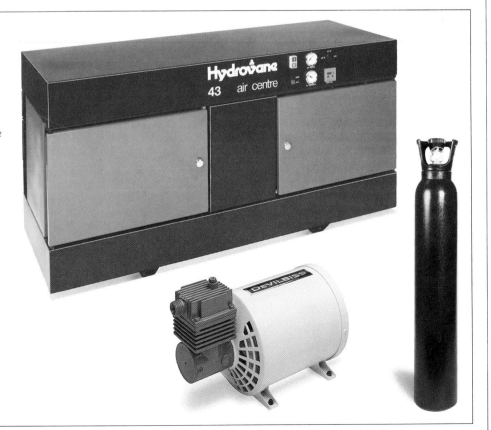

degree by the long life expectancy that its vibration-free engineering gives it. Among the large compressors are also piston-operated ones (single or double pistons) and some employing a diaphragm principle. These can accommodate a large number of airbrushes simultaneously, with each artist setting his own pressure separately. Some of the diaphragm type make little noise.

The next category of compressor, down the scale, is appropriate where a smaller number of artists, perhaps five to twelve, is to be supplied. In this range the question of whether it is wise to install a large compressor should be considered first: it may be that several smaller compressors, to accommodate two airbrush artists each, will be more satisfactory. The advantages, such as portability, must be weighed against the additional outlay and running costs.

One-person compressed-air systems range from a simple foot-pump device to quite costly but quiet and highly efficient piston-driven compressors. Between these extremes are two other systems: the 'throw-away' version, a small propellant gas device, which can be bought very cheaply but because it must be replaced frequently may

well be found to be the most expensive system of all; and the compressed-air cylinder delivered to the artist's premises by suppliers, to be used until empty, then returned to the suppliers to be refilled. Both of these systems have the advantage of being silent. The large vessels are extremely heavy, and therefore an inappropriate choice for any studio reached by several flights of stairs. No large investment is involved, but the supplier will require a deposit and you will probably have to buy the pressure and contents gauges, which are expensive items.

Rulers
Two rulers will be needed: one plastic straight-edge for measuring lengths and for drawing and brushwork; and one metal type-scale (useful for cutting straight lines).

Set Squares (Triangles)
These are used primarily for measuring angles and secondarily for ruling straight lines. Two are needed: one of 30-60 and one of 45-90 degrees.

Templates
Two types of templates, French curves and ellipse guides, are essential. A typist's metal erasing shield of the old-fashioned type, is another useful template to have.
French curves Two sets are needed, a basic set and a specialist one, such as yacht curves or railway curves (all these sets have similar curves). Flexible curves may also be useful, for those occasions when you need to draw large, shallow curves.
Ellipse guides You should have on hand one comprehensive set of ellipse guides, such as the Leitz guides, which are very accurate, and an ellipsograph, with which ellipses of any ratio can be made.

Magnifiers and Reducers
Two types of magnifiers will be needed and one reducing glass.

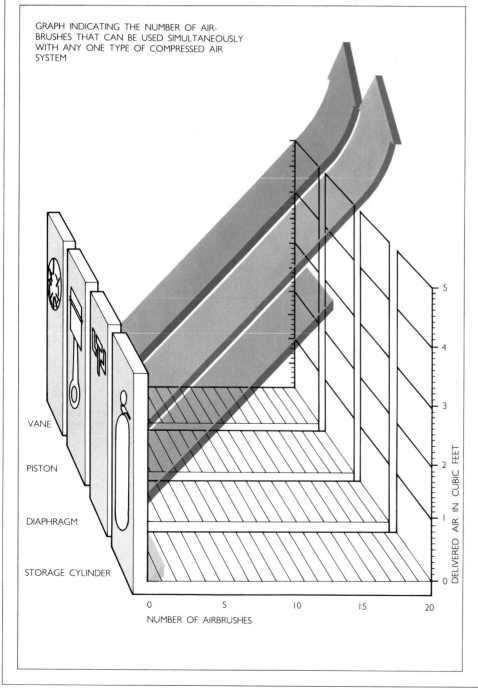

GRAPH INDICATING THE NUMBER OF AIR-BRUSHES THAT CAN BE USED SIMULTANEOUSLY WITH ANY ONE TYPE OF COMPRESSED AIR SYSTEM

VANE

PISTON

DIAPHRAGM

STORAGE CYLINDER

DELIVERED AIR IN CUBIC FEET

0 5 10 15 20

NUMBER OF AIRBRUSHES

Magnifiers One linen tester and one adjustable-stand model will be required, the latter being an essential for photo retouching.

Reducing glass This is useful for allowing you to see an approximation of what the work will look like after reduction (there will be slight distortion) and particularly for checking small segments of work, to see whether any fine detail is likely to 'clog up' in the printing.

Cutting Tools

Three types of cutter will be needed for mask cutting:

1 a scalpel-type cutter, with spare blades;

2 a swivel knife which employs a trailing-edge principle for cutting of smooth curves;

3 compass cutters in three sizes: one for extremely small circles, down to 2mm (⅟₁₆in) in diameter; another for standard size circles up to 20cm (8in) in diameter; and a beam-type cutter, for circles above that size.

Paintbrushes

Sable brushes are best for all uses except the filling of the airbrush reservoir (the fine hairs might pass through the nozzle). Choose long-haired sable brushes rather than short-haired ones. The more expensive brushes, such as Winsor & Newton's top lines, can be expected to be of consistently high quality but even these should not be purchased without being tested: in the shop ask for water to dip the brush in, then, after shaking the water off, hold the brush tip upwards and examine it to make sure the end is not forking. Three types are needed:

Sable 'pencil' brushes You should have three types: one number 00 or 0, one

A line scored onto your set square (triangle) with geometric accuracy will prove invaluable, enabling you to rule right angles on both sides of a line.

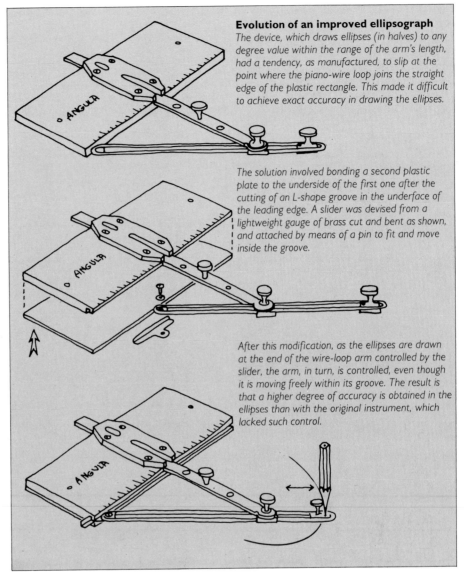

Evolution of an improved ellipsograph
The device, which draws ellipses (in halves) to any degree value within the range of the arm's length, had a tendency, as manufactured, to slip at the point where the piano-wire loop joins the straight edge of the plastic rectangle. This made it difficult to achieve exact accuracy in drawing the ellipses.

The solution involved bonding a second plastic plate to the underside of the first one after the cutting of an L-shape groove in the underface of the leading edge. A slider was devised from a lightweight gauge of brass cut and bent as shown, and attached by means of a pin to fit and move inside the groove.

After this modification, as the ellipses are drawn at the end of the wire-loop arm controlled by the slider, the arm, in turn, is controlled, even though it is moving freely within its groove. The result is that a higher degree of accuracy is obtained in the ellipses than with the original instrument, which lacked such control.

number I and one number 2.

Sable flat-end brush One flat-end brush will be needed for laying in washes.

Coarse-hair brush A bristle stencil brush or other brush with coarse hairs is essential for filling the airbrush reservoir.

Tapes and Dispensers

Choose dispensers of the heavy-base type, and keep on hand five kinds of tape:

1 standard transparent tape

2 'magic' tape

3 double-sided tape

4 photographic tape (black or red; the red is more practical because it is more easily seen among black portions of a negative)

5 draughting tape, for fastening artwork to the work surface

Other Equipment and Supplies

Besides the paper and boards, paints and dyes that will be your grounds and mediums (discussed in the next chapter), you will also need: masking film, which is available in sheets and rolls, and masking fluid, for certain fine work; an eyedropper-type paint applier; a burnishing tool; water jars; a palette (water-colour type); rubber cement or gum, with its accompanying pickup eraser; paper towel rolls; cotton wool or absorbent cotton; a range of pencils; and distilled water. The acquisition of a set of perspective grids is also strongly recommended.

There are also two electrical appliances that have been found to be extremely useful. The first is an electric eraser, which is rather like a small electric drill with a rubber eraser in the chuck in place of a cutting tool; the other is a hand-held hair dryer, for drying artwork.

Finally, a soft dusting brush is an indispensable piece of equipment for cleaning surfaces and materials.

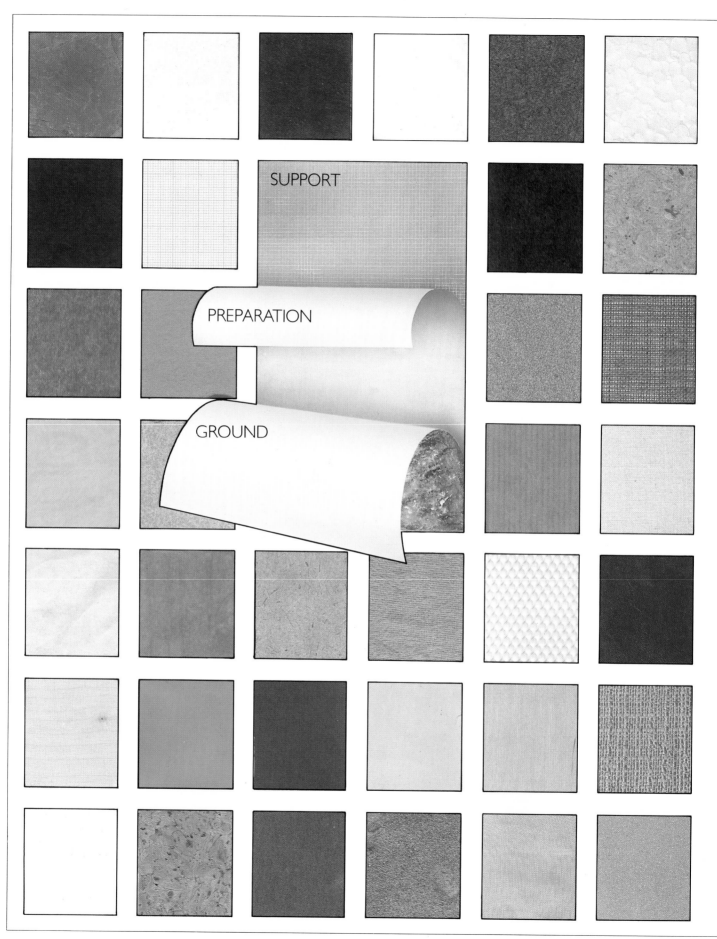

SUPPORT

PREPARATION

GROUND

MATERIALS
AND
PROCEDURES

The function of the airbrush is to atomize a diluted pigment and apply this fine spray to a surface. Airbrushing is never an isolated procedure, however: there are several processes to be carried out before, after and in between sprayings. First comes the conception of the artwork, followed by the all-important drawing of the picture. After the drawing is transferred to the chosen ground and—sometimes—inked in, the cutting of masks is begun. It is only at this stage, with the first mask in place, that the airbrush comes into play.

As the airpainting proceeds, the application of pigment is almost invariably accompanied by a parallel and equally important operation: the selective removal, by one means or another, of a certain amount of that pigment, as for highlights. After the airbrushing there is finishing work to be done, usually by hand with a paintbrush.

MATERIALS

The ground and the medium, whatever they may be (and in each case the range of possibilities is extremely wide), are the materials with which the airbrush artist does his work.

The Ground

In this book the ground is defined as the surface upon which the artist applies the medium. It is called the 'support' by some artists, but that term is used here for the material supporting the ground, if any—for example when paper (the ground) is mounted on board (the support). The ground is usually paper or artist's board, but it can be almost anything: brick or stone, any fabric from satin to hessian (burlap) or canvas, ceramic material, glass or metal.

The artist may also choose to alter the ground, to make it not one material but a complex of materials; for instance, by applying sand or powdered granite to glue-coated hardboard, the ground can be given an interesting texture.

Cleaning the ground Paper or board to be used as a ground must first be made free of grease, since even at the time of purchase it will have been handled repeatedly, and hands leave a residue of the skin's natural oil on surfaces. This cleaning is best done by wiping with tissue or cotton wool lightly saturated with either carbon tetrachloride or lighter fuel. (Caution: don't inhale, keep well away from flame and, if using lighter fuel, do not smoke.) It is important to clean the entire surface of the ground uniformly, or as the work progresses a distinct difference may become visible between the cleaned part and the rest: the edges of the cleaned area will show and its shape will emerge. After cleaning, blow air over the surface with either a hair dryer or the airbrush to remove any loose fibres that may have been left behind.

A Variety of Grounds

1 Rustic slate	20 Greaseproof paper
2 Illustration line board	21 Sensitized paper
3 Suede	22 Hard board
4 Tin	23 Blanket material
5 Hard board	24 Textured plastic
6 Polystyrene	25 Leather
7 Display board	26 Block board
8 Graph paper	27 Rubber
9 Velvet	28 Newsprint
10 Chipboard	29 Display card
11 Tissue paper	30 Plywood
12 Felt	31 Synthetic woven
13 Coarse sandpaper	material
14 Hessian (burlap)	32 Plastic
15 Nylon	33 Cork
16 Tracing paper	34 Adhesive paper
17 Marble	35 York stone
18 Brown paper	36 Silk
19 Cotton drill fabric	37 Fine sandpaper

1	2	3	4	5	6
7	8	SUPPORT		9	10
11	12	PREPARATION	13	14	
15	16	GROUND	17	18	19
20	21	22	23	24	25
26	27	28	29	30	31
32	33	34	35	36	37

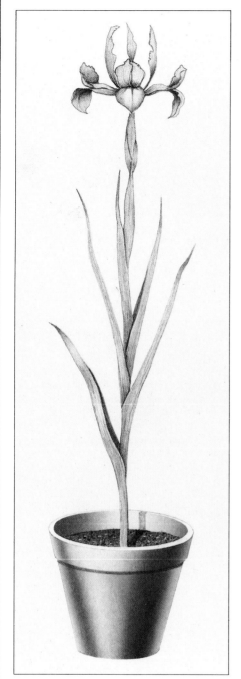

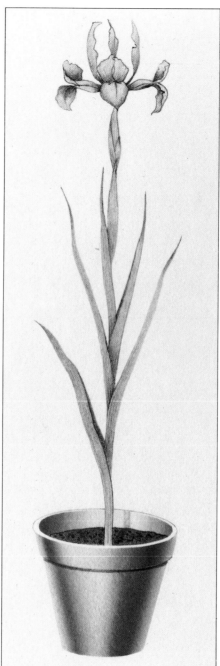

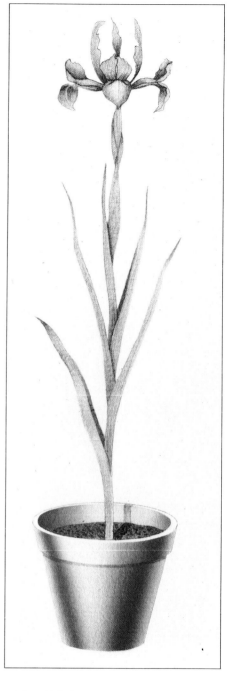

If you are going to use as your ground Pantone or any of the other transparent or opaque self-adhesive colour sheets now available, the same process of pre-cleaning should be carried out, and because of the non-absorbent nature of these surfaces, it will also be necessary to add gum arabic or another bonding agent to the ink or dye to be airbrushed, since a surface lacking 'bite' tends to repel water-colour. Do not attempt to give the surface this 'bite' or 'tooth' by the use of a dry-scrub abrasive as this may remove the colour from the surface.

Other types of ground may be cleaned by the following methods:

White enamelled surfaces Dampen a soft cloth in warm water, dip it in gilders' fine whiting powder and gently rub over the enamelled surface.

Brass Pour a little ammonia into warm soapy water and submerge the brass surface to soak for up to 15 minutes, or rub with a soft cloth soaked in this solution. Tarnish can be removed from brass by a weak solution of oxalic acid; wash this off with water and then, using sawdust and a soft chamois leather give the surface a polish.

Gold leaf Sponge gently with methylated spirit and let dry.

Copper Mix together (taking care because of the fire risk) 1 part hot wax with 2 ½ parts citric acid and 2 ½ parts white soap powder; rub onto the surface with a soft cloth. After cleaning, treat the surface with another solution: dissolve 42 g (1 ½ oz) sodium hyposulphate in 600 ml (1 pint) water and add 40 ml (1 ½ fl oz) sulphuric acid in 600 ml (1 pint) water. Finally, wipe down with a clean cloth.

Aluminium Rub with a mixture of equal parts of methylated spirit and sweet oil (a term for light oils, such as olive oil).

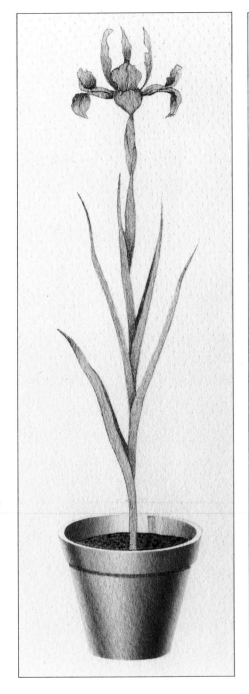 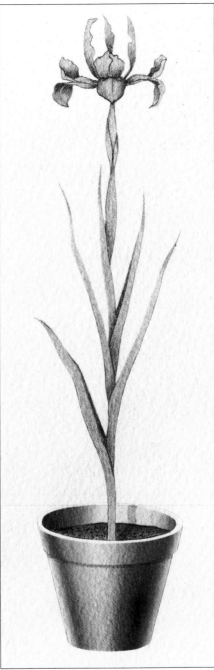 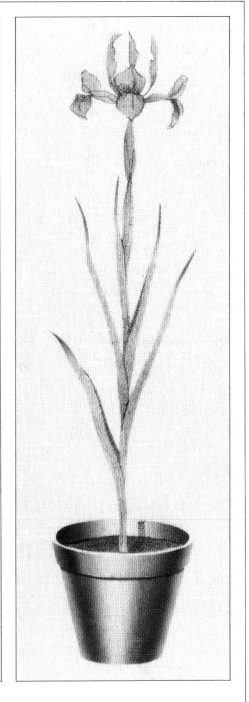

Stone If weathered stonework is to be used and simple washing is not enough, a solution of 1 part spirits of salts (hydrochloric acid) in 32 parts water is often successful; apply with an old brush and then rinse repeatedly with clean water.

Embossed glass Dampen a swab of cotton wool in a solution of 1 part methylated spirit and 2 parts water, then dip in gilders' fine whiting powder and rub the surface with it; if the glass is deeply etched, a soft brush may be used. Allow to dry wash the surface with a clean cloth, then polish with another clean cloth.

On six grounds of differing texture—five grades of paper, smooth to coarse, and a canvas of standard weave—an identical picture has been airbrushed employing identical masking and spraying techniques with remarkably similar results, demonstrating the unifying influence of the airbrush itself. The master picture of the flower in a pot was transferred as a line drawing to each of the grounds, then the mask cutting of the first was duplicated as closely as possible for the others; the same medium (water-colour) was applied by the same airbrush in each case, set at the same pressure and held at consistent distances from the grounds. The spray was directed at a vertical or near-vertical angle throughout, in accordance with the aims of the exercise. Conversely, if the object had been to

emphasize the difference in textures, the airbrush would have been held at an acute angle (the more acute the angle, the more pronounced the dissimilarities would be). Ironically, when the originals were being photographed for reproduction here, it was necessary to resort to side-lighting in order to bring out the textural distinctions, which were otherwise in danger of disappearing entirely in the reproduction process.

Variety grounds It seems that there is literally no material or object of any sort that won't at some time be explored for its possibilities as a ground by some enterprising and inspired airbrush artist somewhere. The five British designers and craftsmen working in totally different marketplaces—clothing, furniture, custom vehicles, home furnishings and decorative objects—whose work is shown here represent only a tiny fraction of the experimenters who are these days exploring the airbrush's diverse uses.

A painted-wood cupboard forms the ground for floral decorations, stencil-masked and airpainted with six spray can colours, by Lyn LeGrice.

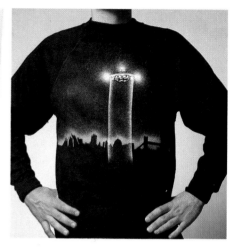

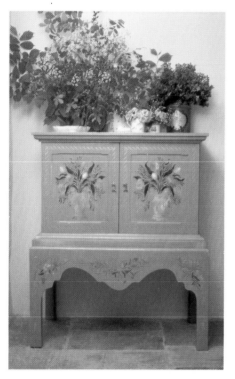

Airbrushed designs on ceramics by Fiona McKinnon using a Badger 250 airbrush to spray enamel onto glazed and fired surfaces which she reheats first: a pool-side scene on backsplash tiles for the basin in a fashionable bathroom, and parasol design on an enamelled clock 17 cm (6¾ in) in height.

Paul Alan Harrison's spaceship T-shirt design, silk-screened and airbrushed with an Aerograph Super 63, and Sue Rangeley's quilted silk jacket, beaded, embroidered and dye-sprayed with a Brown airbrush.

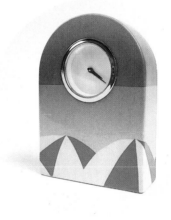

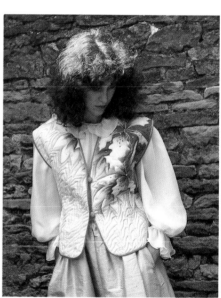

Toy company delivery van masked and custom-painted by Ray Habgood on roof, front, sides and rear doors using a Badger 150 IL airbrush with acrylic 'candy' colours over white and yellow base.

The Medium

Almost any pigment can be used in an airbrush provided it has been ground sufficiently finely and suspended in the proper liquid. The wide range available—a range that is now rapidly expanding—includes water-colours, gouaches, dyes, inks, acrylics, cellulose and other synthetic paints, and oil-based paints.

Some of these mediums are actually poisonous, and reputable manufacturers label such products accordingly in their catalogues. Remember that, when using the airbrush, the back of the hand not holding the airbrush is vulnerable to pigment poisoning and should be protected. A suitable face mask should also always be worn, and it is important never to give in to the temptation to put a paint-brush in your mouth to shape the point. The following is a list (not necessarily a complete one) of colours that should be used with particular caution in this regard.

Water-colours Chrome deep, chrome lemon, chrome orange, chrome yellow, lemon yellow, mauve, purple lake, rose carthamine, scarlet vermilion and vermilion.

Designers' Gouache geranium, geranium lake pale, havannah lake, rose carthamine, rose malmaison and rose tyrien.

Lamentably, one of the finest of mediums ever available for airbrush artists, Winsor & Newton's Draughtsman's Colours in sticks, has now been withdrawn from the market.

It is best to use distilled water for diluting water-based mediums, unless you live in a soft-water area. Hard water impairs a colour's clarity.

Water-colour paints Of the various mediums, water-based water-colour paints, which are transparent unless white is added, are the least likely to cause blockage or trouble in cleaning the airbrush.

Gouaches These are also water-based, but opaque (though with these, as with all airbrush mediums, dilution inclines them towards transparency). Of the two types, designer colours and student colours, only designer colours should be used in an airbrush. They are intended to be mixed with water, to the consistency of milk. Gouaches are more troublesome than water-colour paints, tending to solidify around the nozzle and air cap, particularly in the case of process white. It is necessary to clean out the reservoir and air cap frequently.

Dyes and inks Most dyes and inks are water-based, although some are transparent and more or less permanent, which makes the rectifying of any small errors a bit trickier than when using water-colour or gouache. Among the fabric dyes on the market that

USEFUL TIP *When water-based paints have dried up, don't throw them away. First pound them, then make into a paste with a few drops of glycerine and a few drops of distilled water. Mix this paste with more distilled water to the desired consistency, then press through a fine mesh, such as an old nylon stocking, to strain. For an even better result, a little gum arabic and a drop of ox gall may be added with the glycerine.*

are used for airbrush work are some that can be heat-fixed, either in an oven or by ironing.

Acrylics These have been gaining in popularity recently due to the speedy results, versatility and brilliance of colour they give, along with the added attraction of their adhesive properties, caused by the polymer binder. This binder is a type of emulsion, soluble when mixing, yet water resistant when dry, and is found in three consistencies: liquid, gel and paste. Finishes are also available in gloss varnish, matt varnish and eggshell. It is in the liquid form, with new additives variously called retarder, tension breaker or flow improver, that acrylics are most suitable for airbrush work.

In the past, airbrush manufacturers have warned against using acrylics because of their tendency to clog the airbrush, but there are new products that can greatly mitigate the problem, which is caused by the paints' fast-drying property. These products include not only the improved paints with the retardant additives mentioned above, but also cleaning agents and airbrushes specially developed for acrylics.

Despite the improvements, when acrylics are used extreme care must still be taken to avoid the process called polymerization, which causes clogging and means that the airbrush must be repeatedly dismantled. Acrylic paints can be diluted with water, but as this will not affect their fast-drying characteristic, it is probably worth using one of the new diluting solutions instead, despite the added cost; and a cleaning agent specially developed for acrylics, such as Winsor & Newton's 'Winsol', is also worth buying.

In deciding between tubes and tub containers of acrylic paints, choose whichever one is the more finely ground, if you can determine

WARNING *when spraying any of these, be aware at all times of the fire hazard; and always wear your face mask, as these paints are particularly harmful if inhaled.*

this. The pigment in tubs is usually likely to be finer.

Cellulose paints Cellulose and similar synthetic paints are suitable for the airbrush, although these also tend to be quick-drying. There are two types of cellulose paint, pure cellulose and cellulose synthetic; the latter is the slower-drying of the two. Each has its own suitable dilution agent.

Oil-based paints and lacquers Model-makers' oil-based paints are appropriate for airbrushing onto three-dimensional constructions but not onto untreated paper, which becomes stained by the oil content. (If oil-based paints are to be used on paper, the paper should first be treated with a special sealer.) To dilute use a mixture of linseed oil and turpentine.

Lacquer is made by combining alcohol with lac, a transparent resin produced by a tree insect. When buying lacquer, read the label carefully to ascertain its suitability for the airbrush, and also buy the dilutants specially prepared for lacquers. When airpainting with lacquer, clean the airbrush frequently.

Mixing mediums It is sometimes desirable to mix mediums for textural interest and reflective quality. For instance, a cellulose paint—either of the two types—or an acrylic paint can be sprayed first, then an oil-based paint used for overspraying. (Do not attempt the reverse order for combining these mediums, however, without spraying a suitable primer-sealer over the oil-based paint or a chemical reaction may take place).

Unsuitable and difficult mediums It is not advisable to buy paint in powder form to mix yourself; generally speaking these powders are not ground finely enough for an airbrush. Another unsuitable product is the sort of metallic paint, in silver or gold, which has long been widely available, although claims of suitability for the airbrush are being made for some new gold and silver paints. In general the metallic flakes of which these paints are made are not ground but simply stirred into the suspension liquid and held by surface tension, and this clearly could lead to clogging. They are best employed as primer-sealers for some projects.

Modern developments make various synthetic mediums more suitable for use in the airbrush than ever before, while on the other hand the use of scanners for colour separation in printing brings a problem with some mediums, particularly the luminous or 'day-glo' paints, which cannot be reproduced within the standard four-colour system. Some artists who have welcomed the new synthetics are now going back to water-colours after encountering technical problems

with the reproduction of their work. It is impossible to say which products will prove most popular in the future; but it is likely that the more esoteric materials, while perhaps used to advantage by fine artists, will not be feasible for art projects intended for reproduction by standard printing procedures. There can also be a problem with some methods of laying the mediums: for instance, the introduction of white paints over colours in order to lighten them may result in the scanner either exaggerating the white or ignoring the white layer almost completely.

PROCEDURES

After the ground has been cleaned, the pre-airbrushing procedures are the stretching or mounting of the ground; drawing the picture, transferring it to the ground and inking it in (optional); then the assembling and cutting of masks. After the airpainting and its accompanying process of selective removal of pigment comes the finishing.

Mounting

If you are using board as your ground, mounting is not necessary, but all papers except the stiffest will need to be firmly mounted before artwork is begun. There are two mounting methods, wet and dry. Spray mounts are also available but are not satisfactory. They are banned entirely in the United States, because of the threat to the ozone layer caused by aerosols.

Wet mounting Fastening the ground onto a stiff surface while wet means that it shrinks as it dries, and thus adheres smoothly. This is a useful technique for very large works.

Dry mounting More usual than wet

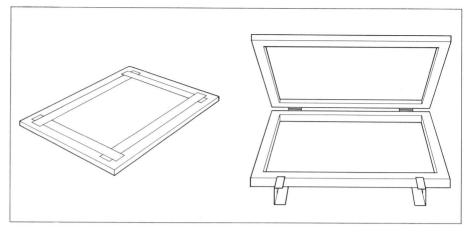

Stretching I *Here the paper, well saturated, has been placed face up on a base board and its edges securely fixed down with gum-soluble packaging tape, to dry. This is probably the most practical method of stretching a paper ground.*

2 *A stretching frame such as this one, in which the saturated ground is held tightly clamped for the shrinking process, is suitable for heavier papers, but has the disadvantage of being limited to one size, fixed by the frame's dimensions.*

mounting for the airbrush artist is dry mounting, with or without heat. In dry mounting without heat, the underside of the ground and the mount's surface are both coated with rubber cement or gum which is then allowed to dry thoroughly (in the case of Cow gum this means letting it dry for at least half an hour) before the two coated surfaces are precisely placed together. For mounting heavier materials, a heavier adhesive will be needed. For dry mounting with heat, you need a dry-mounting press, a tacking iron and specially treated tissue. (Both dry-mounting methods are illustrated.)

Stretching

If either canvas or water-colour paper is to be used as the ground, it will be necessary to stretch it first.

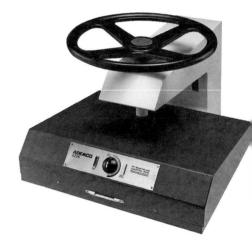

A photographic mounting press, which employs heat and weight to bond two surfaces together.

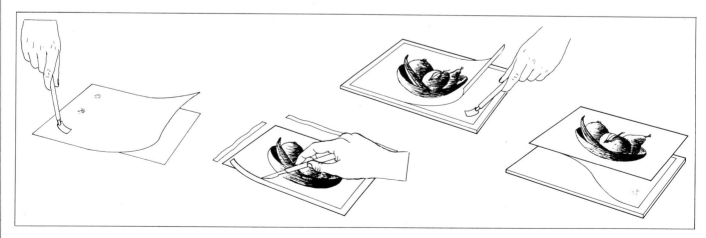

Dry mounting *To prepare artwork to be mounted by use of a photographic mounting press (above): The artwork is placed face down on a clean surface and a sheet of specially coated mounting tissue is laid over it, more than covering it. The two* surfaces are bonded in several places at one end with an electric tacking iron; then artwork and tissue are turned over and placed on a cutting mat; after the excess tissue has been cut away the artwork is positioned on the mount as desired. The tacking process is repeated, this time to bond the tissue to the mount at the opposite end. The three surfaces are now joined as shown at right. Other tacking methods can be employed for similar results.

Mounting with adhesive I *The ground or artwork is placed in the predetermined location on the mount, and a minimum of two marks made as far apart as possible on the borders, to ensure that subsequent registration will be accurate.*

2 *For the very firm bond that is needed in successful mounting, the best method is impact adhesion. After the two surfaces are cleaned a thin even coat of gum adhesive is applied smoothly to both surfaces and allowed to dry.*

3 *To avoid mishaps when joining the two dried surfaces together, first cut a piece of tracing paper in half and place the two pieces abutting one another to cover the treated area on the mount; the partial marks should be visible.*

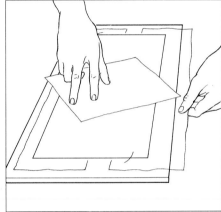

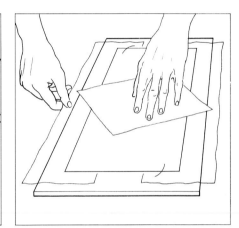

4 *The artwork or ground is laid with its treated surface down over the tracing paper and moved into register. For the next stage a protective piece of clean paper is placed on top to keep the artwork surface free of fingermarks.*

5 *While the fingers of one hand press down on the paper shield, maintaining register, with the other hand gently pull one piece of tracing paper partway out from between the treated surfaces so that pressure can be applied in the middle.*

6 *With the two surfaces now joined in a small area at the centre, the second piece of tracing paper is likewise pulled a short way out; the bonded area is then increased by rubbing evenly from the centre outwards to eliminate air bubbles.*

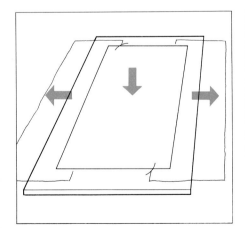

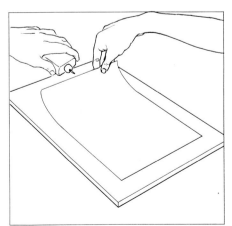

7 *The mounting is continued by alternately removing the pieces of tracing paper, to left and to right, and rubbing the treated surfaces together in an ever-increasing area outwards from the centre, with pressure exerted from above.*

8 *After both pieces of tracing paper have been withdrawn and the two surfaces firmly joined over the entire area, the mounting is complete. The artwork or ground may need rechecking for cleanliness despite the use of the paper shield.*

9 *While this method gives a strong bond, it is nevertheless a simple matter to separate the two surfaces, if the need arises, by edging up one corner and applying lighter fluid to dissolve the adhesive, then peeling away carefully.*

For canvas, the process is the same as in preparing it for oil painting, that is, the canvas is stretched over a wooden frame. In the case of water-colour paper, the word 'stretching' is a misnomer since it is actually shrunk after being mounted: first it is saturated with water, then fastened to a flat surface (chipboard and hardboard are both suitable) with gum-backed paper or tape, and allowed to dry to a stable size. In this form it can then be removed from the board if flexibility is desired (as when it is to be placed on the rollers used in colour separation). Frames for stretching water-colour paper are available but aren't very satisfactory, as they tend to tear all but the heaviest weights of paper.

The Picture

As this book is aimed at advanced students and professional airbrush artists, it may seem inappropriate to include any discussion about how a picture is drawn. However, a great many airbrush artists lack a firm grasp of the fundamentals of drawing, most notably the principles of perspective. The common practice among professional artists is to copy from photographs whenever they can, rather than working out the lines of perspective for themselves. This has its drawbacks, among them the fact that the client may have to get a photographer to take a picture in order that it may be given to the artist. In many cases this is appropriate, but in others it is likely that the client may decide that next time he will use the photograph itself, rather than paying for photograph and artwork. Another and more important drawback is that reliance on photographic sources can lead to incorrect drawing if the artist does not have a thorough grounding in the fundamentals that will enable him, in executing the drawing, to compensate for any distortion in the photograph. (Although the distortion will vary with the equipment

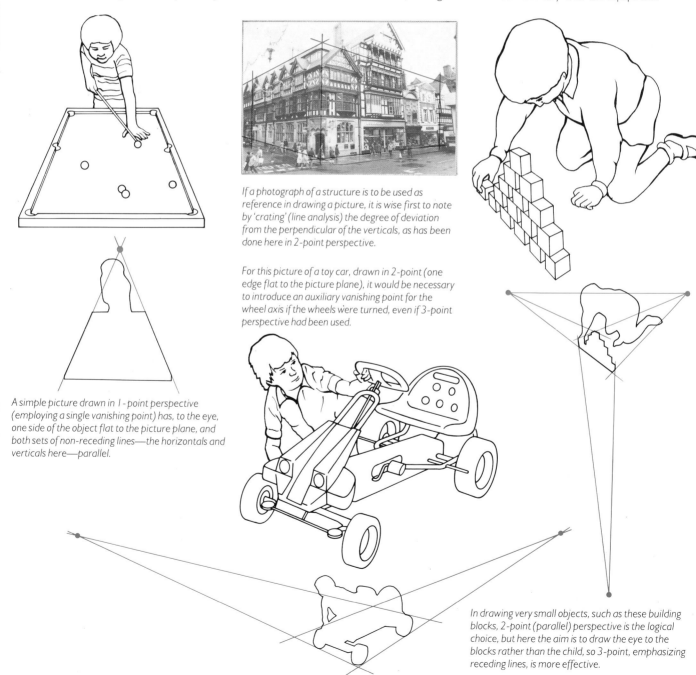

A simple picture drawn in 1-point perspective (employing a single vanishing point) has, to the eye, one side of the object flat to the picture plane, and both sets of non-receding lines—the horizontals and verticals here—parallel.

If a photograph of a structure is to be used as reference in drawing a picture, it is wise first to note by 'crating' (line analysis) the degree of deviation from the perpendicular of the verticals, as has been done here in 2-point perspective.

For this picture of a toy car, drawn in 2-point (one edge flat to the picture plane), it would be necessary to introduce an auxiliary vanishing point for the wheel axis if the wheels were turned, even if 3-point perspective had been used.

In drawing very small objects, such as these building blocks, 2-point (parallel) perspective is the logical choice, but here the aim is to draw the eye to the blocks rather than the child, so 3-point, emphasizing receding lines, is more effective.

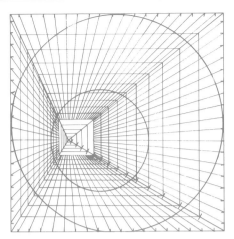

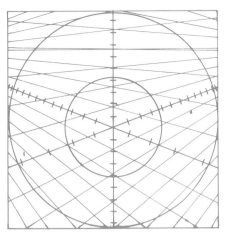

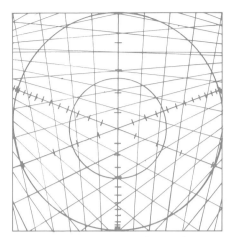

Perspective grids I *The circles represent cones of vision of 30 and 60 degrees, and lines recede to either 1, 2 or 3 vanishing points. In this 1-point grid the vanishing lines are drawn from a common scale on 4 sides and 1 diminishing scale.*

2 *On this 2-point grid the calibrations are marked off (to represent units of measure) on 1 vertical scale and 2 diminishing scales leading to their respective vanishing points. Where the 3 scale lines cross is the zero datum point.*

3 *This similar-looking grid is in 3-point: the 'vertical' here is a diminishing scale; thus all 3 scale lines lead to vanishing points. The grid's other lines, which lead to the same VPs, act as directional aids for drawing the picture.*

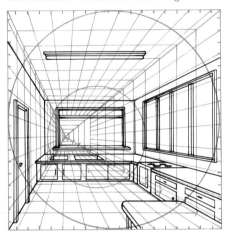

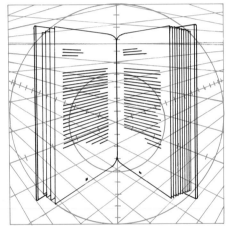

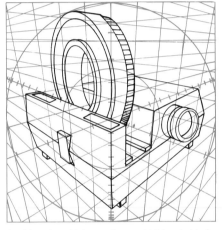

4 *Here a kitchen has been drawn in correct 1-point perspective using the grid directly above, that is, the 60-degree cone of vision, has the effect of making the kitchen seem more spacious than it really is.*

5 *This open book has been drawn in parallel perspective by use of the grid directly above, but here the grid is adapted rather than slavishly followed, as will be seen in the freely interpreted receding line of the bottom of the pages at right.*

6 *Here the grid shown above, which is suitable for massive subjects such as skyscrapers or ocean liners, is effectively employed to lend mass and weight to a relatively insignificant object, the carousel of a slide projector.*

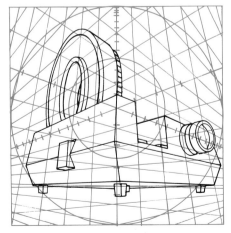

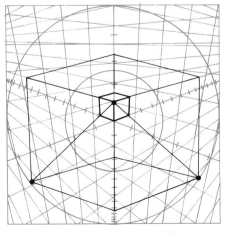

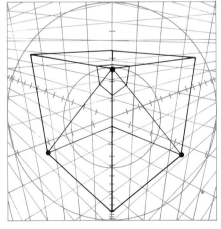

7 *The capability of one grid to offer different viewpoints is demonstrated here: the same grid (upper right) is employed, but here it has been turned 180 degrees to reverse the viewpoint by dropping the horizon line below the object viewed.*

8 *The same 3-point grid (upper right) is used yet again to solve two contrasting problems. Above, a small cube (1 × 1 unit of measure each side) is magnified to a large cube by projector lines drawn from one corner to the perimeter.*

9 *Here the object was to obtain an acute foreshortening in a small cube. The large cube was first drawn to scale within the 60-degree cone of vision, and then reduced to the required size by a reverse process to that of the magnification.*

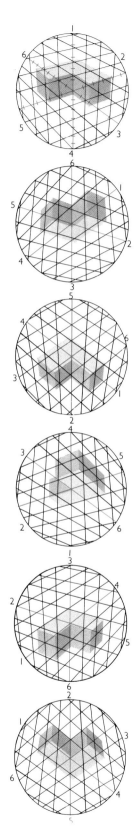

used and its placement, some distortion is present in most photographs.) The drawing may, of course, be extremely simple or enormously complicated, but the level of skill required for the airbrushing will not necessarily be accordingly lower or higher. Some drawings of the utmost simplicity may demand a great deal more mastery of the instrument, in control and fine balancing of tones, than illustrations of far greater complexity in which tones will be applied in small areas. While it is true that in the right hands the airbrush can perform near-miracles, no amount of airbrush technique can cover up bad drawing. It frequently happens that because of impatience to be getting on to the airbrush work, the artist gives too little time and attention to the correctness of his drawing. There is also a widespread misapprehension about the relative importance of accuracy in the case of a drawing that is to become a painting as against one that is itself to be the finished artwork: the fact is, accuracy is important in both cases.

Perspective grids For drawings in which correct perspectives are of great importance (which means most drawings), the use of perspective grids is strongly advised. (These are available from artists' suppliers—although in limited versions—in clear or semi-opaque plastic with the lines printed in black.) Any artist properly trained in the use of grids can make a correct drawing of practically anything. Even many professionals who are well advanced in their careers and have been managing without them may discover that the grids become indispensable.

In using the grids, the artist works out his drawing's perspective lines on tracing paper

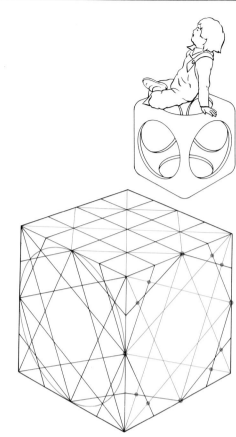

Ellipses *Two of the methods of plotting accurate ellipses are by trammel (below) and by the 8-point star technique shown here, which is probably the least complicated in cases where the axes are not known. A perspective square is subdivided into 16, then an 8-point star superimposed on the gridded square. From the top centre point of the star, a line is drawn diagonally to the lower corner of the outboard quarter on either side; the same geometry is repeated for the other 3 sides, and the 12 plotting points then found, as shown.*

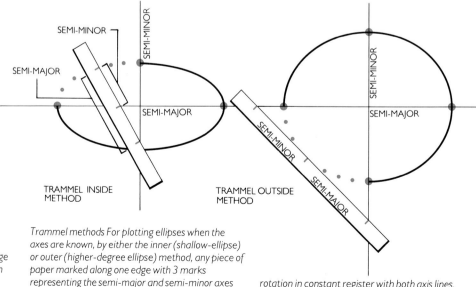

Grid rotation *These six views of the same image were drawn using a common grid by rotating from the first position clockwise. If the relation of the image to the zero datum point were varied, a great many more views would be the result.*

Trammel methods For plotting ellipses when the axes are known, by either the inner (shallow-ellipse) or outer (higher-degree ellipse) method, any piece of paper marked along one edge with 3 marks representing the semi-major and semi-minor axes can be used as a trammel. Plot points are found by moving the trammel a complete

rotation in constant register with both axis lines, their frequency being increased in proximity to the major axis line.

placed over the appropriate grid, which has been positioned correctly to give the sight lines wanted for the drawing. Ideally the artist would have an extensive selection of printed grids in one-point, two-point and three-point perspective to choose from (in one-degree increments, grid variations will total 720 from one station or viewing point (SP) alone, 360 of them for alterations in tilt and 360 for alterations in rotation; and changing the distance from the SP multiplies the total almost endlessly, which means that some grid exists, or could be created, to cover all possible requirements). But even a single grid offers many variations: six separate views of the same object can be achieved in the central part of the grid if it is rotated; their mirror images give six more; then, by using quarter-segments that touch the centre, forty-eight further views become possible; and finally, using the portions of the grid further out from the centre will take the total into the hundreds.

It is a mistake to think that learning to use grids is too daunting because too technical and tedious. The few hours needed to learn how to use them will be well rewarded, since you will henceforth be confident of getting every one of your drawings right, and also take much less time about them. The use of the grid ensures against errors in perspective of the sort that bring bitter disappointment when the shortcomings show up in a piece of work only after many laborious hours have been spent on it. There are other methods for working out the perspectives in a drawing correctly, but all will probably take longer.

For certain group-projects, such as rush jobs in industry requiring that several artists

labour simultaneously on various aspects of one work, the use of a common grid is essential. For example, various illustrations of component parts of what will eventually be one drawing can be executed separately using orthographic drawings of totally different scale, and provided the identical grid with the identical zero datum point is used in each case, the results will automatically fit in register to form the completed master drawing. There is no other way such a project can be satisfactorily carried out.

A further advantage of grids is the ease with which later changes can be made to supposedly completed drawings.

Tonal recession Perspective is not, however, simply a matter of lines; there is also the fundamental importance of tones, and the application of tones is what airbrushing is about.

As every first-year art student knows, the tones one sees when looking into the distance lighten progressively, so that a range of mountains seen far away against the sky will be paler in tone than the nearer elements of the landscape. Where there is a gradation of tone, the darkest part will be in the foreground. There is in addition the

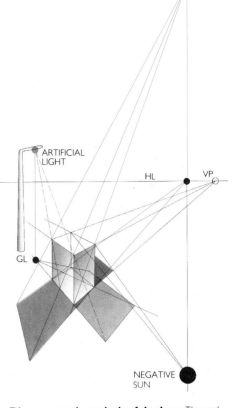

Perspective geometry of shadows *This shows how the shadow cast by an open box can be plotted when the light rays are parallel to the picture plane (thus not ruled by the laws of perspective), and therefore themselves parallel. The shadow at left is established by dropping a perpendicular line from the ray's contact point to the ground, then drawing a horizontal line—with rays parallel to the picture plane a right angle is invariable—to meet the ray line at the first shadow point; the other shadows can be found in the same way.*

Diagrammatic analysis of shadows *The sun's ray lines represent parallels drawn in perspective. The sun is in front of the viewer, the negative sun behind, and the shadows' vanishing point, directly below sun, is common to both. The shadow points for shadow 1 are found where the sun's rays meet the ground, i.e. where a ray bisects a line drawn from the shadows' VP. Applying the same principle to the negative sun produces shadow 2. In the case of artificial light, the VP is found not on the HL but on the ground since the rays are not parallel.*

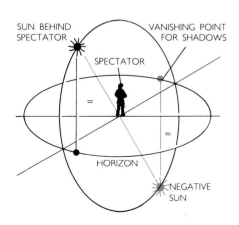

Diagrammatic geometry of shadows *Euclidean-style diagram in which the shallow ellipse is horizon bordering the ground plane (with rotation), the other ellipse is the sun's (earth's) orbit, the figure is spectator, with light rays from behind.*

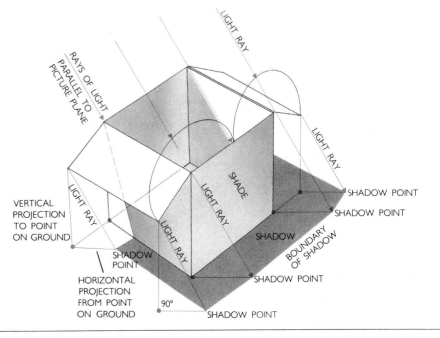

matter of colour recession: the cooler the colour is the farther away it seems, and the warmer it is the nearer it appears.

This does not, of course, mean that the darkest tone in a finished picture will necessarily be that of the nearest element in the picture. A most useful device for directing the eye to the element on which you wish attention focused is to interrupt this logical recession of tones, either deepening the tone of this special element, or in some cases making it paler than it would be in the 'natural' situation.

By airbrush application of delicate gradated tonal washes, alternating accents between light and shade with the observed effects of illumination, reflected light and shadow to give spatial dimension (light against dark against light), the illusion of vast distances can be achieved.

Simultaneous contrast An area of one given luminosity will appear bright if surrounded by a dark region, and conversely will appear dark within a light region. This phenomenon, known as simultaneous contrast, can be made good use of by the airbrush artist. There is also a roughly equivalent influence on the visual use of colour, when a white area surrounded by colour appears to possess a colour complementary to it.

Light source At the start of a drawing, one of the decisions to be made is the location of the source of light in the picture. As most people are right-handed and feel happiest with light from the left (sensing perhaps only subconsciously that otherwise a shadow might be cast on work in progress), a light source in the picture at upper left, other considerations aside, is likely to make the majority of viewers feel most comfortable. Never lose the sense of precisely where that light source is in your picture.

Shade and shadows Here shadow is used to mean cast shadows. The shaded plane of an object is that which faces the shadow cast. The geometry of shadows is best explained by means of diagrams, as shown here. The negative sun can be a difficult concept for non-technically trained people to grasp, but it may be helpful to consider that it represents the sun in situations where the sun is to be behind the viewer rather than within (or above) the area covered by the drawing itself, in which case the shadows cast within the drawing will be on the other side of the object or person whose shadow it is.

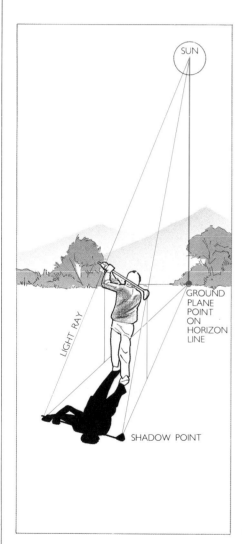

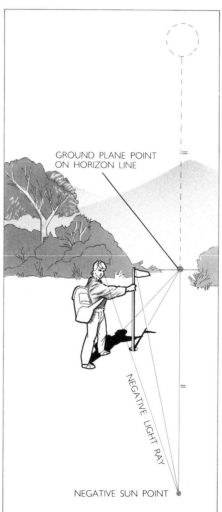

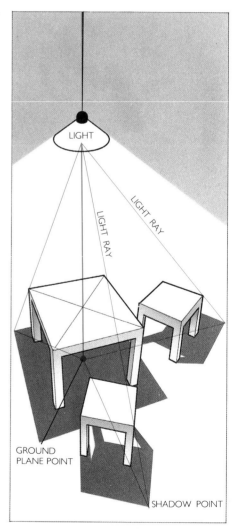

Plotting shadows *The outer shadow points here are found by ray lines drawn from the sun through the outer points (hands and club head), perpendiculars dropped from these points to the ground plane, and one from the sun to the HL at the shadows' VP.*

To plot shadows cast away from the viewer, the same principles of geometry are applied. The negative sun represents the light coming from behind the viewer, and the ghosting of the sun gives its position in the sky behind the viewer.

The radiating rays of light from a nearby source provide the shadow points for several shadows by means of the same geometry: the vanishing point for the shadows is established by a perpendicular dropped from the light source to the floor.

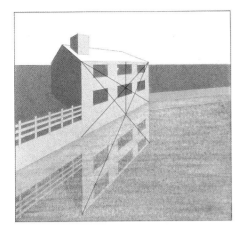

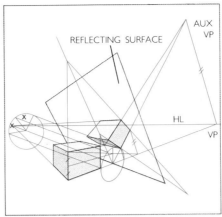

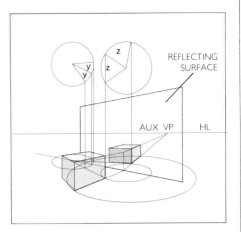

Reflections *A building directly at water's edge is reflected as a mirror image in perspective. The two diagonals establish the perspective centre, then a line is dropped to the bottom (AB) and one from an upper corner (C) through B determines D.*

Careful 'reading' of this diagram will reveal how the angle and placement of the box's mirror image on the tilted reflecting surface were arrived at by geometry employing points on the radii of a circle drawn in plan and projected to an ellipse.

When the base of the reflecting surface is not parallel to the edge of the object, the image can be plotted similarly, using two circles and their projections, and a further ellipse determining the outer point of the base line of the image.

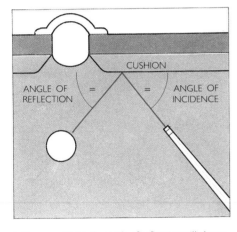

In the case of light, the angle of reflection will always be equal to the angle of incidence (attack); this diagram conveys that principle in a simple visual way (although it will only hold good for a billiard ball if it is not spinning).

When a reflection is moving, the geometric rules for finding its outer points hold good, but its image changes in sympathy with the movement. On a mildly disturbed water surface like this one it retains its general integrity although distorted.

In slightly heavier seas, when the surface is somewhat more agitated with brisk breeze blowing, the image is now both distorted and broken, while its limits are still defined generally within the geometric structure.

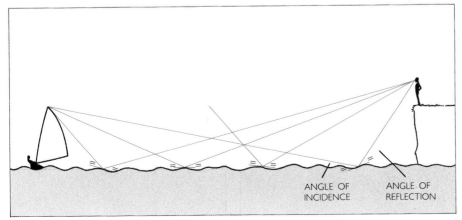

In the situation presented here diagrammatically, above, and, at right, as seen by the spectator in the diagram, the light is now intense and the water quite choppy. The light rays from the sun, both those hitting the water directly (single line at centre) and

those from the white sail, hit all surface points of the waves' peaks and troughs. Since the angle of incidence and the angle of reflection are equal in each case, the reflection is elongated, seen by the spectator as fragments of white interspersed with

the darker surfaces of the water, together with the 'white horses'. The reflectivity of the image diminishes in the direction of the spectator, while the reflection broadens, because of the perspective of the water's surface.

The stronger the light source from a given direction, the more sharply defined the shadow will be. The geometry dictates that the end of the shadow will be where the light is no longer obstructed by the object. However, according to the tone and texture of the ground plane, the shadow will differ in sharpness of outline and may appear to shorten in length.

Reflections The airbrush is especially well suited for the addition of reflections to a picture, and it is regrettable that many artists neglect to learn the principles involved, thus limiting the ways in which they can kindle the viewer's interest. Think of the gloomy scene presented by a city street on a dark and drizzling late afternoon, and the transformation when street lights are switched on and the wet pavements become mirrors for the spots of reflected light. A similar uplift of the senses can be effected in a picture with the addition of reflections.

The reflected image of an object will be located at the same distance beyond the

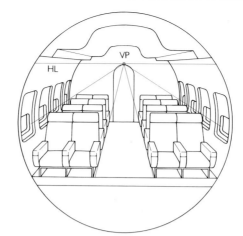

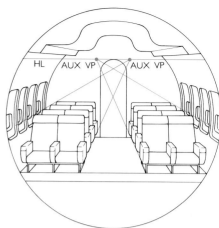

For a drawing of an aircraft interior, the use of 1-point perspective, which is the logical choice, results in elongation of the distance to the aft bulkhead. This presents the prospect of an uninvitingly narrow, tunnel-like passage. This might well put off potential passengers, and, therefore, might be unacceptable to the client in a commercial commission.

To draw the same cabin to the same accurate dimensions, and yet make it appear roomier and wider, and make the passageway seem shorter, the true VP was eliminated and two auxiliary VPs introduced, equidistant on either side, the one at right relating to the elements at left, and vice versa. The result is a foreshortening, and a more pleasing, welcoming sense of the interior space.

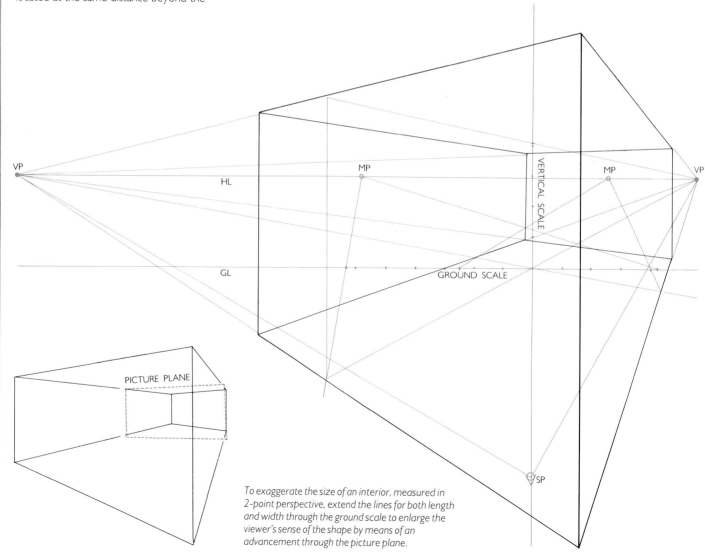

To exaggerate the size of an interior, measured in 2-point perspective, extend the lines for both length and width through the ground scale to enlarge the viewer's sense of the shape by means of an advancement through the picture plane.

reflecting surface as the image is in front of or above it. The degree of clarity of reflected images is dependent upon the nature of the reflecting surface: still water, glass, smooth polished materials will all be more reflective than dry, matt or textured surfaces.

Distortion by design When the artist is in full command of all the principles of drawing correctly, he is, paradoxically, in the happy position of being able to draw 'wrong' in any way he likes, and his drawing will be 'correct'—that is, it will be convincing and even pleasing to the viewer on a sensory level even when intellectually the viewer may be able to perceive at once that it contradicts 'reality'. This is, of course, deeply important, because the ability to create a convincing reality is a mark of a true artist.

Normally, the only acceptable tilting of the horizon line applies to drawings of flying objects (perhaps birds in flight or banking aircraft) because any subject is shown in relation to the ground, therefore the HL would be horizontal. But in an enclosed picture such as this one, to make the scene more dramatic that general rule can be broken by the technique shown here: the correct view (perhaps a photograph to be used as reference) is put down and on tracing paper placed over it a tilted frame is drawn, then the missing elements added at the corners.

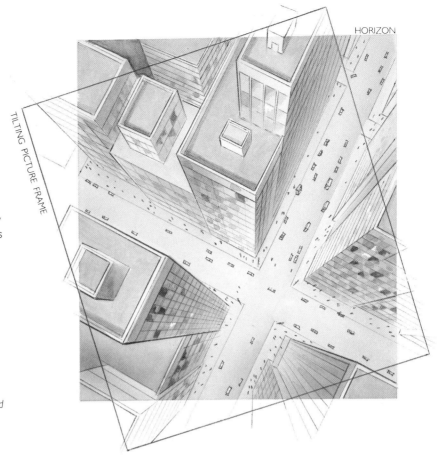

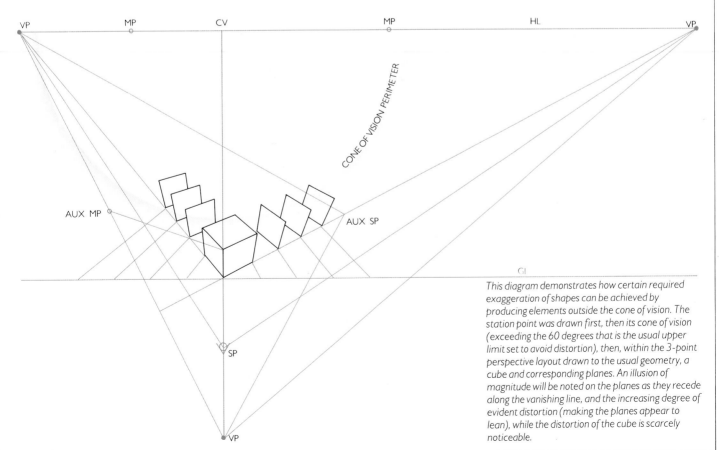

This diagram demonstrates how certain required exaggeration of shapes can be achieved by producing elements outside the cone of vision. The station point was drawn first, then its cone of vision (exceeding the 60 degrees that is the usual upper limit set to avoid distortion), then, within the 3-point perspective layout drawn to the usual geometry, a cube and corresponding planes. An illusion of magnitude will be noted on the planes as they recede along the vanishing line, and the increasing degree of evident distortion (making the planes appear to lean), while the distortion of the cube is scarcely noticeable.

However, the successful translation of images or forms into art by means of this manipulation requires the control and authority that come only with mastery of the fundamentals of accurate drawing.

Altering shadows or reflections For purposes of composition, artists may depart from reality and the rules of geometry to

Deliberate distortion: Italian artists Nicola Falcioni and Margherita Saccaro have broken all the rules of geometry in a most authoritative fashion in this painting commissioned by a pharmaceutical company, executed with a Pressione d'Aria airbrush. Perspective lines on the floor have been drawn accurately, but the placing of the horizon line below the vanishing point effectively makes the floor run uphill; and shadows cast by the two figures contradict one another blatantly, the interests of the composition being well served by the L-shaped shadow echoing the doorway shape.

good effect by manipulating shadows, for example, depicting a shadow as cast on the ground in the sun's direction, or by introducing contradictory shadows in one composition, as in the painting here. The disharmony produced by such devices may be appropriate or desirable for certain subjects.

If a shadow is going away from the viewer at an angle, with the light source at one side, the near edge of the shadow will be more sharply defined than the far edge; reversing this order in a picture can serve to remove the viewer's 'anchor', his sense of the reality of the situation: he knows at once that he is in fantasy-land.

Playing with the rules for reflections can result in striking or amusingly eccentric images as well: for example, a surface such as a mowed lawn will not in reality be reflective, but if a grass surface is drawn and then

painted, and made to reflect an image, the instant impression might be a witty one, of grass that is made of glass.

Transferring the Picture

There are various techniques for transferring the picture to the ground. Perhaps the most satisfactory is the powdered graphite method shown below because of its double convenience: in one process you obtain very sharp pencils for getting the desirable fine line in pressing-through the drawing, and you also obtain the material for coating the underside of the transfer paper. Only a very hard pencil, 6H or harder, should be used.

For the pressing-through operation either a pencil or a stylus (a needle in a chuck) can be employed. There are advantages and disadvantages to each. The needle will not need to have its sharp point constantly renewed, as the pencil will, but there is another problem with the stylus: if the process is interrupted it can be difficult to see what has been done.

Inking

For those artworks in which a black line outline is wanted under the airbrush colour (whether or not it is to be completely covered by the colour), inking in the line drawing with a permanent black is the next step, before the masking is begun. The usual method is with a pen or fine brush.

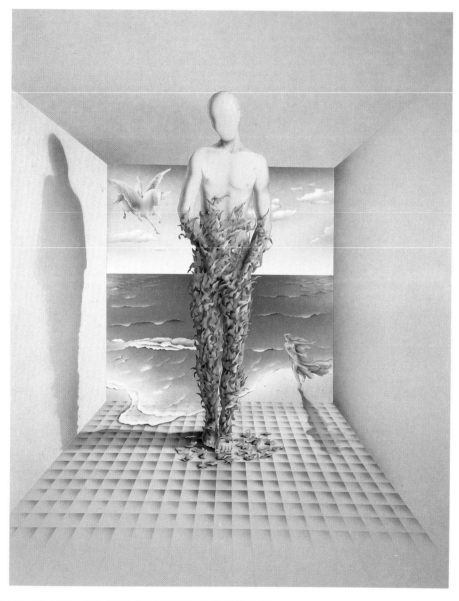

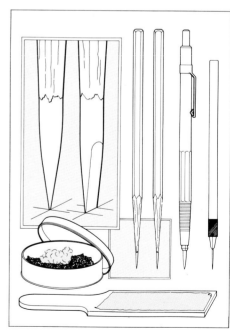

Transferring materials *Stylus or chuck pencil (right) can be used, or 9H drawing pencils (centre) sharpened with a long taper both to a wedge and a point (left) by means of sandpaper (below) which gives graphite for rubbing (in box).*

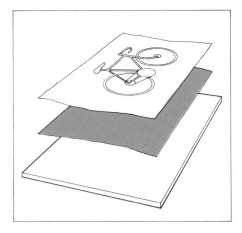

Transferring I *A common (but slightly imprecise) method is to place special transfer paper treated on the underside with jewellers' rouge or the equivalent between the drawing to be transferred and the ground, for the pressing-through process.*

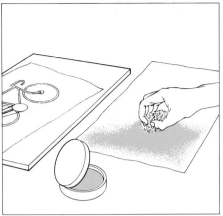

2 *A second method is to rub graphite, saved from pencil-sharpening, or cosmetic rouge, with cotton wool or a powder puff, onto the back of the drawing to be transferred or onto a sheet of tissue to be used as in the previous method.*

3 *With the artwork held firmly in position by tape, and with registration marks if colour separation is intended, the image is carefully traced with the pencil or stylus, and drawing aids as needed: set squares (triangles), ellipses or French curves.*

4 *The artwork now appears on the illustration-board ground, ready for inking, painting or airbrushing. The transfer-paper artwork may be discarded at this point, or, if the interleaving method has been employed, it will be clean enough for filing.*

5 *If inking is to be done before airbrushing, a protective piece of paper with a hole cut out to expose the artwork should be placed over the ground first, to keep it perfectly clean.*

Light box *A portable or fixed light-box is an essential piece of equipment for transfer work.*

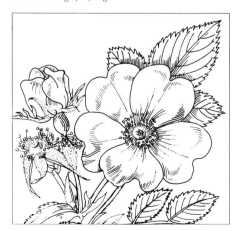

Light-box transfer I *The only transfer method that is absolutely precise requires a light box; it is painstaking but worth the trouble in certain cases where a completely accurate duplicate of the original is needed.*

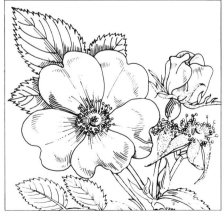

2 *The original (left) is reversed and placed on the light box, so the image shows through, as above, then the lines of the drawing are very carefully traced onto Permatrice or similar plastic film, on the side treated for the subsequent transfer.*

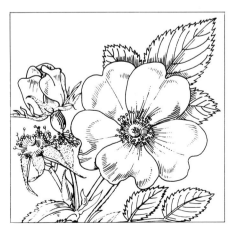

3 *The Permatrice is itself then reversed, placed onto the ground, stretched tight and carefully 'boned through', or burnished. The result is a facsimile of the original line drawing. A tone drawing can be reproduced in line by this method.*

Masking

The purpose of all masking is to control the area receiving the spray. While many artists like to do much of their airbrushing freehand—indeed, a few airbrush artists don't employ masking at all—in general it is true that the skilful cutting of fixed masks and the imaginative use of loose masks are integral to the craft of fine airbrush work.

A mask is either for covering up, or for exposing, a certain shape. As a generalization it can be said that in fixed masking the sort that exposes predominates, while in loose masking the sort that covers is more common. In this book the word 'mask' is used to indicate the cover-up type and the term 'stencil mask' for the cut-out type.

Other loose pieces of material, not properly masks, are also used in airbrushing, to protect the work in progress. These are moved about on the vulnerable portions of the ground's surface as the work proceeds, to guard against any rubbing or soiling of the work by the artist's hand or wrist.

Liquid masking Formerly more widely used than it is today, liquid masking neverthe-less remains nearly indispensable for certain kinds of fine, detailed work.

Fixed masking Fixed masks are generally used to create a hard edge (soft edges are achieved by a variety of other techniques, usually employing loose masks of one sort or another). The advantage of fixed over loose masks is that they remain firmly in the desired position until peeled away. Unfortu-nately, there is a danger, when applying masking film over pigment, of peeling away some of the colour along with the film; this happens if temperature or humidity affects the adhesive on the film's under-surface. The best way to avoid such accidents is never to leave film attached to the ground for very long, certainly not overnight, so that no undesirable bonding of pigment to the sticky underside of the film will take place. (Some new paints which are claimed to be impervious to adhesive pick-up have been developed specifically for airbrush work; these may solve the problem in the future.) When removing the film, always pull it away very slowly and with great care.

For fixed-mask work, begin by applying masking film either to the entire area of the artwork (plus perhaps an extra 13 mm (½ in) all round), or to only a part of the work, covering the image or shape which is to be airpainted first, and a surrounding safety area. If the film is applied over the entire space, you can either do all the cutting before any of the spraying, or cut, spray, cut and spray. That is to say, you either: a) cut out all the shapes before peeling away just one, expos-ing the first area to be airpainted; or b) cut out only the first shape, peel it away and airpaint the area, before cutting out the second shape.

Loose masking Loose masks are not normally cut for a specific art work, but are shapes that are used and re-used. Airbrush artists should aim to save all the loose masks they make, in order to build up a collection for versatility's sake. A wide range of curves

is perhaps the first thing to acquire, ready-made in plastic or cut out of paper using a set of ellipses. Beyond that, one can go in any direction whatever.

Raised masking Loose masks can be held touching the ground or, for softer edges, raised off the surface. Their distance from the ground will determine the softness.

Combination masking A combination of masking techniques is probably most com-mon among airbrush artists, although there are some who have built entire reputations on one single technique.

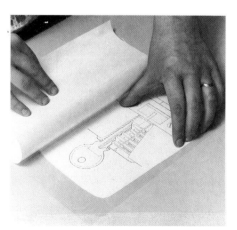

Fixed masking I *Airbrushing of a large work may best be done one area at a time. A paper stencil mask is cut to expose the area, then masking film is laid over and its backing peeled away while it is pressed down to overlap the paper mask.*

2 *The film is gently smoothed down to ensure even adhesion over the entire surface (without an adequate bond, the air pressure during airbrushing could lift the edges of the cut mask), and rubbed down firmly where it overlaps the paper mask.*

3 *The lines in the working area are meticulously traced with the tip of the scalpel blade to cut the masks; then the first element to be airbrushed, in this case the key, is exposed by carefully peeling away that portion of the film.*

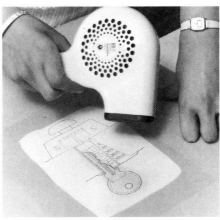

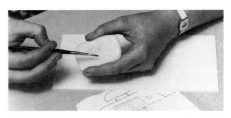

4 With the air pressure set at normal (30 psi), a base coat is laid down over the entire key area. Here the airbrush is held at an angle to spray both the rim of the mask and the exposed ground, which will give greater density at the edge.

5 An ordinary hair dryer, set for cool air rather than hot, is useful for speeding the drying process so that the job can go ahead. It also serves the secondary function of keeping dust particles away from the immediate working area.

6 Masking fluid can be appropriately used for certain small details. Before dipping the brush in the fluid, it is wise to rub the hairs with soap; this makes it easier to clean the rubber-based fluid from the brush when the masking is finished.

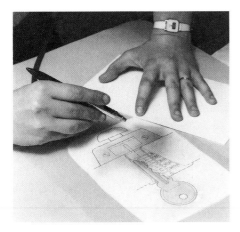

7 With masking film repositioned to cover all but the lock-face area, and with liquid masking over the screw heads and central rectangle of the lock, the airbrush applies a subtle gradation of tone over the lock. Take care not to overspray.

8 When it is certain that the pigment is dry, a small piece of transparent tape is used to remove the liquid masking, which sticks to it and comes away. A light, plucking technique with the tape is safer than actually pressing it down.

9 Alternatively, the complete artwork can be masked in a single operation; film is laid down over the entire area and smoothed down well. Then with the tip of the scalpel blade all the lines are cut before any of the pieces are peeled away.

Loose masking I Freehand curves are cut in a medium-weight plastic-coated film on a cutting mat, 'employing'(top) quick strokes for smooth curves, and a metal type-scale, for straight edges; a wide range of masks will be useful.

2 On a ground that has two small areas already airbrushed, two loose masks chosen from the collection in the box are manipulated into a position to form the desired profile and, preferably, so that they can be held by the fingers of one hand.

3 At a later stage, with more of the airbrush work completed, another two loose masks are held in place by one hand while with the other a very controlled spray is directed over the middle finger to a small area just beyond the mask edge.

Variety of masks I *A few pencil lines, for the contours of hills, are all that is needed as a base drawing for the landscape created here, with the airbrush used both for drawing and painting, and employing an imaginative range of masks.*

2 *After sweeping strokes of tone are applied to the sky for upper cloud strata, a dampened sponge is used to wipe away lightly some of the pigment, and when dry, gentle rubbing with a soft eraser further develops the modelling of cloud shapes.*

3 *Work on the cloud formation is continued with a loose mask of blotting paper torn in different directions to provide various interesting blurred edges, moved about in raised positions for the spraying of soft, increasingly subtle curves.*

4 *Cotton wool, loosely teased, is laid on the dry surface, then arranged and thinned in places to enable penetration by the spray directed downward from hovering positions, with a finely controlled pulsating action on the airbrush lever.*

5 *With work on the sky completed, airbrushing of the lower portions of the picture, which have been covered throughout by a protective fixed mask of film, is ready to begin. The masking film is now peeled away and several loose masks are selected.*

6 *After a base tone has been laid on the middle and far distance areas, the road in the foreground is sketched in lightly by freehand airbrush, and, with a suitable loose mask held to touch the line of the road, the left side of the road is sprayed.*

7 *Multiple tonal recession is applied to the farther terrain; then, with a loose mask held down following its contour, the brow of the foreground hill is defined. The tone is vignetted, lighter at the rim and darkening in the nearer distance.*

8 *Masking film is laid down lightly to cover the middle distance and the sky for the next process: the spraying of a darker pigment through an open mesh, folded and crinkled, to give texture to the surfaces of the fields on either side of the road.*

9 *The drawing of the picture is completed by hand work: a line of telephone poles receding into the distance painted in with the aid of a straight edge, and stippling in the foreground for texture. Last of all, finishing is by freehand airbrush.*

Mesh masking I *Instant-transfer lettering is lightly fixed to the ground, then a fabric mesh and a stencil mask are placed on top, both in alignment. The airbrush applies the pigment in sweeping horizontal strokes for a grain effect.*

2 *When dry, the mesh is removed, and small pieces of transparent tape are used to pluck away the letters—a finicky process requiring frequent change of tape fragments to avoid soiling the artwork with crumbled pigment from the letters.*

3 *After the letters have been checked for definition and are cleared of all traces of film, a tone of colour is airbrushed smoothly over the whole panel to unify the two elements, the lettering and the textured background.*

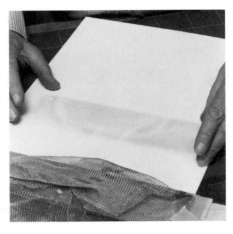

4 *On a smooth line board chosen as ground for its good hard surface, a soft metal mesh that has been distorted by stretching and compression is placed and stencil-masked; then the ground is sprayed with the mesh held firmly by a type scale.*

5 *With the mesh and mask removed, the results of the airbrushing are examined to see if the textured effect is close to what the artist had in mind for the work: a panel of sky with subtle cloud effects and a few wheeling birds in silhouette.*

6 *Rather than building up the sky's tonal effect by different placement of the mesh for further spraying, the artist decides that it needs only some removal of pigment, for modelling, and reduces the colour with a rubber eraser.*

7 *The surface is first cleared of any particles left behind in the rubbing process by blowing air through the airbrush over the entire area, then the birds in flight are painted in by hand, with a loose sheet of paper protecting the ground.*

8 *The modelling of the clouds is finished with a razor blade held perpendicular to the ground and moved swiftly back and forth in a scrubbing motion; simultaneously air is blown over the surface of the work to maintain a clear view.*

9 *Another use for a razor blade (in this case a quarter of a blade, for greater flexibility) is to give neat sharp boundaries to the artwork: all excess pigment is scraped away along a metal straight edge held on top of the artwork.*

Applying and Removing Pigment

In airbrush work the removal of pigment is just as important as its application. In many cases the addition of colour is the crude part of the job, while it is in the subtraction of some of it that the refining of the art work is accomplished.

If the ground is white, which is likely, the correct way to get an area of white in the finished artwork, in most cases, is to re-expose an area of the ground rather than to apply white pigment on top of another colour. This is done in different ways, for example by rubbing out the pigment that has been applied on a spot, for a highlight, or by scraping away a strip of pigment.

The greater the degree of penetration of the ground by the pigment, the harder it is to remove with any degree of control. Water-colours soak into paper less than dyes or inks, but more than gouaches, which tend to remain on the surface. The latter may sometimes be completely removed by gentle scraping with a razor blade, the edge held perpendicular to the ground. The most delicate means of removal is probably a putty eraser as it can be rolled to a fine point.

With soft papers or poor-quality water-colour paper, a rubber eraser is usually best, but there will always be some picking up of the fibres. On the other hand, a good-quality water-colour paper is so durable that it is possible to scrub out an entire artwork and start again; since the price of good water-colour paper is so high, it is worth the trouble. A hard-surface line board will tolerate repeated scraping by razor blades.

Sponging out water-colour is usually done with dampened cotton wool. A bit of white

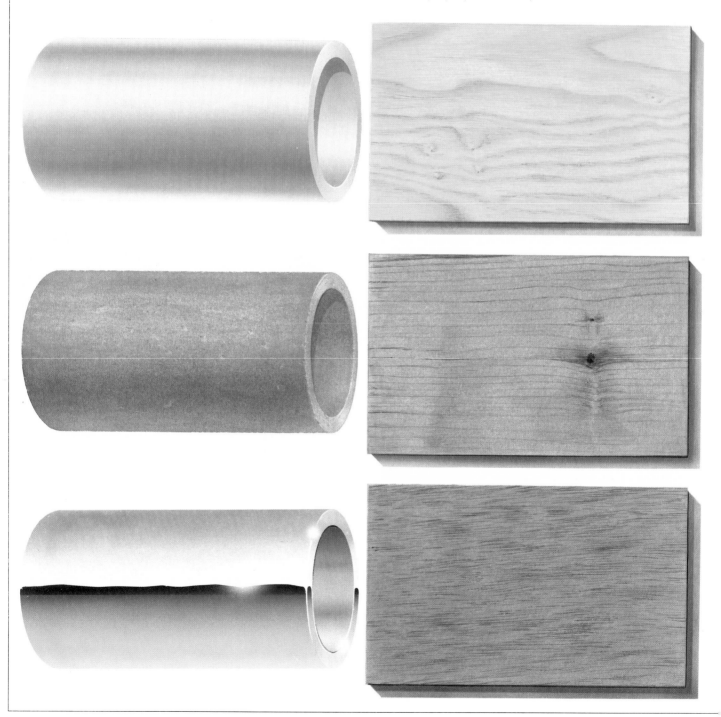

bread (without the crust) can be used to remove a certain amount of colour, if reduction is all that is wanted. An electric eraser is the preferred method of colour removal by some artists, but it has a tendency to scorch paper unless handled with care. Another removal method is to sprinkle a little pumice powder on the colour to be reduced, and then to rub with a tissue.

To remove dyes it is necessary to use a chemical such as potassium ferrocyanide. Apply with a Q-tip or the equivalent made by spinning a toothpick in a bit of cotton wool. Never allow the chemical to touch your skin so wear protective gloves.

Spatter and stipple effects Some airbrushes are equipped with a special nozzle for spattering or stippling; otherwise the best way to get these effects is by reducing the air pressure and airbrushing fairly close to the ground. It will be necessary to remove certain of the larger spots by careful scraping with a blade, unless a fairly crude result is the aim, that is, if spots ranging from very fine to quite large are wanted. In advanced technical illustration the spatter technique is useful to represent cast surfaces. The best spatter results usually require final touching-up with a fine pen nib.

Some Special Airbrush Effects
The expert airbrush artist has a large

Form and surface *The airbrush artist needs a good understanding of the variations in reflectivity/ light absorption of different colours and surface textures, as exemplified in these 3 cylinders. The first, a plastic water pipe, has a semi-matt finish which, though dull, does reflect light, so the darkest tones are inside the outer edges. The second, terra cotta, also a semi-matt finish, is in colour, the surface irregular and pitted, thus more light-absorbent. The bottom cylinder is chrome, a highly reflective surface with sharp tonal contrasts (lightest against darkest). The wavy line recognizes imperfections in machined surfaces; airbrushed starbursts highlight the darkest areas. Note the convexity of inner shadows.*

Wood graining *Real wood should always be used for reference. The first step, as with the cylinders at left or any similar rendering, is to spray a ground coat representing the general colour and texture. For the European ash, first below, this was a light yellow-ochre mixture. Grain was added by delicate hand painting with a thin water-colour mix including green, removal by rubbing, and fine-line finishing with brown pencil, all interspersed with further spraying. The grain of the second wood below, European wild cherry, was painted by hand on a deeper-toned ground colour, finished by rubbing, alternating with spraying. The West African mahogany (bottom), a denser, more pitted grain, was handled similarly but with less rubbing.*

> **USEFUL TIP** *If you have to replace an airbrush nozzle because it is faulty or has become blocked or damaged, don't throw the old one away; enlarge the old nozzle by carefully reaming with a needle, and it can serve as a spattering nozzle.*

repertoire of techniques with which to achieve special effects. Paradoxically, these techniques and the errors of the novice practitioner have much in common. For

instance, in the first example below, flooding, which can be a problem for the inexperienced, is manipulated to achieve an effect.

I Twig-like effects Flood the surface of either the ground or the mask in a small pool, then blow air only, as with movements of the airbrush you direct the pigment into streams, starting with an uneven centre line, then branching out repeatedly.

The airbrush artist first completed the pine door with its graining in the light colour seen here in the letters, then placed the letters as masks for the darker spraying. He hand-finished with white.

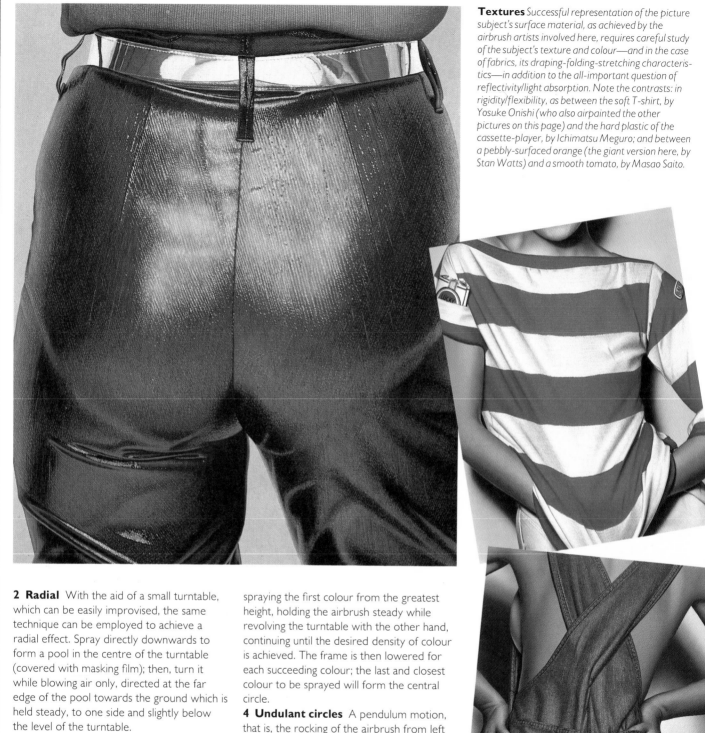

Textures *Successful representation of the picture subject's surface material, as achieved by the airbrush artists involved here, requires careful study of the subject's texture and colour—and in the case of fabrics, its draping-folding-stretching characteristics—in addition to the all-important question of reflectivity/light absorption. Note the contrasts: in rigidity/flexibility, as between the soft T-shirt, by Yosuke Onishi (who also airpainted the other pictures on this page) and the hard plastic of the cassette-player, by Ichimatsu Meguro; and between a pebbly-surfaced orange (the giant version here, by Stan Watts) and a smooth tomato, by Masao Saito.*

2 Radial With the aid of a small turntable, which can be easily improvised, the same technique can be employed to achieve a radial effect. Spray directly downwards to form a pool in the centre of the turntable (covered with masking film); then, turn it while blowing air only, directed at the far edge of the pool towards the ground which is held steady, to one side and slightly below the level of the turntable.

By way of variation, rather than being steadily rotated, the turntable can be manipulated directionally to achieve a more complex pattern or to produce an intertwining network.

3 Multi-coloured concentric circles For this a turntable will be needed and a frame of adjustable height to rest the fingers on while holding the airbrush vertically to spray directly down.

Start the pattern with the largest circle,

spraying the first colour from the greatest height, holding the airbrush steady while revolving the turntable with the other hand, continuing until the desired density of colour is achieved. The frame is then lowered for each succeeding colour; the last and closest colour to be sprayed will form the central circle.

4 Undulant circles A pendulum motion, that is, the rocking of the airbrush from left to right quickly but smoothly while spraying straight downward, as in the previous technique, will give an interesting effect consisting of circles composed of undulant strips of colour.

5 Wave forms The pendulum movement can also be employed to achieve running waves. This is best done by moving the ground along in a straight line with one hand while the other manipulates the airbrush downward.

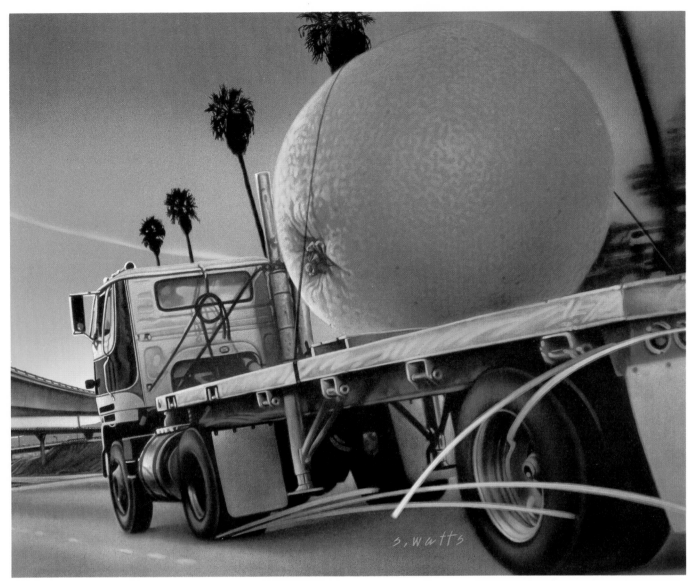

Some Problems and Solutions

Every project poses the artist certain problems, in some cases best solved by the airbrush itself, while in others matters of geometry must be overcome before airbrushing can be considered. The following are several examples of the sort of projects that might be undertaken, with the problems presented in each case, and some discussion of the ways in which the solutions can be worked out. (Note that these solutions are arrived at without the use of perspective grids, even though they might appropriately be employed in various cases; this was done in order to cover the geometric principles involved, which can be utilized as an alternative to the use of grids.)

1 Poster design A very simple image is required: a silvery balloon, floating in mid-air, at eye level, with no horizon line or background other than an impression of cloudless sky. The objective is brilliance and instant impact of image. The artist need not consider any words or lettering. The work is to be in monochrome. It is the subtle manipulation of the tones on the balloon's surface, applied by the airbrush, that will determine the success or failure of the work in this project rather than the drawing.

The first decision is whether to make the image of the balloon a realistic one or a fantasy; here a realistic image was chosen.

Preliminary sketches are rendered in tones, to determine the best light source and shading. For the actual drawing to be transferred to the ground, the drawing requirement is minimal: the upper three-quarters of the balloon here was drawn with a compass and the lower part with ellipses.

The most suitable of the tonal sketches is made use of as a guide for the airpainting, for reference. First a stencil mask is cut in the shape of the balloon and fixed in place, then with the airbrush a matt tone is laid down, of the basic grey of the balloon, a mixture of black and white with a little yellow ochre added to make it warm. This results in what looks like a flat disc. With the airbrush held at a distance of 3 or 4 cm (1 or 1 ½ in) from the ground, a light cream colour is applied in a circle to the upper left segment of the balloon shape, closest to the light source. This circle touches the edge of the balloon. Darker grey is then added, sprayed onto slightly more than half the edge of the balloon, starting at upper right and moving in a clockwise direction, leaving a narrow strip of the base colour showing at the very edge (this is the reflected light). Next a sprayed crescent of even darker grey is added, centring on the larger crescent and with its own centre directly away from the source of light: when the light comes from eleven o'clock, as here, the dark crescent is centred at five o'clock. The same dark grey is then applied, with a loose mask, in a small curve of hard edge just outside the small crescent, softening at the edges. The finishing work is

done by freehand airbrushing, and the length of string painted in with a brush.

2 Architectural A building constructed of curveless planes, a simple picnic shelter, is to be drawn in perspective from orthographic drawings (plans composed of parallel lines).

The first question to be decided is whether to use one-point, two-point or three-point perspective. From rough sketches employing each, the amount of information revealed can determine which one to use. The first sketch here is of the structure as seen head-on, with the lines of ground level and roof base as horizontals, parallel to the bottom of the page, and all the receding lines converging at a common point on the artist's horizon (eye level). The second sketch is from a viewpoint taking in two sides of the structure, and the third from lower ground looking up. This angle is inappropriate in the case of a low building, and the perpendicular lines are judged to be better parallel; thus the two-point perspective seems the best choice.

To establish a scale, draw two parallel lines, the upper one being the horizon line (HL), the lower one the ground line (GL). The two are joined by a perpendicular. It is this line, which represents the distance from eye level to ground level, that gives the height-line scale, worked out as follows: a line is drawn from the lower corner on either side of the vertical line at any angle, then marked at ten equal intervals.

Estimating the actual distance from eye level (when the artist is seated sketching) to the ground to be 1 metre (39 in) means that each interval can represent 10 cm (3.9 in). At the tenth mark a straight line is drawn to the point where the perpendicular meets the horizon line, thus forming a triangle with the vertical and angle lines. Within the triangle are drawn nine lines parallel to the last line drawn; this is done by taking a set square (triangle) and a straight-edge, and placing the set square aligned with the last line drawn, and the straight-edge along one edge of the set square. Sliding the set square down the straight-edge to the ninth mark, mark off a line to the vertical; this process is then repeated for the other eight lines. The result is the completed height scale.

The appropriate spot on the horizon line is chosen to represent the centre of vision (CV). A line is dropped at a right angle to HL, through the ground line to a point representing the station or viewing point (SP). The line from CV to SP equals the distance from the artist to the object viewed. No matter where the SP is, the two vanishing points on the horizon line will form a 90-degree angle at the SP. A measuring point (MP) is now

Problem 1 *The balloon for a poster design is simply drawn with a compass and an ellipse, then the drawing is stencil-masked and airbrushed in* *monochrome with highlight at upper left, darkest tone at lower right inside rim of reflected light.*

ORTHOGRAPHIC PROJECTION

Problem 2 *The orthographic projection of the picnic shelter showing the plan and elevations (above) is translated into the 1-point perspective view below with gutter edge selected as horizon line (HL), with vanishing point (VP) lines shown.*

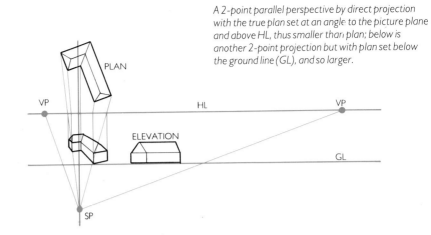

A 2-point parallel perspective by direct projection with the true plan set at an angle to the picture plane and above HL, thus smaller than plan; below is another 2-point projection but with plan set below the ground line (GL), and so larger.

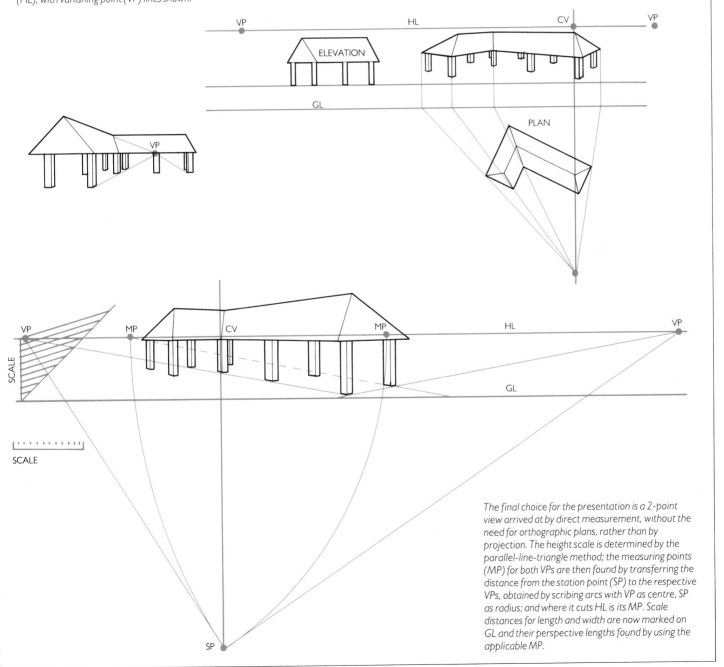

The final choice for the presentation is a 2-point view arrived at by direct measurement, without the need for orthographic plans, rather than by projection. The height scale is determined by the parallel-line-triangle method; the measuring points (MP) for both VPs are then found by transferring the distance from the station point (SP) to the respective VPs, obtained by scribing arcs with VP as centre, SP as radius; and where it cuts HL is its MP. Scale distances for length and width are now marked on GL and their perspective lengths found by using the applicable MP.

Problem 3 *After creating a 'crate' to encase the car in a 2-point view from above, perspective centres are established by diagonals, and the planes subdivided into quarters, sixteenths, sixty-fourths, as needed for the car's planes.*

From the reference data supplied, the car is then drawn within the crate, each of its points and surfaces arrived at in correct proportional perspective by these subdivisions; the open gull-wing door is then drawn by extending these lines.

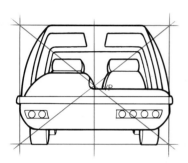

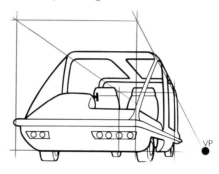

Any 1-point view has the advantage of squaring with blocks of type-face; in this one, in which the diagonals are also vanishing lines (VP is at centre) a limited amount of information is shown.

A 1-point view with the VP outside the crate gives more visible information about the car than the frontal one did; its low HL also makes the car look bigger, and gives a more dramatic effect.

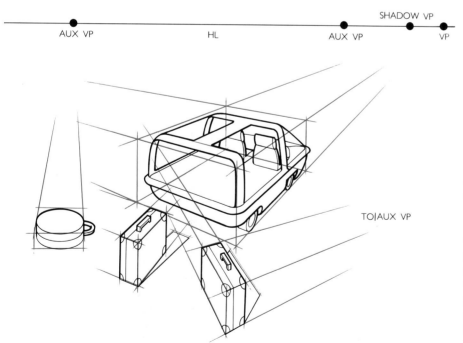

A high angle of view in 2-point is chosen for the car. The other objects being suitcases leads to a logical focusing on the car's rear luggage area. Only one of the car's two VPs is in the picture (top right corner);

the VP next to it is for all the shadows; and the VP at top left serves both as the only VP for the 1-point of the hatbox and as the left VP for the 2-point of the suitcase at right.

needed for each of the two vanishing points. An arc is scribed centered by the compass tip at VP1 with SP defining the radius, to bisect HL; the bisecting point is MP1. This is repeated for VP2 to get MP2. Using these measuring points with the scale devised for height—and applicable to all dimensions— every perspective distance of the structure can be determined for the drawing.

3 Combining one-point and two-point perspectives A car and other objects to appear in one drawing employing both one-point and two-point perspectives.

The car is first 'crated'—that is, the external planes are drawn as if to form a transparent boxlike enclosure. This enables a judgment to be made as to whether the first viewpoint attempted, from above, will reveal or obscure important elements. This is followed by two low-level views in one-point perspective, one a frontal and the other from an angle. Extending the lines of the car in a rear-view sketch gives one VP on the page; the other is well off the page. This necessitates the use of the crating technique a second time, to arrive at correct proportions. Each suitcase has its own vanishing points; all are on the same horizon line.

4 Mirrored image A figure is to be drawn and the head and torso shown reflected in a mirrored surface below.

After preliminary sketches are made from one vantage point at various levels, an upper viewpoint, with a single vanishing point in the direction from which the figure is approaching, is adopted, in order to place all the elements below the horizon line.

For the reflection, a perspective square is devised, by drawing a perpendicular line from the head down through the feet and beyond, to the bottom of the picture, and two lines from the head and the feet to the VP. Diagonals are drawn to join the opposite corners of the perspective square to deter- mine the square's perspective centre, that is, the point where the diagonals cross. A line is then dropped from that centre to cut the base line of the square; this establishes the perspective half of the base line. A line is then drawn from the top far corner of the square through the centre of the square's base line and extended until it bisects the line that had been drawn to the bottom of the page. Where these meet establishes the point of the reflection's lower limit.

5 Steepening a slope Often in a photo- graph what is actually a steep slope appears flat, or nearly so; the problem is to make a drawing with the slope artificially steepened. This can be achieved by means of an auxiliary vanishing point.

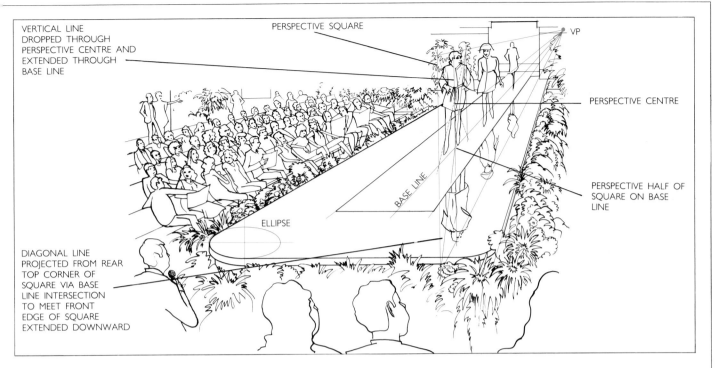

VERTICAL LINE
DROPPED THROUGH
PERSPECTIVE CENTRE AND
EXTENDED THROUGH
BASE LINE

PERSPECTIVE SQUARE

VP

PERSPECTIVE CENTRE

PERSPECTIVE HALF OF
SQUARE ON BASE
LINE

BASE LINE

ELLIPSE

DIAGONAL LINE
PROJECTED FROM REAR
TOP CORNER OF
SQUARE VIA BASE
LINE INTERSECTION
TO MEET FRONT
EDGE OF SQUARE
EXTENDED DOWNWARD

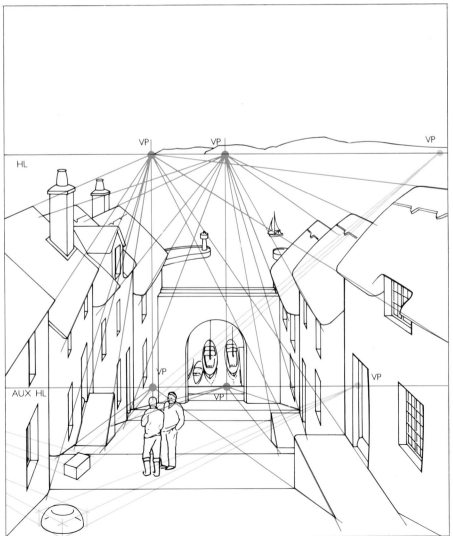

HL

VP VP VP

VP

VP

AUX HL

Problem 4 *The geometry of the mirror image here is identical to that of the reflection on water dealt with on p. 89 (1st picture) although here the reflection is interrupted by the strip of carpet.*

Problem 5 *In a photo of this scene the slope seemed flattened; to emphasize its steepness in the drawing, the technique employed was to drop the auxiliary HL farther than normal below the HL.*

The VP is first established on the HL (when an auxiliary VP is introduced, the main VP is always on the eye-level horizon line). An auxiliary VP is then determined directly below the VP; the farther below it is placed, the steeper the slope will appear.

In the illustration here a village street was chosen for the exercise. The receding lines of the roofs and windows of the houses on either side of the road (which are stepped because of the hill) then converge at the main VP on HL, while the lines of the road and of any objects on the road recede to the auxiliary VP directly below the main VP.

6 Two viewpoints A picture of an outdoor scene is to be composed from sketches made from two different viewpoints.

For this example a bridge and its surroundings were chosen as the subject, the idea being that a certain element not visible from one viewpoint was to be included by shifting to another position for the second working sketch. The solution will involve employing two SPs and two corresponding CVs. A common HL is determined by the first sketch. From a second vantage point the second sketch is made; this is superimposed on the first with all elements visible.

On the HL of the original sketch CV1 is marked, and the receding lines of the bridge elements, such as its guardhouse, are seen to converge at vanishing points on HL. In the second sketch CV2 is established by the new position. With the corollary receding lines— of church and other buildings on the hillside—converging at VPs on the same HL, the picture's perspective will appear to be correct. (It cannot be truly correct, because with two centres of vision an element of

Problem 6 *A 1-point view would leave some elements obscured (with CV1 the Saxon church is hidden) so two viewpoints were combined.*

artificiality is introduced. However, this technique does answer the perspective requirements of this case.)

7 Yacht design A sailboat is to be drawn to show the entire layout.

In preliminary sketching of the yacht design shown here, first a 'ghosting' technique was tried to see through the deck to the quarters below, but this proved to obscure certain features, and to be too busy. An alternative technique, called 'exploding' the subject, is adopted, to lift the deck from the hull. The drawing is worked out employing a two-point perspective grid. The airbrushing requires fixed masking of a meticulous and

detailed nature, the main challenge being the wide variety of surface textures depicted.

Cleaning the Airbrush

Cleaning the airbrush frequently is almost a reflex action for the experienced

WARNING: *Never blow air against any skin surface with the compressor set at high pressure, or the air may enter the pores and bring danger of blood clotting. Pressures of up to about 2 bars (30 pounds PSI) are probably safe if not concentrated on one spot.*

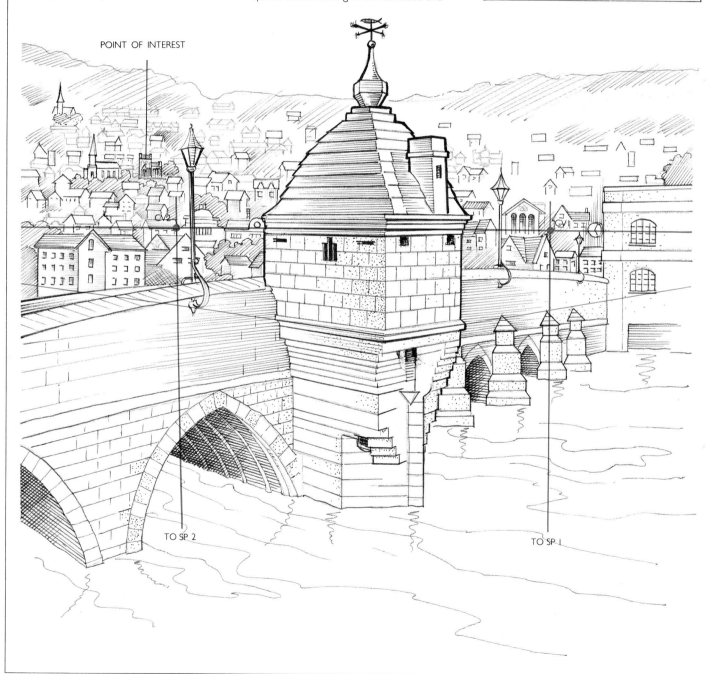

POINT OF INTEREST

CV2

CV1

TO SP 2

TO SP 1

Problem 7 *First the yacht is drawn by means of a 2-point perspective grid in a combined cutaway and 'exploded' view (above). After the drawing is transferred to the ground and suitably masked, the airbrushing begins with blue-grey, which is used for shade and shadows, for modelling, and for enhancing the white of the hull (1st picture, right). Brown is airbrushed next, with stencil masks, for the base colour of wooden bulkheads (2nd); further masking and airbrushing follows, along with hand work. The artist paints by hand for finishing the engine, after airbrushing (3rd). Fine-line detail work, straight and curved, includes brush-ruling using a straight edge (4th).*

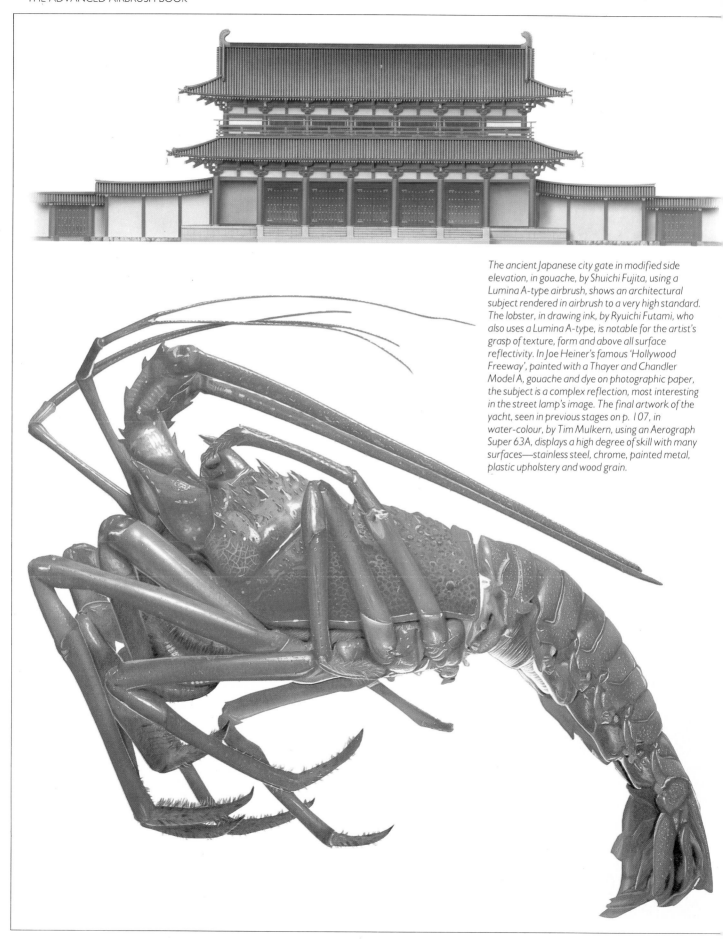

The ancient Japanese city gate in modified side elevation, in gouache, by Shuichi Fujita, using a Lumina A-type airbrush, shows an architectural subject rendered in airbrush to a very high standard. The lobster, in drawing ink, by Ryuichi Futami, who also uses a Lumina A-type, is notable for the artist's grasp of texture, form and above all surface reflectivity. In Joe Heiner's famous 'Hollywood Freeway', painted with a Thayer and Chandler Model A, gouache and dye on photographic paper, the subject is a complex reflection, most interesting in the street lamp's image. The final artwork of the yacht, seen in previous stages on p. 107, in water-colour, by Tim Mulkern, using an Aerograph Super 63A, displays a high degree of skill with many surfaces—stainless steel, chrome, painted metal, plastic upholstery and wood grain.

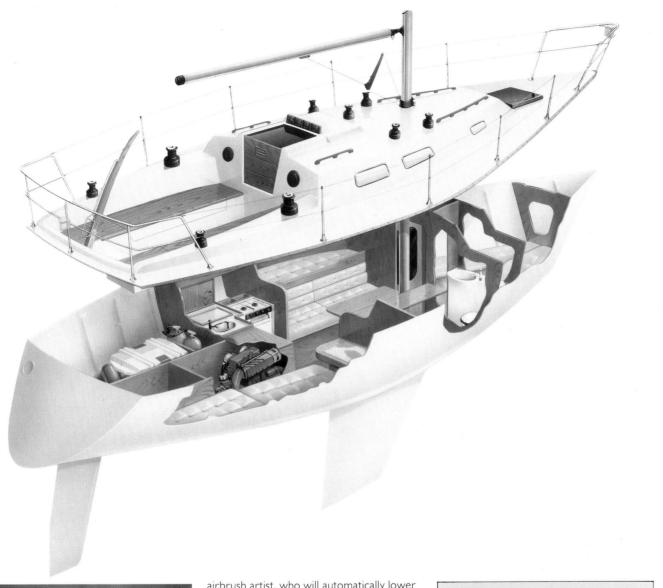

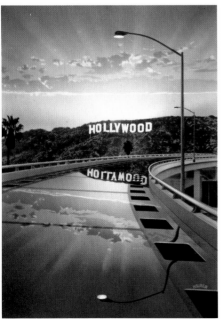

airbrush artist, who will automatically lower the airbrush below table level whenever the work is interrupted, even briefly, and spray air through it while reaching for the solvent. To clean the reservoir, some may dip the tip of the airbrush into solvent (taking care not to submerge the mechanism, which should never be put into liquid), but the more usual technique is to use a coarse-haired brush dipped in solvent to clean the reservoir, then to add a little more solvent to the reservoir, and spray against a piece of paper so that the atomized solvent is blown back inside to clean the area around the air cap.

To avoid the possibility of damaging the delicate needle tip by pressing it against a hard surface, use your fingertip as blow-back surface instead.

When work is finished for the day, after the airbrush is cleaned, it is removed from the air line; then the air in the line can be used to dry the reservoir and the airbrush.

USEFUL TIP *A single drop of castor oil dropped into the mechanism occasionally (perhaps once or twice a month) will keep it lubricated and prolong the life of any rubber seals in the airbrush.*

The last procedure (or it could be the first step on the subsequent working day) is to remove the needle and oil its surface, either by rubbing it along the side of the nose, where the body's natural oils provide excellent lubrication for this purpose, or, if you dislike the idea of a sharp instrument so close to your eyes, the needle can be rubbed with any light lubricating oil, such as sewing-machine oil. This will ensure that no colour remains on the needle's surface either where it enters the nozzle or where it passes through the airbrush, the two important (and otherwise hidden) areas.

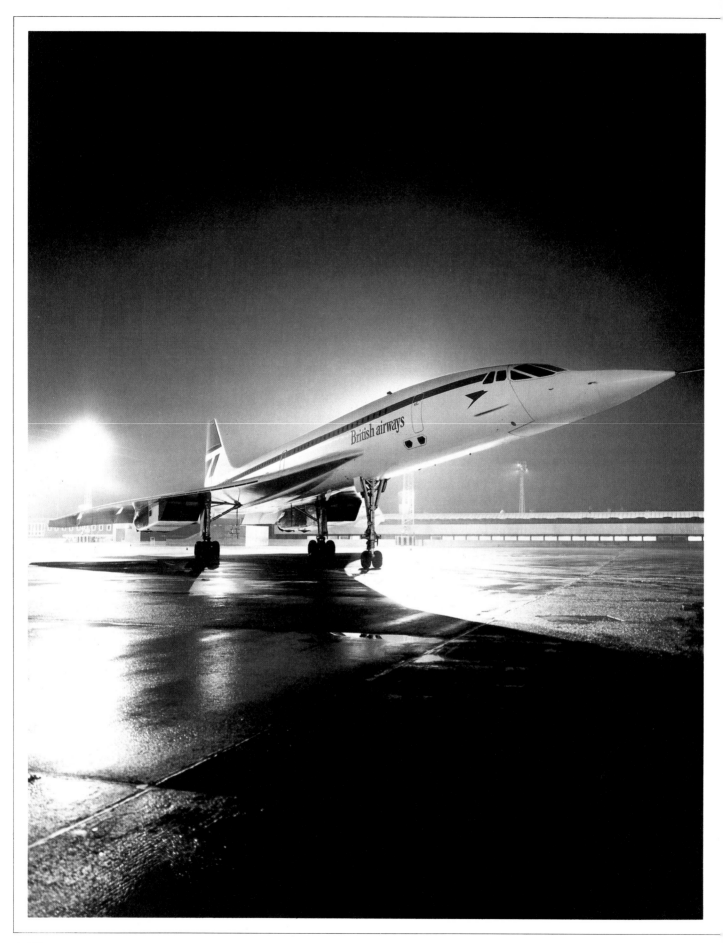

PHOTO RETOUCHING

The airbrush's first widespread application, in the early years of this century, was for altering or enhancing photographs. Over more recent decades, the role of the airbrush in the photographic field has never been eclipsed, because, wherever new tone must be added to merge imperceptibly with existing tone, it cannot be equalled.

In retouching of black-and-white photographs dependence on the airbrush has remained constant but its use in colour retouching varies widely from company to company. In one of the leading custom-work colour photography studios in London, where different retouchers specialize in work on transparencies and in work on prints, the airbrush is employed more or less continuously in both areas, while in another prominent studio where similar work is carried out, the chief retoucher uses an airbrush only rarely, for stippled effects. The question is whether the individual has been sufficiently attracted by the airbrush to acquire the skills and the confidence in its capabilities that comes only with much experience, in which case he is likely to employ it often. If not, he will rely on other processes to make the needed alterations to the photograph. In general the airbrush is more consistently employed for work on

The original identification on the Concorde was eliminated (right) by black paint applied to an overlay over a colour separation negative; after airbrush retouching, mostly on the fuselage, new details were painted in gouache by a lettering artist.

Photograph into line print: The first step in the creation of the desired line print for an advertisement for a 10-year old-port was to shoot the original photograph of the bottle and glass of port (above left); after the required retouching, carried out on the print itself, for increase of definition and contrast (middle), the artwork was photographed through a special screen to get the line print at right, with its scraperboard-like effect, in which the clarity of the lettering is increased, and the whiteness of white assured after printing, as is not the case with half-tones.

prints than work on transparencies; it is probable that the majority of print retouchers use the airbrush while the majority of transparency retouchers do not.

The term 'retouching' often conjures up one mistaken notion or another: either of something a trifle second-rate, based on the feeling that if the photograph were of suitable quality no retouching should be necessary, or of something underhand; indeed, there have been famous cases of deception.

However, some retouching is required in virtually all process photography—that is, photographs intended for reproduction. It may be minor, though necessary, work such as the minute retouching done to eliminate flaws caused by dust particles from a negative. On the other hand it may be very major and extensive work, as is often the case in preparing colour photographs for advertisements.

The most comprehensive version of retouching is when the entire surface of the

photograph is covered with sprayed pigment. This might be done to restore a photograph. Retouching on this scale is also sometimes done to create an airbrush painting, with a photograph as the ground.

In all retouching with the airbrush, the larger the print, negative or transparency, the easier it will be to get utterly convincing results, because in the final, reduced, picture the size of the drops of pigment sprayed on will also be reduced. The larger the image the softer the sprayed edges can be, so loose masking and freehand work can replace the fixed masking required for hard edges.

Retouching is, strictly speaking, the applying of pigment or its removal, or a combination of the two; but it also includes the bringing together of images from separate photographs into one, by stripping-in, dye transfer or other means.

Photomontage is the term for a composite in which two or more images are combined. The result is likely to require airbrushing in some places to match up tones and perhaps to add cast shadows. An example of the use of the airbrush for matching tones is when a figure or a head that is to be cut out and placed against a background has a very fine network of hair showing in outline against the original background, as is often the case. The shape of the image is cut out large enough to include all the hair, then the airbrush is employed to equalize the background tones, with liquid masking likely on the fine outer lines of hair.

BLACK-AND-WHITE RETOUCHING

In the retouching of black-and-white photographs, which is usually done on prints rather than negatives (for the very good reason that it is difficult to see black and think white while working on something), the airbrush is frequently in use throughout the procedure up to the final touches, such as highlights.

Working on Negatives
At its most basic and minimal level, retouching is the simple 'spotting-out' process routinely carried out by the photographer after he has first examined the negative on a light box and seen the tiny pinpoints of light caused by particles of dust getting between the film and the emulsion. With a brush dipped in photo opaque (a red or black masking solution), he dots the negative where these spots occur, usually on the emulsion side, taking care to have the brush semi-dry rather than wet so that there won't be any run-off from the tip. This is sometimes done on the acetate (smooth) side, but the quality of the reproduction can then be impaired, if only infinitesimally.

Some may prefer to employ a mask of black paper to cover areas of the negative outside the central features of the picture, to obviate the need for the tedious spotting-out except in the important areas; this masking is most likely to be employed in cases where the negative is not expected to be preserved beyond the immediate printing.

There is also the exact reverse of this process: the tiny dark specks of emulsion seen in the transparent areas of the negative (the areas that will be black in the positive print) are carefully scraped away from the emulsion side, so there will be no white dots in the black. (Except for some experts who do highly specialized work, this is virtually the only case in which scraping would be done on negatives; scraping techniques are, however, widely employed on prints.)

Although this spotting-out is often done on the emulsion side, as it is intended to be permanent, work on negatives is mostly carried out on the acetate side because its smooth surface allows successful wiping away of the photo opaque. This capability is useful not only in the event of error but also where the retouching to be done is planned as temporary. For example, a magazine editor might want to use as illustration a photograph in which several images are seen, but for one reason or another wishes to have one of these images eliminated. This can be done by careful retouching on the smooth side of the

negative; then, after the printing process, the negative can be cleaned to restore it to its original condition.

For work on negatives, it is a good idea to begin by scratching registration marks to ensure that you can get perfect registration at all the stages when it may be needed. This can easily be done with a needle, on the emulsion side if you are going to need to see the marks after printing, otherwise on the acetate side. Score marks can also be applied at the outset, where appropriate, to enable lining up perfectly with any ruled lines in the layout. Such lines or marks can later be 'stoned out' by the printer.

If a dark area in a photographic print is too dark, a stencil mask placed on the acetate side of the negative can be cut to cover everything else in the picture, and the transparent (or nearly transparent) exposed area sprayed with a grey pigment about half as dark as the tone desired. If an area in the print is too white, some of the dark emulsion can be gently scrubbed away from the negative's surface with cotton wool dipped

into an abrasive such as pumice powder made into a paste. An air eraser can be employed; this is an electrically operated device which sprays silicon, an extremely fine sand, onto the surface to reduce the tonal value or remove the emulsion.

There are three types of negatives: continuous-tone, half-tone and line. In the case of a half-tone negative, that is, a negative produced by processing a picture with a screen interposed for printing in the 'dot for dot' method, any white areas desired will need to be painted in, in black, on the negative, because in a half-tone, white is not solid white but composed of dots. This can be done by careful brush work, or by masking and airpainting.

Restoring: Treasured family-heirloom pictures, even after years of fading and being knocked about and in some cases even chewed by the family pet, can sometimes be salvaged by the retoucher's art, as was the case with this old photograph of a favourite grandmother holding the intermediate generation in her lap and accompanied by the grandfather. Retouching was carried out in sepia on a sepia print.

Stripping-in negatives When two negatives are to be joined, there are various procedures. One is to strip-in a shape from one within the area of the other. The shape can be cut by a blade piercing through both negatives at the same time, or it can be done in two stages, by first cutting out the shape to be inserted, then tracing around it to cut the matching 'hole' in the other one. In either

The client, who supplied the colour transparency of his company's van, shown in black and white (top left) wanted it speeding along the road. The studio made a duplicate and printed it, moving the transparency as it was exposed (top right), to give one element: landscape whizzing by. After airbrush retouching on an overlay to clean up the roadway, separation negatives were made of this background, and of the static van, and combined by dye transfer (bottom left). Airbrush retouching has added motion to the wheels, improved the sign and restored the shadows under the van (bottom right).

case the negative which is to predominate must be studied very carefully first for determining the proper placement of the insertion, which must always be within the dark areas of the negative. In some cases the cutting of the negatives can take place advantageously along a line of some sort in the picture. The two negatives are joined on the acetate side by photographic tape; red is more visible than black.

Sometimes the two negatives can be combined for processing by placing one on top of the other; this is likely to work well when one has large black-emulsion areas where the images of the other are to appear.

When a half-tone photograph is to appear on a page with text—an extremely common requirement in publishing—the usual procedure is to strip-in the half-tone within the line negative. Another method sometimes employed for printing projects at the cheapest

end of the scale is to mask the area designed to contain the half-tone with black or red paper at the paste-up stage, so that when the negative is made there is a clear patch; the half-tone negative is then placed under the line negative in the correct position to show through, for the plate-making process.

Working on Prints

Most retouching of black-and-white photographs is carried out on prints rather than negatives, either with black dye or a 'body colour', white or grey. For the grey mixtures white is the base and black is added gradually until the desired tone is achieved. If the printing of a black area is too 'rich' its intensity can be eased down with a carefully limited amount of pure water-colour (white ink). In some cases entire areas of photographs are bleached out so that a new image can be painted in with dye.

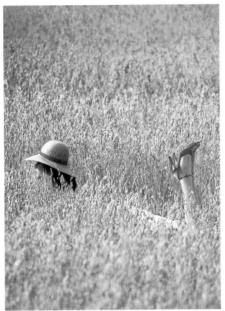

of prints often includes the careful scraping away of black or grey. The tools to be used for scraping work on prints must always be extremely sharp. With a properly sharpened blade and skilful scraping it is possible to go from black all the way down the tonal scale to white.

Highlights can be introduced relatively easily (if crudely, in the aesthetic sense) by scraping finely in small areas; this is commonly done in cosmetics advertising, to give sheen to hair or to skin surfaces.

Line drawings from photographs When a line drawing is wanted, it can be advantageously made in some commercial situations from a photograph rather than being commissioned from an illustrator. On the black–and–white print of an existing photograph or one shot specially for the purpose, the lines (and black areas if any are to be included) are drawn in indelible ink.

The client liked the girl's feet in one shot and her head in another. Colour separation negatives, one blocking out everything but the head, the other blocking out the head, were joined by dye transfer (left), reconciled by detail retouching.

USEFUL TIP *To whiten a dark area on a print, spray the area first, after masking, with a grey base coat, then spray white over the grey.*

Some retouchers mix their own body colours while some prefer to use retouching colours. These can be purchased in graded tones, in both warm greys, which have a small amount of yellow ochre added to the black and white mixture, and cool ones.

In retouching a monochrome print, the first question is whether the print is to be glossy or matt; the glossy is better in some cases where the aim is the sharpest possible contrast, but as retouched areas lose the gloss, matt is preferable when retouching is to be more than minimal. In either case the retoucher should always insist on having two copies of the print supplied, one to be worked on and the other for reference. Prints to be retouched must first be mounted on very firm board.

Scraping technique Besides changes made with the airbrush and paintbrush, retouching

The basic photograph showed horse (greyish), snow, street lamp and shops. The whisky bottle, with its carefully planned distortions, was stripped in and window frames drawn over. The horse, bull's-eye windows and reflections were then airbrushed.

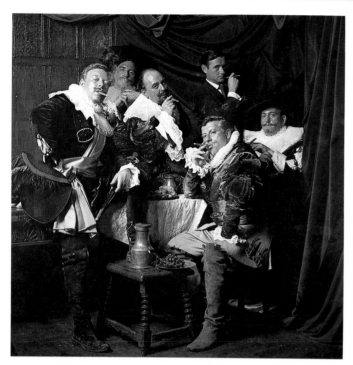

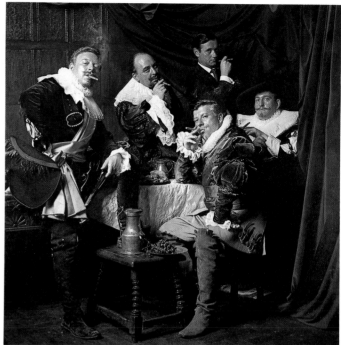

In the original group of jolly cigar smokers was one too many jolly cigar smoker. He was bleached out by a 50-50 mix of sulphuric acid and potassium permanganate; airbrushing with photographic dyes then restored the wall panelling and changed the colour of grapes, drapes and one smoker's sleeve.

The entire print is then bleached out, by immersion in a bleaching chemical solution, which leaves the line drawing. Another (and sometimes better) method to achieve a similar result is the use of radial-line screen, wavy-line screen or other line screen in the camera for the printing; this results in a line print rather than a continuous-tone print.

COLOUR RETOUCHING

Retouching of colour photographs is usually carried out in two stages, on the transparency and on the print. The first process is to create an empty space in the picture, the second is to fill in that space by hand and airbrush work, or, if a second photographic image has been put in the space, to join the two convincingly.

Working on Transparencies

Retouching is normally done using an enlarged duplicate transparency, and blocking out is generally done with black pigment applied to an overlay. Whether on the emulsion side or the acetate, pigment applied directly to the transparency, without an overlay, is always 'washed in', that is, applied to a wet surface. The retoucher, while working, constantly wipes away, removing

In photomontage work the edges of photos should be feathered so that where they overlap they will not cast shadows: the bottom of the print is inverted and the edges chamfered, then, when inverted again for mounting, smoothly pressed down all round.

most of the pigment just applied, to build up the changes gradually. The retoucher cannot rely on eye alone to 'see' the colours while working on them; it is also necessary to know how they will print. This is because putting water on the emulsion side alters the colours as seen by the eye even though they will stay

the same in the printing; and any colour put on a base will dry bluer than it appeared when wet.

Working on Prints

If the white space in the colour print is a small area which is to be filled in with a newly drawn image, the retouching artist (he must be an artist, rather than simply a 'toucher-up', to do this work satisfactorily) draws the needed elements either directly on the colour print or on an overlay, then paints them in, using dyes identical to those used in the printing of the picture, and usually using both an airbrush and a paintbrush.

Dye-transfers When two photographs are to be combined by the dye-transfer process, each of the two transparencies is retouched to achieve the blocking out of certain areas as described above, but in this case it is not an isolated operation as the two must be precisely dovetailed. The aim is to get the exact opposite, or complement, to one another, of blocked-out areas, in the two, in order that the two transparencies can then be printed simultaneously and the resulting colour print will have the elements from one photograph fitting exactly into the space left in the other one. The print is the result of a multi-stage printing process involving colour separations of both transparencies.

Perhaps the rarest form of photo retouching today, but widely practised before the advent of colour photography, is the simple application of colour to a monochrome photograph. James Wedge airbrushed his dancer in inks, freehand and with loose masking.

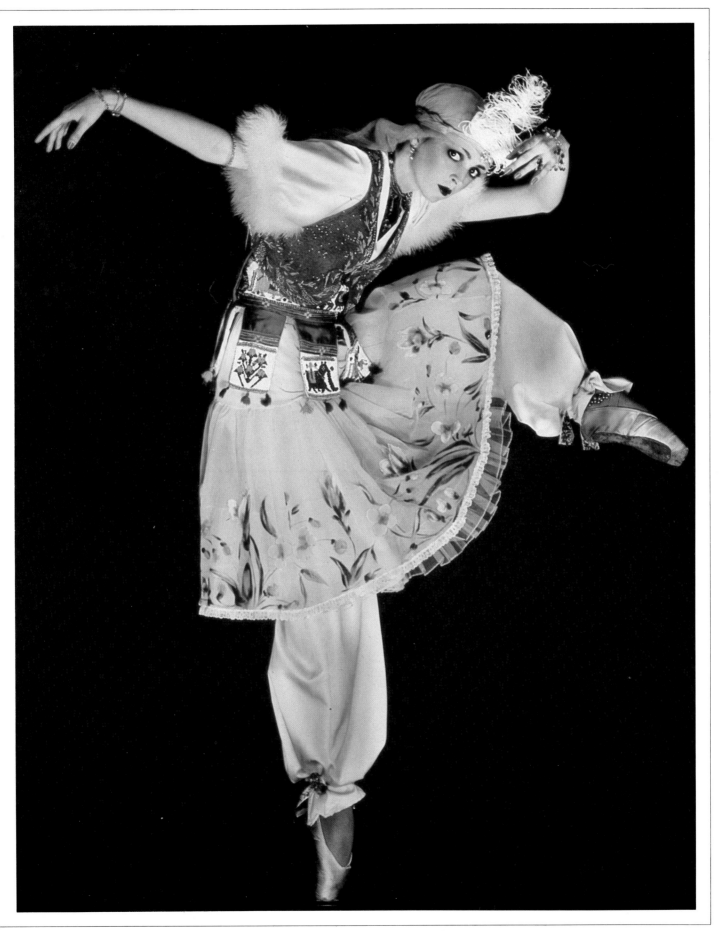

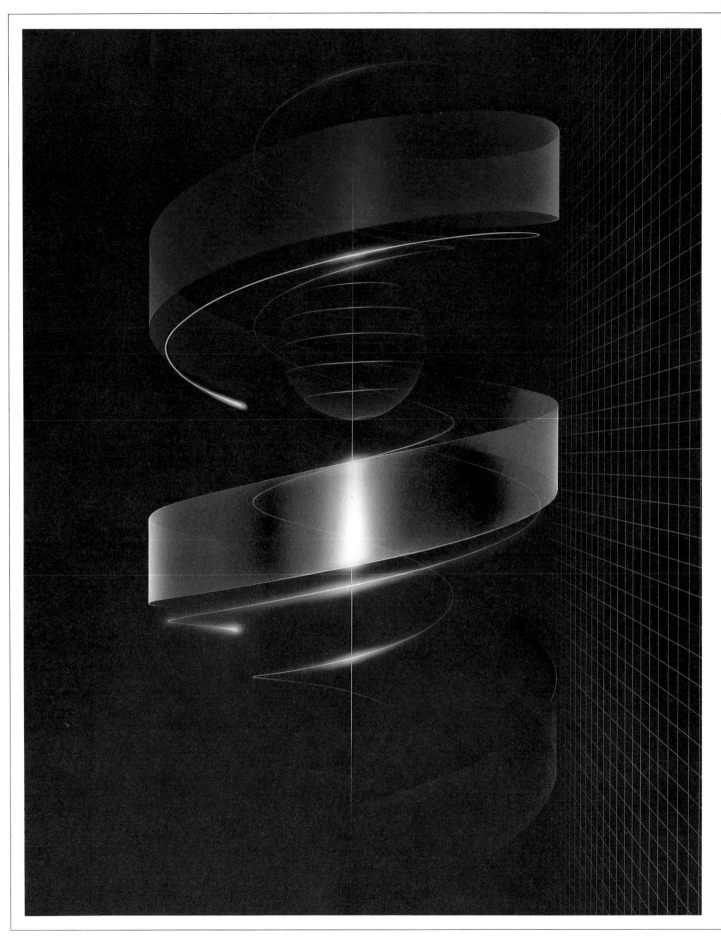

AIRBRUSHING
AND THE
COMPUTER

Over the past two decades the new technology has been developing so swiftly in the graphic arts world that today it is difficult to identify a single area of design that has not been influenced by the computer. The developments have been particularly explosive in the film and television fields, where the smaller, faster and cheaper machines can now create totally new graphic effects.

Parallel to these (hardware) advances have been those in the software (the programs that specify how the computer is to function); and during the same period the 'man-machine interface', as computer people term it, has evolved with such momentum that humans can now intercommunicate with machines via touch, sound and display.

One special computer-based system which incorporates the latest developments in all three areas is the 'digital paint box', a device which enables a designer to create coloured images without any conventional medium such as paints, crayon or chalk, and with direct input to the television screen. One of the options which the designer can choose is the 'airbrush' mode, and although no actual airbrush is involved, the images on the screen can appear to have been airbrushed (convincingly in some cases, or at least so it is claimed). As colours are 'stored' in the machine by three numbers controlling

Both the colour and the shape of the spiral in Tetsu Uehara's 'The Sound' were plotted by computer activated by an electromagnetic sound wave.

the amount of red, green and blue, and considering each of these colours to have 256 distinct intensities, a staggering 16,777,216 combinations can be called up.

The technical explanation of the system is given by Dr John A. Vince, one of Britain's leading experts on computer graphics: 'Paint box systems permit a designer to access the surface of a conventional television screen by controlling the colour and intensity of any area. This is achieved by enabling a

The Quantel 'Paint Box' system in operation (left) with, on the screen, a desert-island scene being created by the stylus. The planetary image (right) was 'airbrushed', then photographed from the screen.

computer to store within its memory (based upon silicon chips) the digital video signal describing a colour television picture; normally this is in the form of three numbers for each screen dot (pixel) which comprise any television picture. The numbers describe

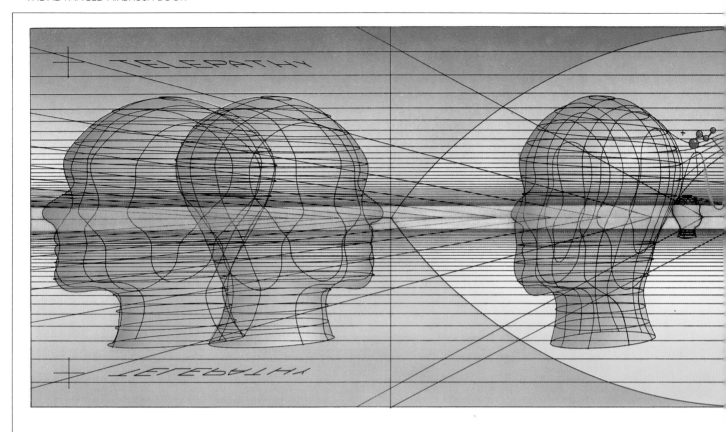

the intensities of red, green and blue, the video primary colours, and are sufficient to encode any colour within the limits of the eye. Obviously this requires several hundred thousand numbers, but a modern computer can handle this quantity of information, and can as a result continuously paint upon a television screen a colour representation of the numeric form currently held within its memory. So, basically a paint-box system is a machine which enables a user to inter-actively modify in real time (in the user's own time) the numeric content of a computer's memory, and as the numbers change, so the picture changes.'

The creation of this on-screen picture begins when the computer-graphics designer seats himself in front of his screen and picks up the stylus connected to his blank painting area, which is a touch-sensitive tablet, of the same dimensions as the screen, lying flat on the table before him. First he mixes his colours: he selects two or more from the various palettes displayed, when requested, on the screen. Moving the stylus over the tablet combines the colours into new mixtures, their intensities being controlled by the pressure applied to the stylus. For each element, line or detail of his 'painting' he can specify what his (mythical) tool is to be, whether a paintbrush (five sizes, from 'camel hair' for delicate lines up to a wide 'bristle'); then the 'wash' mode emulates water-colour

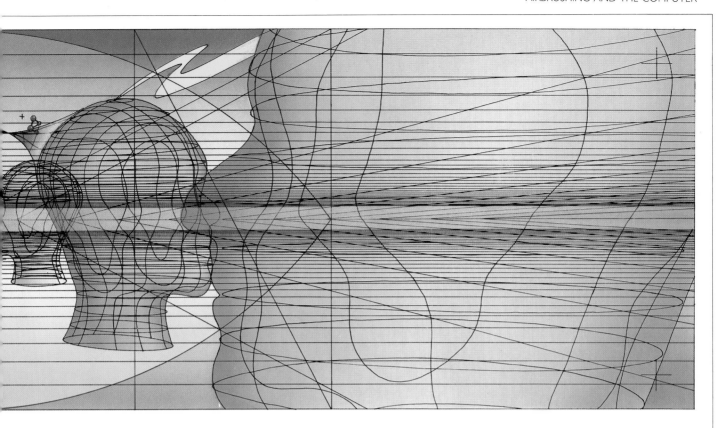

The line modelling of the heads in Ian Winton's 'Telepathy' (above) was executed by computer, then the painting, in water-colours, was done by airbrush. The two abstract images at left were 'painted' directly onto a screen with a computerized system made by Cal Video, and are shown here as photographed from the screen.

for him and the 'shade' and 'chalk' modes control tone and texture respectively. Or he can specify the 'airbrush' mode, in which a fine spray of colour appears on the screen, the spray jet's diameter controlled by the brush size specification, and its opacity by stylus pressure. There is even a version of stencil-masking: the machine will provide circles, squares, ellipses and other regular shapes, or irregular ones can be defined freehand; then the spray will appear only within this 'cut-out' shape, which can be soft- or hard-edged as specified. This same masking technique can be employed to move a defined portion of the picture to another part of the screen.

All of these controls can be changed virtually instantaneously, and instant erasure of any part is simple.

Finally, it is possible to magnify any desired area of the screen, so that delicate, fine 'airbrushing' work can be carried out at convenient scale and then 'reduced' to fit the area of the screen it is intended for. Perhaps for this one feature alone many a conventional airbrush artist might feel a pang of envy.

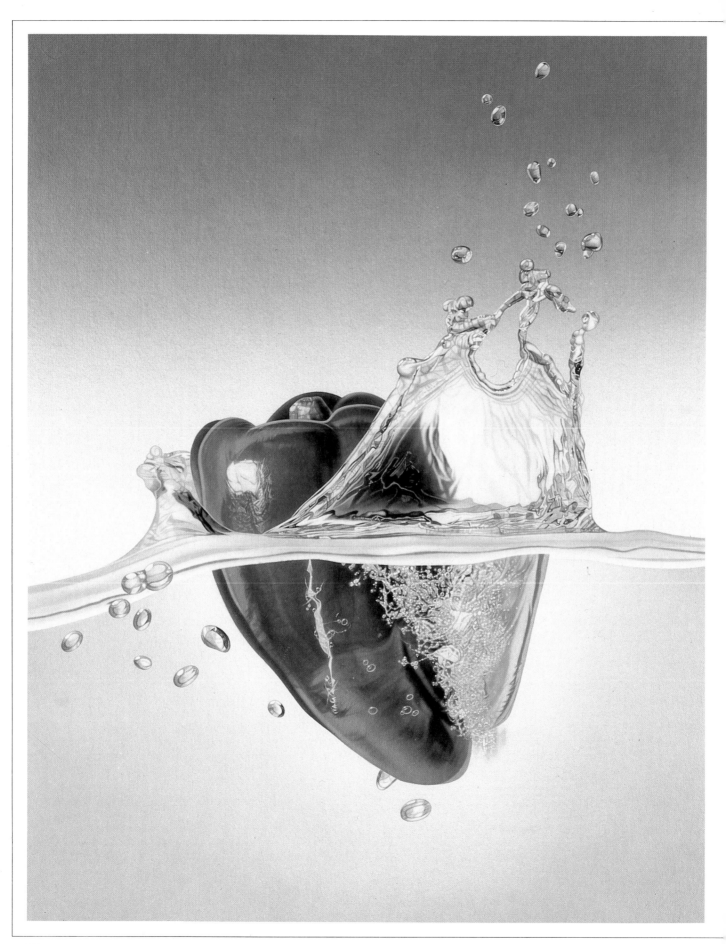

APPLICATIONS AND ACCOMPLISHMENTS

The scope of the Gallery collection amply demonstrates the versatility of the airbrush, an instrument as applicable in the field of creative art as in commercial and technical illustration. With such a wide range of applications for the airbrush, the individual artist has plenty of room to develop his or her own procedures when using it. This chapter focuses on the techniques of twenty artists, each of whom has kindly agreed to demonstrate how he or she has gone about producing a particular piece of work. We are very grateful for the co-operation of these artists in the preparation of their miniature master classes.

Toshikuni Ohkubo
Japan
'Splash' (1981)
51.5 × 36.4cm (20¼ × 14⅜in)

Japan has produced some of the most gifted of contemporary airbrush illustrators and artists, such as Toshikuni Ohkubo, who combine great technical accomplishment with originality. The finish of the best Japanese work is of exceptional quality. In Ohkubo's case this is achieved through close attention to detail at all stages, not least in the

For the fine spray in Splash! (left) Ohkubo has used as reference a photograph of his own earlier work, the famous depiction of a Heineken beer can hitting the water. The artist is shown (right) at a late stage applying background tones with a Hohmi Y-4.

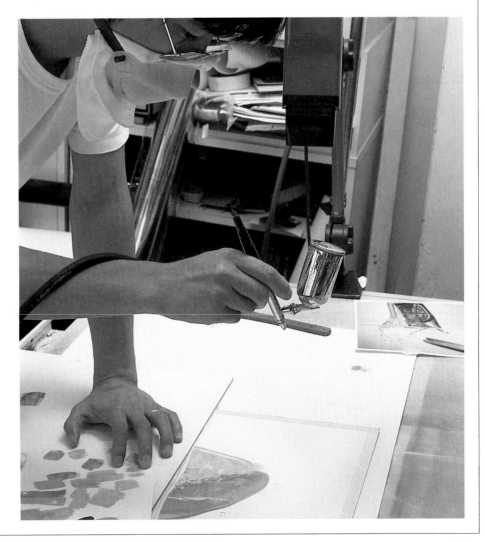

1 *Using 2 photos as reference, one of bubbles in water and the other of a pepper, Ohkubo draws his picture, then adds detail work with blue and green Mars Lumochrom pencils, now using his own picture of a Heineken beer can's splash as reference.*

2 *With paper protectors in place over parts of the artwork to keep it clean, Ohkubo begins the airpainting on the green lines of the pepper, holding his Hohmi Y-1 airbrush at a distance of 1.5-2cm (½ –¾in) from the ground.*

preparatory ones. He always uses distilled water and when he has mixed ink and water he strains the mixture through three or four layers of filtering tissue.

Ohkubo's illustration of a green pepper falling into water was commissioned by the Japanese magazine *Illustration* and is a development of another illustration, commissioned for an advertisement, showing a can of beer splashing into water. Multiple photographic reference was used for both illustrations, which pose the problem of how to capture the crystal transparency of water.

Ohkubo has used two airbrushes in executing the work, a Hohmi Y-4 (nozzle aperture 0.5 – 0.6mm (⅕ – ¼in), held at a distance of about 20cm (7¾in) from the ground and used for the broad airpainting of the background, and a Hohmi Y-1 (nozzle aperture 0.2mm/ 1/12 in), held at a distance of 1.5 to 2cm (½ – 1in) from the ground and used for the detailed work. His method is to work from light to dark and where multiple coats of paint are applied, as in the background, he uses a hairdryer to speed up the transition from one stage to the next.

3 *Brushwork with masking liquid follows; then, after stencil-masking of all non-green details, and with a piece of acetate film as loose mask, he continues spraying the green, working from light to dark, again referring to the green pepper photo.*

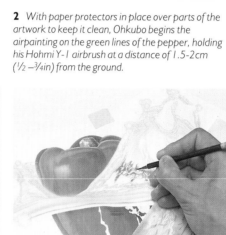

4 *After freehand airbrushing of the water in blue with a very controlled use of yellow, and with all elements masked except the splash area, he adds fine brushwork in green of the reflection on the water, holding his Japanese brush Western-fashion.*

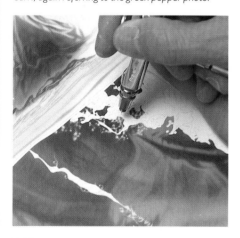

5 *The myriad tiny below-surface bubbles are painted in 3 stages for each one (5 hours' work in all). Ohkubo first sprays a small burst, then adds a spot of white with a brush, then sprays again.*

6 *For the larger bubbles, he alternates spraying and brushwork, with an acetate-sheet stencil mask hinged in register. To complete, he intensifies the white by spraying, holding the Y-1 very near the board, then finishes with fine brushwork.*

Richard Ward
(Based on an illustration by Peter Morter)
Great Britain
Opium Poppy (1983)
43 × 25cm (17 × 9 ¾in)

Peter Morter, an artist whose distinction rests on the accuracy as well as the beauty of his botanical drawings and paintings, drew the original for this airbrush painting by Richard Ward. The Morter original of the Opium Poppy (*Papaver somniferum*), which he kindly supplied for this use, was drawn for one of the illustrations in *Cottage Flora* by Peter Morter and Frank Phillips (Webb & Bower, 1982).

To provide a base on which to work, Ward reduced the original by projector to a convenient size and traced it onto stable tracing film and then transferred it to illustration board: first he reversed the tracing film onto a light box and carefully traced it again; then, after reversing it once more onto the board in the desired position, he burnished the image onto the illustration board.

Once he had made a tracing of the original, Ward's next step was to ink the outlines and some hatching in sepia. He then stencil-masked the entire image to block out the background, and airpainted the leaves, stems and flowers, using a combination of fixed and loose masking within localized areas, completing the foliage before the flowers, using the Morter painting in the book as reference for the exact colours, and finishing detail work by hand.

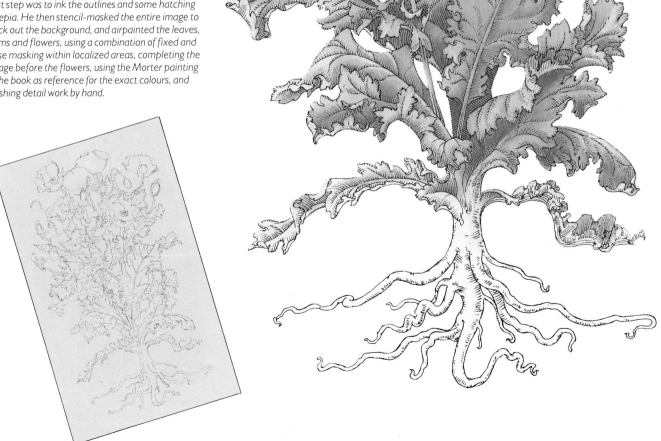

Chris Achilleos
Great Britain
'Watch the Birdy' (1982/3)
86.4 × 55.9cm (34 × 22in)

Although his commercial work is by no means confined to these fields, Chris Achilleos is probably best known for his fantasy and pin-up illustrations. He first learnt about the airbrush in the late 1960s when he was doing a course in technical illustration at art school. In Britain at that time the airbrush was considered, even in art schools, as applicable almost exclusively to technical work. When he first started as a commercial artist Chris Achilleos did not paint with the airbrush at all but he soon came to recognize its usefulness for a wide range of work provided that it was employed in a disciplined way.

This illustration, as many others by this artist, has gone through a long period of development, from thumbnail sketches to finished painting.

1 After the rough sketching of the drawing's elements, the artist works out his first version of an integrated sketch on tracing paper, with both hard and soft (for modelling) pencils, and a camera catalogue's specifications as his reference.

2/3 When he is satisfied with the composition, he makes his final picture of the two elements, first the technical execution of the camera, using instruments, then the modelling of the figure, with references for her one-piece outfit and stockings.

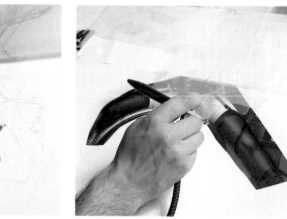

4/5 Using rouge paper, he transfers the drawing to water-colour illustration board, pressing through with a 9H pencil; then he adds minimal toning detail as guide for spraying, taking care to protect the ground from natural skin oils.

6 With his Aerograph Super 63 he sprays first the background, then, working generally from dark to light, the basic elements; here he adds highlights to the black-stockinged leg, stencil-masked with the film fixed to overlap the white-paper frame.

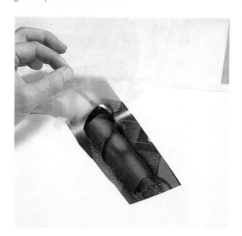

7 The fixed mask is slowly peeled away. The artist's reliance on loose masks, which he collects and guards with care, even recording in a log book each appearance in one of his drawings, is not seen here, but is an important aspect of his work.

8 The illustration is now almost ready for delivery to Men Only magazine, which has commissioned it. The artist, working on a more tilted surface for the final stages, alternates spraying with fine handwork for highlights and surface texturing.

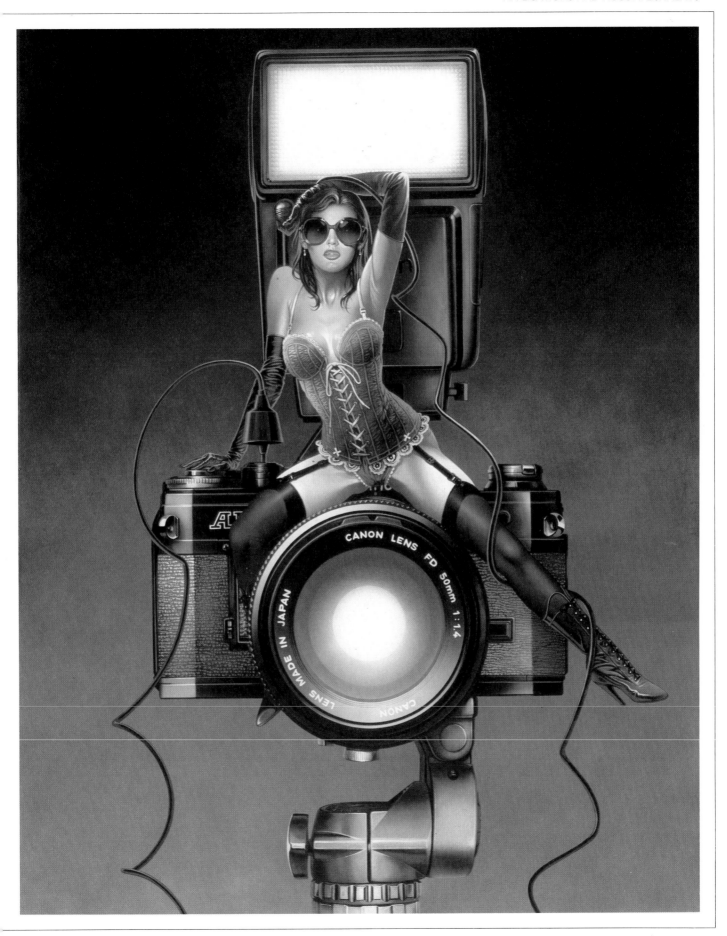

Philip Wilson
Great Britain
Hand, Medical Model (1983)
Life size, height 18cm (7¼in)

Medical illustration and modelling is highly specialized work, calling for sound knowledge of anatomy and a wide range of technical skills. Philip Wilson, who is now a freelancer involved in every aspect of medical graphics, got his grounding at some of Britain's leading hospitals, including St Bartholomew's, London.

One of his special interests is wax moulage, a technique he first used for modelling of neonatal abnormalities. Wilson's casting of a normal hand was prepared by the usual procedure employed in the medical profession to obtain exact duplicates of parts of the body. The exactitude in this case is illustrated by the fact that the person from whose hand the casting was made would be identifiable from the fingerprints of the casting. Airbrushing gives the subtle toning of flesh colours that makes the model so life-like.

1 *The hand is cast in a special hard wax mixture, then airbrushed (with an Aerograph Super 63A) in water-colours, with Aquapasto, a bonding agent, mixed in.*

2 *The only area where the airbrush is not relied on is the fingernails, where each lumula (pale crescent near the cuticle) has been painted in plaka white with a sable brush.*

3 *The subtlety obtained by the airbrush is particularly needed for the veins.*

Cynthia Clarke
Great Britain
Dissection of Superficial Musculature of
the Head Compared with the Bony
Landmarks (1980)
25.4 × 20.3cm (10 × 8in)

Cynthia Clarke, who has specialized in the
exacting field of medical graphics, works
closely with doctors in the preparation of
illustrations for instructional purposes. Her
preferred instrument for airbrushing is a
DeVilbiss Aerograph, purchased in 1959 and
in continuous use for twenty-four years. In
her opinion this model is far superior to
airbrushes of more recent vintage; these she
uses only for less detailed work and for
mediums other than water-colours.

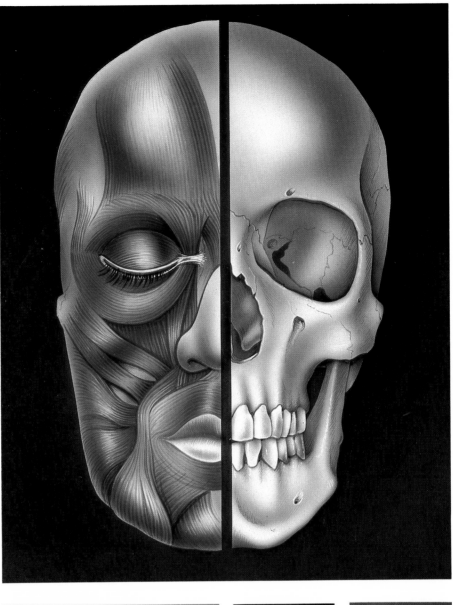

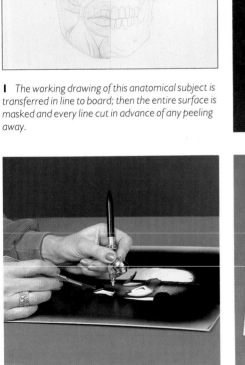

1 *The working drawing of this anatomical subject is
transferred in line to board; then the entire surface is
masked and every line cut in advance of any peeling
away.*

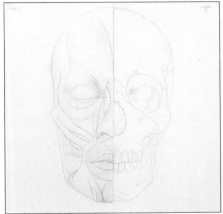

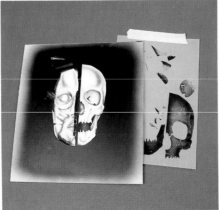

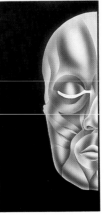

2 *With the entire head still masked, the
background colour, a mixture of sepia and ink, is
sprayed, at an angle away from the mask's edges to
avoid both build-up of paint and underspill, in 5 coats
each dried thoroughly before the next is applied.*

3 *The darkest areas are identified and sprayed in
sequence; each mask when peeled away is kept
attached by a small 'dog ear' to enable accurate
replacement, except those surrounded by hard
edges (as in the nasal cavity), which are removed.*

4 *The two halves are now worked separately:
removed masks are replaced with absolute accuracy
and the muscles sprayed, from deepest colour
upwards in strict order, then the skeletal side
sprayed freehand. Finally, highlights are picked out.*

Harry Willock
Great Britain
Life Support (1982/3)
Height: 29.6cm (11⅝in)

Harry Willock's illustrations in *The Human Body*, a three-dimensional study by Jonathan Miller and David Pelham (Jonathan Cape, 1983), mark a new field for an artist who has already established a formidable reputation with his fantasy book illustrations and a wide range of technical and commercial work. His close co-operation with Dr Jonathan Miller on this project is being continued in a subsequent three-dimensional publication on 'the facts of life'.

Willock wanted to capture the linear quality of Victorian medical illustration and to this end applied colour over a sepia print of his original drawing. Painting the separate elements of the three-dimensional illustration was like working on an unassembled jigsaw puzzle, and the major difficulty this presented was judging the depth of the tone so that the elements would relate to one another when put together.

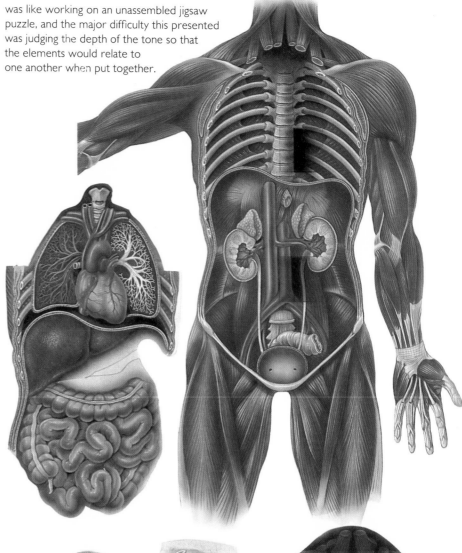

The artist's pencil drawing prepared from standard medical references, was closely checked for accuracy by the authors and then converted to a sepia print.
A DeVibiss Super 63 is used to airbrush translucent inks and syes that allow the sepia drawing to show through.

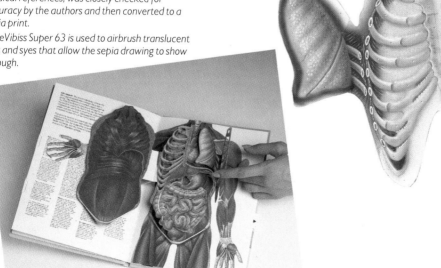

Colin Rattray

Great Britain
Illustrated Panels for the Geological Gallery,
the Royal Scottish Museum, Edinburgh (1975)
Largest: 3.96 × 10.05m (13 × 33ft)

It is common practice for the spray gun to be used to cover large areas of display material, for example in temporary and permanent museum exhibitions or in shop-window decoration. However, in the hands of an experienced artist the airbrush can be invaluable as an instrument for applying detailed colour on a large scale.

When the Royal Scottish Museum, Edinburgh, set out to redesign its Geological Gallery, Colin Rattray, a freelance illustrator, was called on to create a colourful and attractive environment that could also illustrate known facts about the universe and its structure. The work was done directly on specially prepared panels built into the structure of the Gallery. The panels' covering material gave a tooth similar to that of a fine canvas, ideal for both the hand painting and the airbrush work.

The traditional method of squaring up was

used to enlarge one-sixth and one-twelfth roughs. At a certain point the painting took over, dictating certain changes in keeping with the increased scale. For the airbrush work Colin Rattray used a DeVilbiss MP spray gun with a portable, piston-type compressor. When the painting had been completed, the panels were varnished with polyurethane for a semi-gloss finish.

The airbrushing sequence in which the required bright colours were achieved by building up layers of transparent paint is reproduced here by the artist: first the dark-blue background, of part of the galaxy, is oversprayed freehand with white, the stars being done with a yo-yo action. Then the clear colours are sprayed on top of each other allowing the white underpainting to show through, first lemon chrome and ultramarine, then orange, red and a mixture of the two, all still freehand.

Chuck Close
USA
'Self Portrait: Spray Dot Version' (1977)
76 × 56cm (30 × 22in)

Although he does not feel that he has much in common with other American artists who are termed Superrealists, Chuck Close is frequently grouped with them. His subject-matter is the human face. This does not mean, however, that Close is concerned with conveying the psychological complexity of personality captured by direct study of the subject portrayed. He is preoccupied, instead, with rendering in painting precise visual information that

has been previously recorded photographically. The austerity of his work is particularly evident in a series of monochromatic airbrush drawings, of which the self portrait shown here is an example. The airbrush allows very fine control of the density of pigment applied to a ground. Close has capitalized on this, using the airbrush to apply precisely regulated densities of pigment as he builds up his gridded paintings.

This self portrait has been airpainted with a gridded photograph as reference. Each square of the work's equivalently-sized grid was sprayed with the same ink mixture, but variously timed, in increments of 10, for the different tones.

David Jackson
Great Britain
Jean Harlow (1978)
41 × 51cm (16 × 20in)

Since 1975 David Jackson has worked as an 'airbrush technician' doing commercial illustration. His grounding in airbrush techniques goes back much further and includes eight years spent as a photographic retoucher. Most of the commercial work he does calls for a crisp style but in working on a commission for a series of portraits of Hollywood stars, a series to which the Jean Harlow portrait belongs, he has enhanced the glamour of the images by using a softened edge.

David Jackson airbrushed his painting of Jean Harlow freehand, with ink on illustration board, using an Aerograph Super 63. The late film star's photo (below) was used as reference but interpreted freely for the desired 'soft-focus' effect.

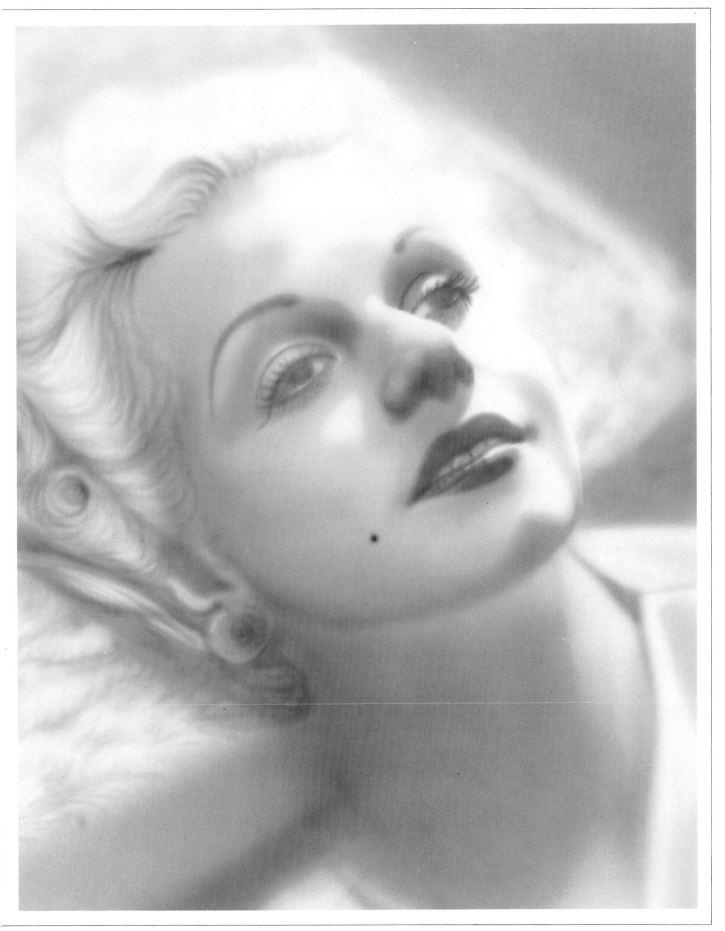

Maureen Daniel Ellis
USA
Whiteware Clay Wall Piece with Airbrushed
Underglazes (1983)
61 × 61 × 7.6cm (24 × 24 × 31in)

The use of airbrush techniques for applying
decoration to ceramics has been successfully
explored by a number of artists. Maureen
Daniel Ellis's wall pieces are made from thin
slabs of clay, variously torn and shaped, with
a thrown bowl attached. They are given a
bisque firing and then the designs are
carefully airbrushed in multiple layers of
underglaze before refiring.

1 *Once the wall pieces have been fashioned and
bisque fired they are rinsed off to remove dust. The
airbrushing is done with the ground surface
positioned always at a near-vertical angle.*

2 *After masking the design with contact paper,
liquid latex and 2 sizes of graphic tape, she starts the
spraying, using a Paasche H-1, and beginning with
the large areas of colour.*

3 *Wearing her face mask whenever spraying, she
builds up multiple layers of colour around small
masked areas to give each a haloed effect. Here a
small mask is lifted with the aid of a knife tip.*

4 Her medium is a 1-to-3 mixture of water and commercial opaque underglazes, chosen for their consistent colour palette, granule size and the fact that their particles remain in suspension.

5 She blends her colours at times by spraying one on top of another, at other times by mixing them in the jar; between colours she clears the airbrush with water squeezed from an atomizer bottle.

6 After the major mask is removed, the piece is fired in an electric kiln at 1050 degrees C (1920 F), and when it is cooled, an acrylic fixative is sprayed on to seal and protect the surface.

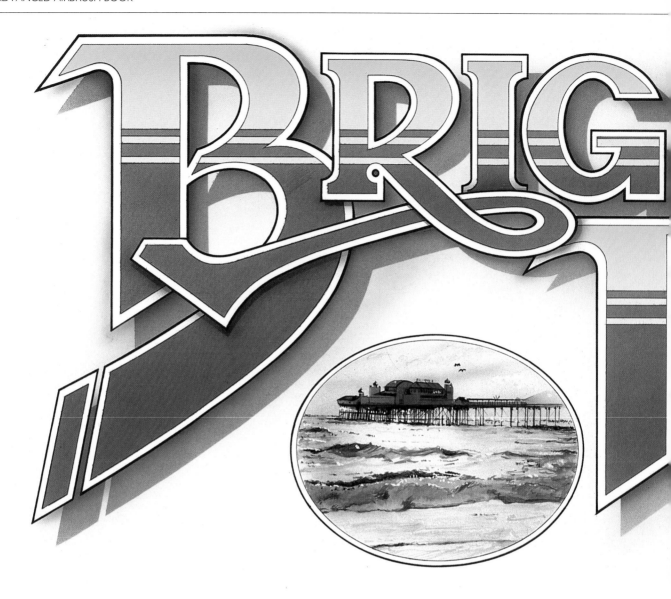

Chris Mynheer
Great Britain
'Brighton Rock' (1983)
122 × 46cm (48 × 48in)

The airbrush is a particularly versatile instrument for lettering artists, enabling a high-quality finish to be given to ornate and complex letter-form design.

Chris Mynheer trained as a technical illustrator and now works as a book designer and illustrator. Before beginning his formal training as an illustrator he was inspired to experiment with lettering by the flamboyant signs of fairgrounds. His early airbrush lettering included motor-vehicle customizing.

1 *The artist first works out the basis for his original lettering design in a series of rough sketches; after he has made his choice of the general style, the lettering is hand-drawn.*

2 *When his small water-colour of Brighton pier, to be integrated into the design, is finished, he transfers the lettering with rouge paper onto illustration board by hard-pencil line drawing.*

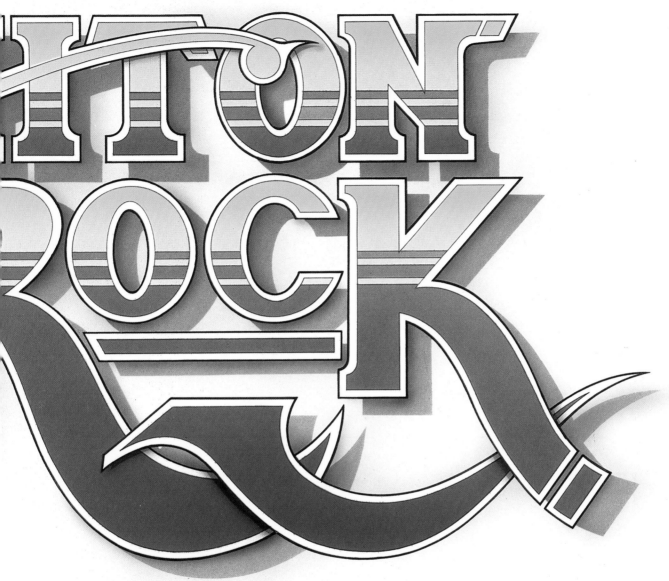

3 Some of the curves drawn freehand are corrected as the form outline is inked in, with French curves. After inking, the entire surface is cleansed of grease by tissue lightly soaked in lighter fluid.

4 With fixed masking, the colour dye is applied in the letters with an Aerograph Super 63 E-type; after spraying yellow at the top, the artist cuts masking film for the brick red at the bottom.

5 At the finishing stages of airbrushing, the yellow is an evident gradation, the brick red a subtler and more gradual one; shadows in cool blue have been masked for a hard edge, then overpainted.

Tim Mulkern
Great Britain
Tower Bridge, London (1983)
59 × 42cm (23¼ × 16½in)

Tim Mulkern, who is now in partnership doing technical illustration with another artist featured in this book, Max Rutherford, is concerned with presenting complex visual information in such a way that it can be understood by the non-specialist. He finds the airbrush particularly useful for transparent 'ghosting' effects, as employed here, and for the highly finished illustration needed during the development of products, such as household appliances. Mulkern's experience includes illustration for vehicle development.

1 *The line drawing of London's Tower Bridge, made from on-site sketching and photographing, and old reference data, is transferred from tracing paper to the illustration-board ground with hard pencil.*

2 *With masking film over a portion of the drawing, and working inside an opening in the protective paper covering, the artist uses a set square to cut a straight edge for the first mask.*

3 *Before spraying begins, the edges of the protective covering are taped down to prevent any undesirable 'fallout' outside the artist's target area, within which he sprays a ground coat.*

4 *A loose mask is held firmly to give a hard edge for one of the verticals of the near tower's side, as airpainting continues through many stages of fixed and loose masking accompanied by hand work.*

5 *The component elements of the picture slowly build to a coherent whole, as the spraying of each part is finished off, as here on the upper part of the tower, with fine brush work.*

6 *The final procedure, after all the masking and spraying steps and the alternating hand work with the paint brush are completed, is the adding of subtle colour tones with hard coloured pencils.*

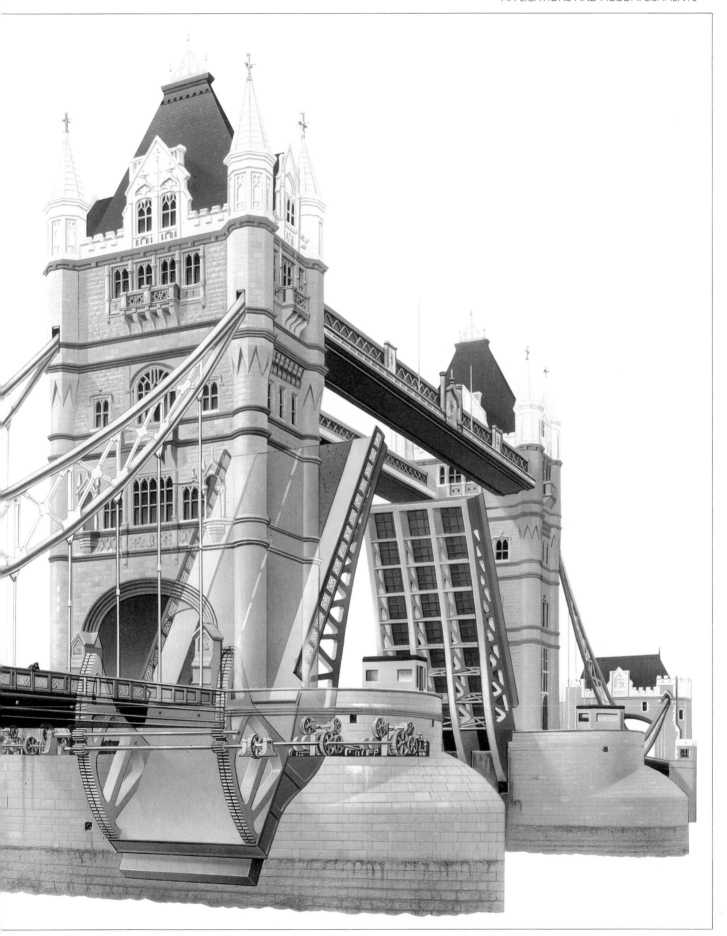

Christopher J. Elliott
Great Britain
Pike Trophy (1983)
102cm (40in)

After studying sculpture at art school, Christopher Elliott turned to taxidermy, a field in which he has established himself as a leading professional, mounting specimens and trophies that are sent to him from all over the world. It was while working in Australia that he first saw the colouring of mounted fish – big game fish, such as shark and marlin – being done by airbrush. His airbrush is not only an essential instrument for preparing fish trophies but also for painting background settings for mounted specimens of all kinds.

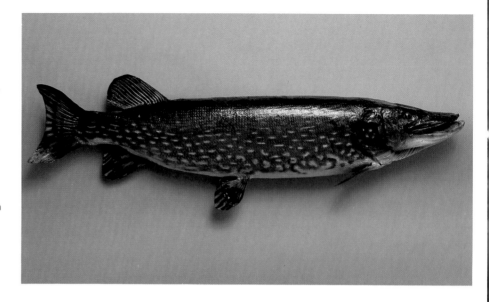

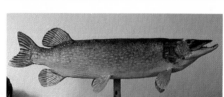

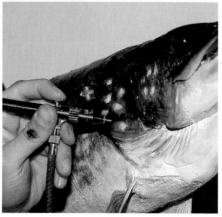

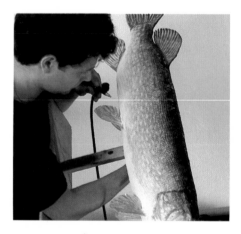

1/2 *After measuring the newly-caught fish, in this case a 25-lb pike, and noting the details of its colours and contours, the taxidermist carves a body out of plastic foam, to cover with the skin.*

3/4 *Before airbrushing, the fish, now virtually colourless after drying for several weeks, is made ready: the inside of the mouth is modelled, fins trimmed and repaired, and glass eye set in place.*

5 *With a Sprite Major airbrush and pressure set at 30 psi, a series of undercoats of thinned oil paints, which become absorbed into the skin, are sprayed as a base for the following stages.*

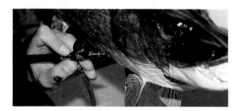

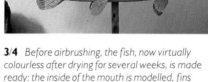

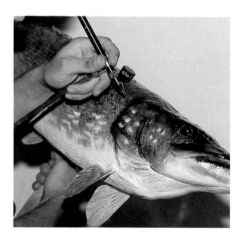

6/7 *On the fish's back and sides, the oil paints tend to bring out the natural markings, while the undercoats on the belly and lower jar, less diluted, mimic the whiter hue of the original.*

8 *The most demanding part of the airbrushing process is the careful blending, with acrylics, where the white of the belly meets the green of the upper part, and shading of the contours of the lower jaw.*

9 *After highlighting of certain spots and the ribs in the fins, a light final spray, in the taxidermist's words, is 'flashed over the body to "sparkle" the scales' and add a metallic sheen.*

Max Rutherford
Great Britain
Viola, Exploded View (1982)
59 × 42cm (23¼ × 16½in)

Max Rutherford is a technical illustrator whose work covers a wide range and includes illustration for product development. He was able to observe the various stages in the making of the viola illustrated here, which was built with meticulous care by a craftsman friend. Hand brushwork and special texturing of the paper supplemented the airbrush work to convey the tone and grain of the wood.

1/2 *For his picture of a viola, exploded to show all its parts, the artist transfers his finished drawing onto illustration board with rouge paper, then cuts the masking film, fixed to overlap the edges of the cutout in the protective paper sheet.*

3/4 *Using an Aerograph Super 63A, he applies a ground coat of the viola's basic colour, working from test strips prepared in advance for matching the wood. With a new fixed mask in place, he then sprays the ebony colour of the fingerboard.*

5/6 *He applies highlights to the fingerboard by removing some pigment with a pencil eraser, with the aid of a straight edge; other finishing work is largely by handwork with a paintbrush, as here along the edge of the back panel of the viola.*

Cecil Misstear
Great Britain
'Connemara Landscape' (1983)
51 × 76cm (20 × 30in)

After daily involvement in the field of technical graphics, Cecil Misstear finds relaxation in experimenting with various media to create landscapes. The collage shown includes elements from the Irish landscape that is depicted.

Misstear is currently experimenting with a carpet air gun (100 psi/6.8bars), which blows either yarn or wool through a canvas backing that is held taut on a frame. It is possible to vary the depth of the loop pile, which is secured to the canvas backing with latex

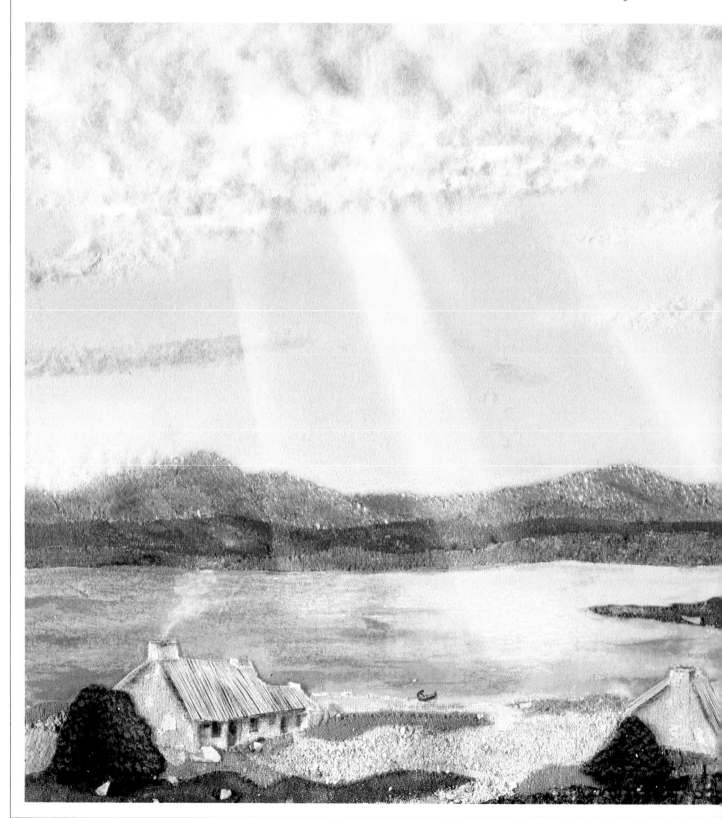

adhesive. An electric shearing machine is used for cutting into the pile to give the relief and contours of the landscape. The yarn or wool used is natural colour and an airbrush is extensively employed to airpaint with appropriate dyes to complete the picture.

1 *For his collage made up of local Irish fabrics, stones and straw from Connemara, and sheep's wool from barbed wire fences in County Wicklow, the artist first coats the ground with adhesive and positions his carefully chosen pieces of tweed.*

2 *For the road, the bits of crushed stone are spilt onto the surface, then the hardboard ground is tilted and tapped so that the larger pieces slide to the foreground (for correct perspective). Grass verges of tweed are touched up with yellow ochre.*

3 *The larger stones of the foreground, after having adhesive applied to one side, are placed by hand on the dark tweed of the turf; the weathered surfaces of the original stones are restored by further hand work with the long-hair sable brush.*

4 *The airbrush work begins with the pale-blue-linen sky: a white mixture (with blue and a little red) is applied to lighten the sky toward the horizon and to form a basis for the sheep's-wool clouds, which are placed after the sun's rays are sprayed.*

5 *On the same linen base, the inlet from the sea is airpainted with loose masks held and shifted as required; a cool mixture of violet, blue and ultramarine dyes deepens at the sides, away from the picture's focal point, the luminous centre.*

6 *Fine brush work with water-colours, dyes, acrylics and gouache creates the yellow hay cocks, the thatched roofs, windows and half-door, fisherman and boat, piles of peat, and the sun's rays on the water. Airbrushing of shadows is the final step.*

George Green
USA
'Talking Picture Biting the Stick' (1983)
125 × 95cm (50 × 38in)

There is no simple way of categorizing the painting of George Green, despite its abstract and illusionist elements. He began experimenting with the airbrush in 1968 after finding that a group of his own figure paintings looked as though they had been airbrushed, although they had been executed with conventional paintbrush techniques. Green now employs the airbrush with the same ease as he does paintbrushes, and may make use of the instrument at almost any stage in the process of building up a painting. He finds it indispensable for creating particular effects of light that could not otherwise be achieved on a discontinuous surface.

1 *On his 60 × 45cm (24 × 30in) stretched canvas, the artist first paints in black and grey acrylics the 'drawing' (from rough sketches in pencil) for what is later to emerge as the painting 'Talking Picture Biting the Stick'.*

2 *He broadly sketches in the colours in oils, making notes to himself ('red', 'gold') as he works. The new elements in his paintings are animalistic; the creature here (it could be a dolphin, or a dog), visible at first but now obscured, will re-emerge.*

3 *Extensions are added in the form of armatures, and strips that serve as design lines, all made of plywood; heavy layers of pigment—as thick as 2.5cm (1in) in places—are then applied in outer areas, a contrast to the flatness of inner planes.*

4 *In the course of the work, each area is separately stencil-masked for airbrushing (with a Badger—the artist recently switched after many years with a Paasche); additionally masking tape is used for spraying the hard edges that delineate the areas.*

5 *Illusions of space, to combine with real spaces in the multi-layered finished work are accomplished with shadows; the fine paint that is sprayed onto the thick pigment, the surface of which is folded in and out of the light, is for colour changes.*

Ken Wellington
Great Britain
Blue Pontiac with Firebird (1983)
18 × 38cm (7 × 15in)

Ken Wellington is a young artist who, since
leaving art school, has been able to combine
as a technical illustrator two pleasures, a love
of mechanical things and a passion for
working with colour. His first experiments
with airbrushing were made while he was at
art school. He enjoys particularly, as in this
image of a customized car, exploiting the
airbrush's versatility as an instrument for
treating the reflective surfaces of metal and
glass.

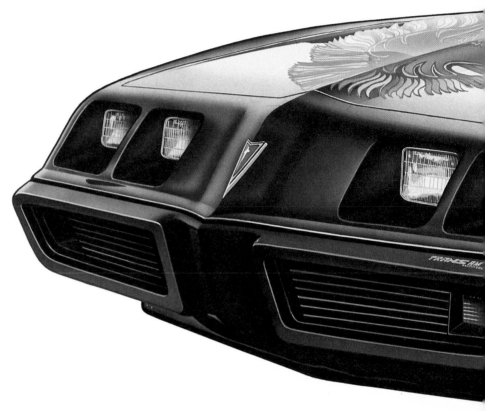

1/2 *The artist 'customizes' his car, on paper, first
reversing the image to turn the American Pontiac
Trans-Am into a right-hand drive model. With fixed
masking, he sprays a gouache mixture of Peacock
and Windsor blues, then black is added.*

3/4 *Spraying continues with further modelling at
the front of the body shell and the air intake on top;
an ellipse template is used as a loose mask for a sharp
edge in a warm grey-to-black gouache mixture on
the side profile of the second tyre painted.*

5 *After masking and painting of the flame-coloured
motif, detail work on the wheel rim is carried out
within a cutout of a protective paper mask, with the
Aerograph Super 63A held close, limiting the area of
spray, and a combination of loose masks.*

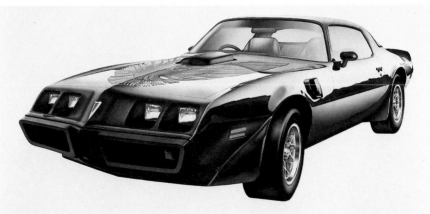

6 *After the spokes of the wheel are airbrushed with fixed masking, light against dark against light, further spraying of the spokes' and wheel rim's bright metal is done with one of the loose masks now held in readiness to be re-applied as needed.*

7 *The use of water-colour is introduced with warm red in the spoke area of the wheels, and the sky reflected on the car's side above the dark hills' silhouetted image is a transparent orange-yellow. Finishing handwork is extensive, on the headlamps,* *the close fitting of the bonnet (hood), intake-grill panel edges, door, plastic upholstery, and contoured lettering. Final work with the airbrush includes refining of the subtle differentiation between reflective surfaces of metal and glass.*

**Luck and Flaw
(Peter Fluck and Roger Law)**
Great Britain
John Cleese (1982)
Twice life-size

The partnership of Peter Fluck and Roger Law, which began in 1976, has produced a veritable army of three-dimensional caricatures, the originals including such public personalities as Richard Nixon and Margaret Thatcher. Although they are three-dimensional, the figures have been created to be photographed for use as magazine illustrations, often making startling cover subjects. These highly original artists are now working on a new venture, creating animated puppets for a thirteen-part television series. For these puppets, whose faces move most expressively, the airbrush sprays paint mixed with a special adhesive that has been devised to give the necessary flexibility.

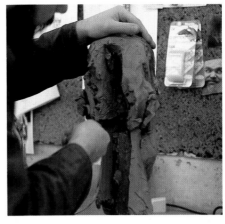

1/2 *For the caricature of John Cleese, to be constructed in three-dimensional form (but designed to be photographed, not displayed), the two artists' first step is a series of preliminary sketches in which they work out the basic features.*

3 *On an armature, the broad planes are roughly sculpted in modelling clay. Because only the side to be photographed will ever be seen, the work proceeds always with that view in mind, and all concentration focused on the face itself.*

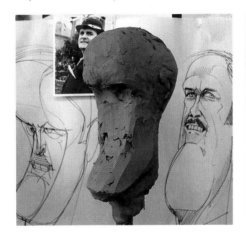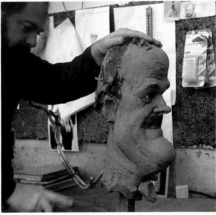

4 *The overall form is beginning to take shape; the overhanging forehead and protruding chin give the face a pronounced convexity, closer at present to the sketch at left than to the one at right, though elements of both are becoming incorporated.*

5 *Detailing work begins with an elaboration of all planes, particularly rounding of the chin and jowls, and furrows and skin folds, with numerous photographs used as reference. Teeth, ears and eyes (glass) are added, and rough hints of hair.*

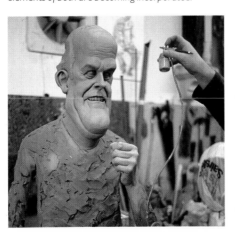

6 *After a torso is added, which will be covered by clothes, and a clenched hand, airbrushing begins (with air extraction) with a grey acrylic base coat. 'First you wreck your airbrush,' the artists say, 'if anyone's mad enough to use our method.'*

7 *Strong facial colours in acrylic—reds and pinks, greys and greens—are airbrushed freehand, with the desired spatter effect, then muted by overspraying; spots of colour are added with loose masks. The final stage is grooming and clothing.*

Pater Sato
Japan
'Venus III' (1982)
50.8 × 40.6cm (20 × 16in)

His highly stylized illustrations derived from fashion photography have established an international reputation for Pater Sato, one of the most successful and talented contemporary Japanese airbrush artists, who is now based in New York City. The main source of reference for his vividly coloured and arrestingly exaggerated images are the illustrations of such magazines as French *Vogue*. He maintains a large file of reference material and will generally take elements from several sources when drawing and painting one of his own illustrations.

Although he aims, as do more conventional commercial artists, to produce a glamorous image, the originality of his work and his subtle handling of detail place his illustrations in a different category to that of the crudely glittering images too often associated with airbrush painting. The example of his work shown here was used in Japan in a poster advertisement for a cosmetic company.

1 The artist prepares his tonal sketch, projected to a larger size from his original sketch. Images to be airbrushed should be kept as simple as possible, he feels, and the shapes within the picture drawn with the cutting of masks in mind.

2 In pencil, he completes the tonal sketch; this will be his base for mask-cutting and his guide for the airbrushing of tones. He uses a photo in French Vogue, one of his favourite picture-research sources, as reference for drawing the left ear.

3 He commences the airbrushing with the darkest areas, around the eyes and the line between the lips, in a mixture of violet, ultra blue and black inks (Dr Martin's), lifting the mask occasionally to convert hard edges into slightly blurred ones.

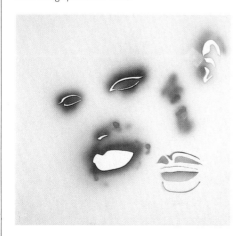

4 Since the facial elements are sufficiently distant from one another, Sato cuts his stencil masks of these all in one, using a heavy weight of tracing paper. For the lips he cuts several in different sizes, to achieve what he calls his '3-D' effect.

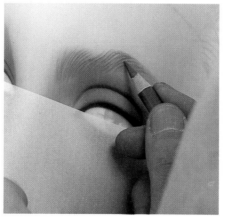

5 After spraying the skin tones with a mixture of tropic gold and moss rose, with grey, purple and sepia added in some parts, Sato draws the eyebrows with a grey coloured pencil. His ground is transparent; the tonal sketch shows through.

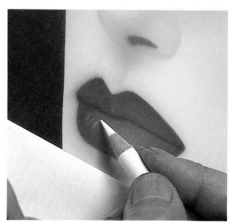

6 For the highlights on the lips which give them their form and make them an important feature of the work, second only to the eyes in giving the face its impact, Sato uses white pencil, brushwork with process white, and red pencil for emphasis.

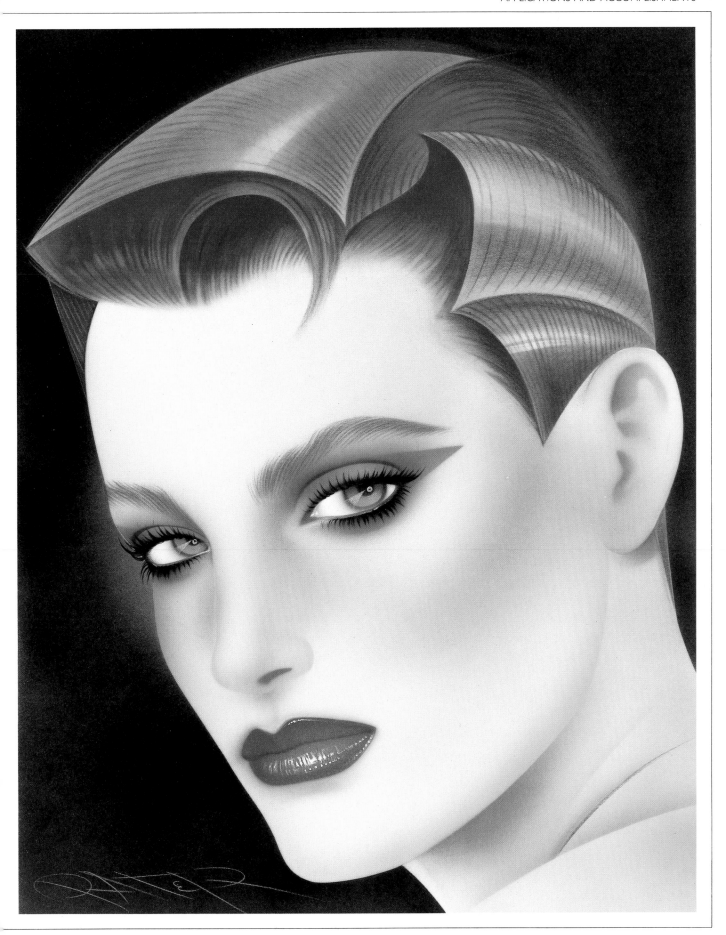

David Penney
Great Britain
Spring Clock, 1677, by Joseph Knibb (1981)
25 × 38cm (10 × 15in)

David Penney is an illustrator with a special interest in early technology and horology. To celebrate the 350th anniversary of the British Clockmakers' Company he set out to show in one illustration all the technical information about a particularly fine late-seventeenth-century clock by Joseph Knibb and, as Penney himself puts it, to convey as best he could 'the feel of the piece'.

David Penney uses the airbrush for all his work but warns against letting the instrument dictate how an illustration will go. He uses transparent colour and never airbrushes with white as an opaque medium.

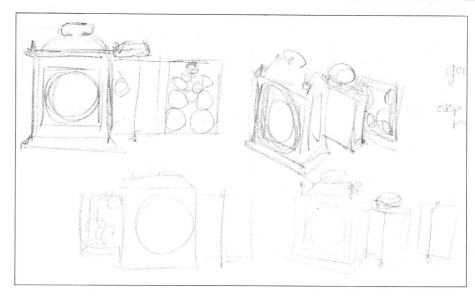

1 *For his detailed representation of Joseph Knibb's 17th-century spring clock, the artist holds a loose mask away from the artwork while spraying the clockface tones with his Aerograph Super 63.*

2 *With most of the artwork covered, he adds a highlight to the clock case by removing pigment with a pencil eraser, to expose the white of the ground, always preferable to adding white paint.*

David Penney 1981

3 *After spraying the ground colour on his panel of the clock's engraved, gilded back plate, he uses a razor blade, which he has carefully broken to an acute angle, to etch cross-hatching of shadows.*

4 *The ruled line of the lower rim of the bell in the clockwork panel is pencilled, as is the shadow giving the bell its form (with spraying); graphite is convincing for the satin finish of the original.*

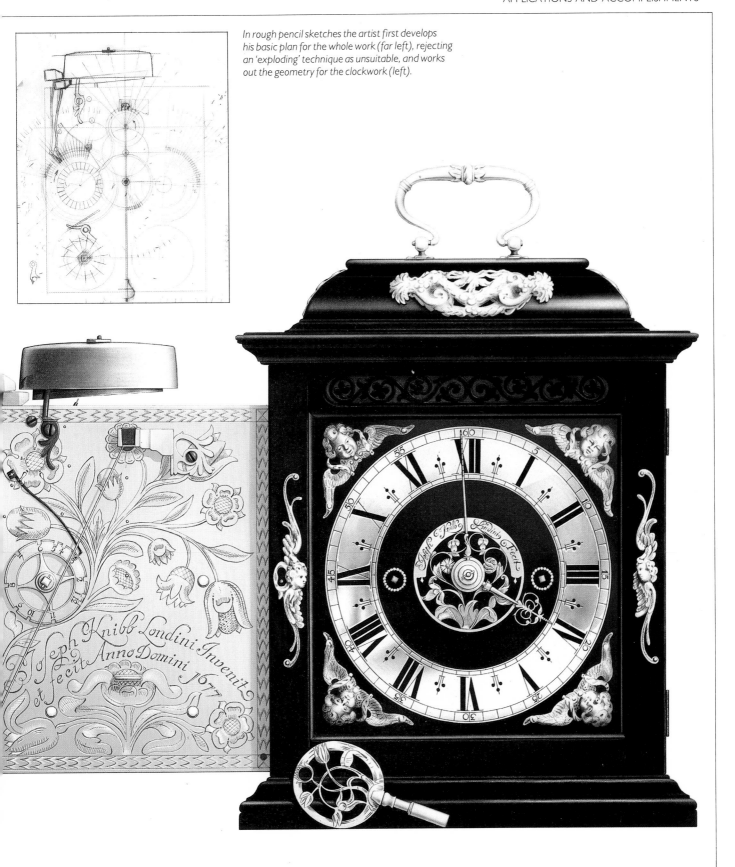

In rough pencil sketches the artist first develops his basic plan for the whole work (far left), rejecting an 'exploding' technique as unsuitable, and works out the geometry for the clockwork (left).

Don Eddy
USA
'V/IV/C' (1981)
150 × 193cm (5 × 6½ft)

Black and white photographs are essential reference material for the paintings of the American Superrealist Don Eddy but their role does not go beyond providing accurate visual information in convenient form. As many as fifteen or twenty might be used for a painting such as the example shown. The colours of the painting are a product of the artist's imagination.

Don Eddy's chosen subject-matter – predominantly windows, glass and other reflective surfaces – poses formidable technical problems. What is remarkable is that, despite these problems, Eddy works freehand throughout. It is not surprising that the execution of this painting took six months, with the artist working six days a week, ten hours a day.

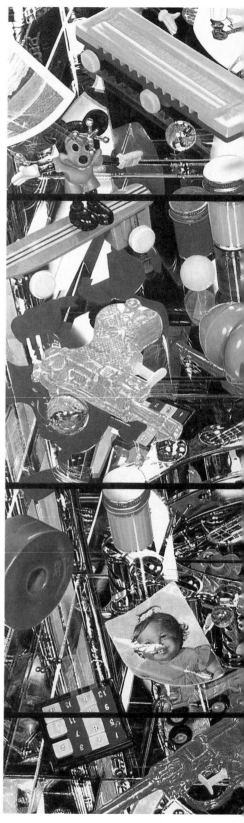

1 *The drawing, of myriad objects on glass shelves, derives entirely from black-and-white photographs. Airpainting, with a Paasche airbrush, on canvas in transparent acrylics, proceeds in 3 main colour stages, first of which is phthalo green.*

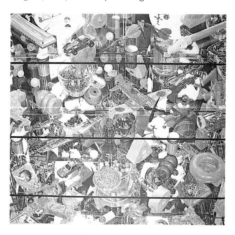

2 *The second layer is in burnt sienna. All the colours are 'imaginary', the artist says. He uses a Paasche, no tape or masking of any kind, sprays entirely freehand in extremely small areas, in a tiny-circle technique that is almost pointillist.*

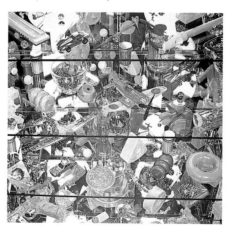

3 *Dioxazine purple is the last of the main colour layers. With the essentials laid down, the elaboration begins: 10 further colour stages of painting follow, all airbrushed (the finished painting has had no brushwork whatsoever).*

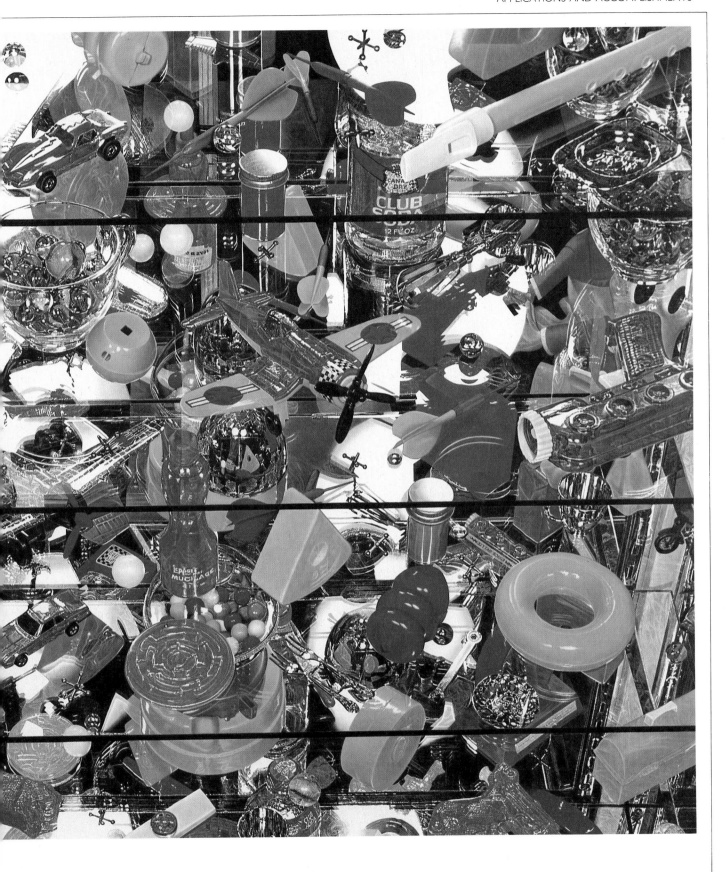

GLOSSARY

Acrylic
A water-thinned paint that is based on acrylic resin.

Aerograph
The name of the first airbrush and sometimes used loosely of the airbrush in general.

Air eraser
A device operating like an airbrush that is used to propel fine granules of an abrasive on to a surface for the purpose of removing pigment.

Air valve
A controllable valve that regulates the flow of air to the airbrush nozzle.

Blocking out
The process of painting out parts of a photograph or artwork during retouching.

Bowl
A receptacle for pigment that is an integral part of the airbrush.

Brushwork
Handpainted work that is executed with a hair paintbrush.

Colour separation
The breaking down of an image into base colours for the purpose of reproduction.

Compressor
The most common propellant used to power airbrushes.

Crating
The drawing of the external planes of an object as if to form a transparent box-like enclosure.

Dye
Any medium coloured by an agent that is totally soluble.

Ellipsograph
A mechanical device that permits accurate drawing of ellipses.

Freehand
A term used to describe airbrushing in which no masking is used.

French curve
A template that incorporates in a single shape a variety of concave and convex curves.

Ghosting
The method, used frequently in technical illustration, of making the surface layer of an object or mechanism appear transparent so that the interior structure or workings can be shown.

Gouache
Acrylic- or tempera-based paint that is thinned with water.

Gravity feed
A method of introducing the medium into the airbrush by gravity with the fluid reservoir mounted above or to one side of the air channel.

Ground
The surface on which the artist applies the medium.

Hard-edged
A term applied to airbrush work in which there is a clean edge between colours; it is generally achieved by close masking.

Highlights
The parts of an illustration where light is brightest. The effect is often achieved by the application of an opaque white medium or by removing dark pigment to reveal a lighter colour beneath.

Independent double action
A type of airbrush design that allows the ratio of the amount of air and the amount of paint released to be varied.

Liquid mask
A solution that is applied to a surface and that when dry acts as a mask. After airbrushing it can be rubbed or peeled away.

Loose masking
Any mask that is not attached to the ground.

Montage
The combination of different images or parts of images to make a new image.

Mouth diffuser
A simple form of spraying tool that is powered by blowing.

Needle
The part of the airbrush mechanism that controls the amount of paint that passes through the nozzle.

Negative sun
A term used in drawing and painting to refer to a notional sun behind the viewer as opposed to one within or above the area of the drawing.

Nozzle
The part of the airbrush mechanism that directs the flow of atomized pigment.

Oil paint
Spirit-thinned paint in which the pigment is mixed with a light oil and varnish.

Perspective grid
A grid imposed on a clear or semi-opaque sheet and used as an aid to drawing so that relative distance and size are accurately represented.

Pigment
Colour particles that can be suspended in a medium to create paint.

Propellant
The mechanism – foot pump, air can, air cylinder or compressor – that powers an airbrush.

Retouching
The modification of an artwork or, more particularly, photograph.

Spatter
A granular effect produced with the airbrush by increasing the amount of paint in proportion to the flow of air.

Spray gun
A heavy-duty device for spraying pigment over large areas.

Stencil
A ready-made cut-out shape that can be used as a mask.

Stipple
A grainy effect achieved by applying the paint rather coarsely.

Stretching
The process of making a ground of paper or material taut so that it will not bubble when a medium is applied to it.

Suction feed
a method that utilizes a difference in air pressure to draw the medium into the airbrush's airstream from a receptable or cup that is attached beneath the fluid channel.

Support
A term sometimes used as a synonym for 'ground' (which see). Commonly, as in this book, it is the term applied to the material supporting the ground.

Template
A pattern in plastic, board or thin metal that can be used as a mask.

Trammel method
A method of drawing an ellipse using as a trammel to plot the outline a strip of paper marked with the semi-major and semi-minor axes.

Vignette
An illustration or part of one in which the tone shades off.

BIBLIOGRAPHY

Battcock, Gregory (ed.) *Super Realism: A Critical Anthology* (E. P. Dutton & Co., Inc., New York 1975)

Caiati, Carl *Airbrush Techniques for Custom Painting* (Badger, Chicago 1978)

Croy, O. R. *Retouching* (Focal Press, London 1964)

Dalley, Terence (ed.) *The Complete Guide to Illustration and Design Techniques and Materials* (Mayflower, New York 1979)

Dember, Sol and Steve *Complete Airbrush Techniques for Commercial, Technical and Industrial Applications* (Howard W. Sams & Co., Inc., Indianapolis, 2nd edn 1980)

Fullner, Norman *Airbrush Painting: Art, Techniques and Projects* (Davis Publications Inc., Worcester, Mass. 1983)

Goldman, Richard M. and Rubenstein, Murray *Airbrushing for Modellers* (Almark Publishing Co., New York 1974)

Gill, Robert W. *Manual of Rendering with Pen and Ink* (Thames and Hudson, London 1973: Van Nostrand Reinhold, New York 1973)

Hayes, Colin (ed.) *The Complete Guide to Painting and Drawing Techniques and Materials* (Phaidon, Oxford 1979)

Lindey, Christine *Superrealist Painting and Sculpture* (Orbis Publishing, London 1980)

Marten, Clement *The Artist's Airbrush Manual* (David and Charles, Newton Abbot 1980)

Martin, Judy *The Complete Guide to Airbrushing Techniques and Materials* (Thames and Hudson, London 1983)

Paschal, Robert *Airbrushing for Fine and Commercial Artists* (Van Nostrand Reinhold Company, New York 1982)

Podracky, John R. *Photographic Retouching and Airbrush Techniques* (Prentice-Hall Inc., Englewood Cliffs, N.J. 1980)

Tombs Curtis, Seng-gye and Hunt, Christopher *The Airbrush Book: Art History and Technique* (Orbis Publishing, London 1980)

Vero, Radu *Airbrush: The Complete Studio Handbook* (Columbus Books, New York 1983)

ACKNOWLEDGMENTS

The publishers join the authors in gratefully acknowledging the assistance given by the many people who helped in the preparation of this book. In addition to those listed below, special thanks are due to the following: Eiichi Kono, for help with Japanese contacts and for translation of material from Japanese; Lewis Meisel, of the Lewis Meisel Gallery in New York City; and Dr John A. Vince, Head of the Computer Graphics Centre at Middlesex Polytechnic.

AIRBRUSH ARTISTS

Chris Achilleos
31 Gordon Road
London E4 6BT, England
Pages 99, 126-7

Kazuhisa Ashibe
502 Villa Sansui
1-22-1 Uehara
Shibuya-ku
Tokyo 151, Japan
Page 17 bottom, back jacket

Guerrino Boatto
37 Via Monte Piana
30171 Venezia Mestre, Italy
Page 44 top left

Syd Brak
c/o Meiklejohn Illustration
28 Shelton Street
London WC2, England
Page 10 bottom

Kirk Q. Brown
1092 Blake Avenue
New York, NY 11208, USA
Page 46 top

Mick Brownfield
c/o Jenni Stone Partnership
8 Hornton Place
London W8, England
Page 48

Brian Bull Retouching
16 Little Portland Street
London W1N 5DE, England
Page 112

Cal Video Graphics Limited
7-8 Newburgh Street
London W1V 1LH, England
Page 121 bottom

Philip Castle
56 Burnfoot Avenue
London SW6, England
Page 55

Roy Castle
Jacobean House
Langport
Somerset, England
Page 39

Norman Catherine
c/o Rod Dyer Studios
5550 Wilshire Blvd
Suite 301
Los Angeles, CA 90036, USA
Page 35

Hilo Chen
c/o Louis K. Meisel Gallery
141 Prince Street
New York, NY 10012, USA
Page 58

Cynthia Clarke
Wallets
Great Wakley
Near Brentwood
Essex, England
Page 129

Chuck Close
c/o Louis K. Meisel Gallery
141 Prince Street
New York, NY 10012, USA
Page 132

Jose Cruz
5223 Pershing
Dallas, TX 75206, USA
Page 51 top

Don Eddy
c/o Nancy Hoffman Gallery
429 West Broadway
New York, NY 10012, USA
Pages 13, 154-5

C. J. Elliott
51 Huntingdon Road
Thrapston
Northants NN14 4NF, England
Page 140

Maureen Daniel Ellis
3 Lovell Avenue
San Rafael, CA 94901, USA
Page 134-5

**Nicola Falcioni
& Margherita Saccaro**
Tiagono Illustrazioni
15 Via A. Lamarmora
20122 Milan, Italy
Page 92

Jean-Luc Falque
18 bis rue Henri Barbusse
75005 Paris, France
Page 24

Audrey Flack
c/o Louis K. Meisel Gallery
141 Prince Street
New York, NY 10012, USA
Page 12

Roy Flooks
10 Kingly Court
London W1, England
Page 113

S. Fujita
c/o Shigeo Kasai
3-48-4 Yoyogi Shibuya-ku
Tokyo, Japan
Page 108 top

R. Futami
c/o Shigeo Kasai
3-48-4 Yoyogi Shibuya-ku
Tokyo, Japan
Page 108 bottom

H. R. Giger
c/o Ugly Club
Bahnhofstrasse 15
8805 Richterswil, Switzerland
Page 34

**Gilchrist Studios Group
Limited**
6-10 Kirby Street
London EC1N 8TH, England
Pages 110-11, 114-16

Terry Gilliam
6 Cambridge Gate
London NW1 4JR, England
Page 10 top

George Green
c/o Louis K. Meisel Gallery
141 Prince Street
New York, NY 10012, USA
Pages 65, 144-5

Robert Grossman
19 Crosby Street
New York, NY 10013, USA
Page 11

Dan Gunderson
233 Westrich Avenue
De Land, FL 32720, USA
Page 31 bottom right

Ray Habgood
Page 80 bottom

Paul Harrison
Dreams on Screens Workshop
65 Howard Road
North Lancing
Near Worthing
Sussex, England
Page 80 top right

Joe Heiner
1612 Sherman Avenue
Salt Lake City
Utah 84105, USA
Page 3, 109 bottom

Gottfried Helnwein
Neustiftgasse 36-2
A-1070 Vienna, Austria
Page 67

Thomas P. Hubert
615 East 24th Street
Erie, PA 16503, USA
Page 31 bottom left

Ryoko Ishioka
204 Akasaka Park Mansion
7-6-7 Akasaka
Minato-ku
Tokyo 107, Japan
Page 54

David Jackson
c/o Folio
10 Gate Street
Lincoln's Inn Fields
London WC2, England
Page 133

Ben Johnson
c/o Fischer Fine Art Limited
30 King Street
London SW1, England
Page 60

Kevin Jones
52 The Drive
High Barnet
Hertfordshire, England
Page 17 top

David Juniper
c/o Folio
10 Gate Street
Lincoln's Inn Fields
London WC2, England
Page 49

Ri Kaiser
Frohmestrasse 126
D 2000 Hamburg 61,
West Germany
Page 21

Jane Kleinmann
c/o Carolyn Brindle
203 East 89 Street
New York, NY 10028, USA
Page 42

Hideaki Kodama
3rd Floor
5 Gokan Takahashi Building Minami
3-6-35 Nishi Tenma
Kita-ku
Osaka-shi 530, Japan
Paged 23

Lyn Le Grice
Alsia Mill
St Buryan
Penzance, England
Page 80 left

Kurt Jean Lohrum
Jussaarenkuja 5f
SF 00840 Helsinki 84, Finland
Page 26 top

Luck and Flaw
Victoria Hall
Victoria Street
Cambridge, England
Pages 148-9

Ben Lustenhouwer
Lucas Bolwerk 17
3512 EH Utrecht, Holland
Page 51 bottom

Michael Lye
c/o Andrew Archer Associates
5 Park Road
London NW1, England
Page 27

Gavin Macleod
16 Ayresome Avenue
Leeds LS8 IBE, England
Page 22

Jean-Jacques Maquaire
55 rue du Président
1050 Brussels, Belgium
Page 52 bottom

Fiona McKinnon
Flat 7
41 The Gardens
London SE22, England
Page 80 centre top and centre

Ichimatsu Meguro
c/o Shigeo Kasai
3-48-4 Yoyogi
Shibuya-ku
Tokyo, Japan
Page 15, 16, 101 bottom left

Cecil Misstear
Flat 1
16 Royal Esplanade
Westbrook
Isle of Thanet
Kent CT9 5DX, England
Pages 142-3

Willi Mitschka
Dustmannweg 39
A 1160 Vienna, Austria
Page 45

Chris Moore
c/o Artist Partners
14 Ham Yard
London W1, England
Page 37

Tim Mulkern
Studio 303
Panther House
38 Mount Pleasant
London WC1, England
Pages 109 top, 138-9

Chris Mynheer
38 Cranley Gardens
Muswell Hill
London N10, England
Pages 136-7

Joe Nicastri
c/o Nancy Hoffman Gallery
429 West Broadway
New York, NY 10012, USA
Page 59

Shiro Nishiguchi
3rd Floor
5 Gokan Takahashi Building Minami
3-6-35 Nishi Tenma
Kita-ku
Osaka-shi 530, Japan
Page 43

Bob Norrington
34 The Street
Cherhill
Calne
Wiltshire, England
Pages 4-5

Toshikuni Ohkubo
412 Hashiguchi Dental Building
7 Ichigaya
Shinjuku-ku
Tokyo 160, Japan
Pages 41, 122-4

Yosuke Onishi
3B Yuki Flat
1-14-15 Nishi Azabu
Minato-ku
Tokyo 106, Japan
Page 100, front jacket

Jerry Ott
c/o Louis K. Meisel Gallery
141 Prince Street
New York, NY 10012, USA
Page 19

Otto & Chris
10 Bay Street
Patonga Beach
New South Wales 2256,
Australia
Page 44 top right

Joe Ovies
Suite 120
One Park Place
1900 Emery Street NW
Atlanta, CA, 30318, USA
Page 44 bottom

David Penney
19 Charlotte Street
London W1, England
Pages 152-3

Peter Phillips
Rutistrasse 60
8044 Gockhausen
Zürich, Switzerland
Page 28

Gerry Preston
c/o Meiklejohn Illustration
28 Shelton Street
London WC2, England
Page 46 bottom

Jack Radetsky
75 North Plain Road
Sunderland, Mass 01375, USA
Page 30

Sue Rangeley
11 Market Street
Charlbury
Oxfordshire, England
Page 80 centre right

Colin Rattray
71 Shrublands Avenue
Berkhamsted
Hertfordshire HP4, 3JG,
England
Page 131

Jon Rogers
c/o Ian Fleming and Associates Ltd
1 Wedgwood Mews
12/13 Greek Street
London W1V 6SL, England
Page 63

Max Rutherford
Studio 303
Panther House
38 Mount Pleasant
London WC1, England
Page 141

Masao Saito
402 Lions Mansion Miyazakidai
1-6-12 Miyazaki
Takatsu-ku
Kawasaki-shi
Kanagawa-ken 213, Japan
Page 53, 101 bottom

Mark Salwowski
c/o David Sawyer &
Associates Pty Ltd
146 Wycombe Road
Neutral Bay
New South Wales 2089, Australia
Page 52 top

Pater Sato
c/o Ty Yamanaka
Apt 8E
40 West 24th Street
New York, NY 10010, USA
Pages 9, 33, 150-1

Chuck Schmidt
1715 Ramona Avenue
South Pasadena, CA 91030, USA
Page 47

Todd Schorr
116 Lexington Avenue
New York, NY 10016, USA
Page 50

Peter Sedgley
Lindenallee 20
1000 Berlin 19, West Germany
Page 64

Goro Shimaoko
c/o Japan Creators Association
4th Floor
Umehara Building
3-1-29 Roppongi
Minato-ku
Tokyo, Japan
Page 14

Peter Smith
c/o Technical Art
West Germany
Page 38

Tom Stimpson
c/o Ian Fleming & Associates
1 Wedgwood Mews
12-13 Greek Street
London W1V 6JL, England
Page 36

Ean Taylor
c/o Folio
10 Gate Street
Lincoln's Inn Fields
London WC2, England
Page 26 bottom

Ramon Gonzalez Teja
Ruiz Perelló 13
Madrid 28, Spain
Page 20

Tetsu Uehara
3a Maison Trois
3-14-10 Nishihara
Shibuya-ku
Tokyo 151, Japan
Page 118

John Verberk
Emmastraat 4
1075 HT Amsterdam, Holland
Page 62

Richard Ward
29 Almond Grove
Fairfield
Stockton upon Tees
Cleveland TS19 7DL, England
Pages 8, 125

Verina Warren
Hawthorne House
Stanton-in-Peak
Near Matlock
Derbyshire DE4 2LX, England
Page 31 top

Stan Watts
3896 San Marcos Court
Newbury Park, CA 91320, USA
Pages 66, 101 top

James Wedge
Church Gate Hall
Church Gate
London SW6, England
Page 117

Kenneth Wellington
Woodside
Trethowell
St Austell
Cornwall, England
Page 147

Harry Willock
80 Alexandra Crescent
Bromley
Kent BR1 4EX, England
Page 130

Philip Wilson
23 Normanhurst Road
Saint Pauls Cray
Orpington
Kent, England
Page 128

Ian Winton
3 Beverley Gardens
Thornton Mead
St Albans
Herts, England
Pages 120-1 top

Prof. Paul Wunderlich
Haynstrasse 2
D 2000 Hamburg 20
West Germany
Pages 6, 32

Akira Yokoyama
c/o Japan Creators Association
4th Floor
Umehara Building
3-1-29 Roppongi
Minato-ku
Tokyo, Japan
Page 57

The following illustrations, which have appeared in other publications, have been used with permission: the painting by Roy Castle, page 39, taken from *The Past All Around Us*, copyright 1979, The Reader's Digest Association Limited, London; the painting by Harry Willock, page 130, taken from *The Body Book*, copyright 1983, Jonathan Cape Ltd, London; and the series of step-by-step illustrations on pages 122-4 and 150-1, taken from *Illustration Magazine's How to Draw*, Genkosha Publishing Company, Tokyo.

Photographers

John Bouchier, page 69; Clive Boursnell, pages 79 right, 94-7; Fred J. Boyle, USA, pages 13, 59; David Cripps, page 80 left; D. James Dee, page 30; M. Lee Fatherree, pages 134-5; B. Gunderson, page 31 bottom right; Dave King, pages 136-7; Lommatzsch-Berlin, page 64; Robert Lowry, page 31 bottom left; Nadia Mackenzie, pages 80 top right, 126, 152; Larry Morgan, page 129; Stewart Warren, page 31 top.

The help of the following organizations and permission to use their photographs is gratefully acknowledged: Ademco Drimount Ltd, High Wycombe, Bucks, page 82; Beatties of London Ltd, Hemel Hempstead, Herts, page 80 bottom; The DeVilbliss Company Ltd, Bournemouth, page 73; The Distillers Company (Carbon Dioxide) Ltd, Reigate, Surrey, page 73; DW Viewboxes (J. K. Lighting), Milton Keynes, page 93; The Hydrovane Compressor Company Ltd, Washford, Redditch, Worcestershire, page 73; Quantel Ltd, Kenley, Surrey, page 119; The Royal Scottish Museum, Edinburgh, page 131.

Diagram illustrators

Richard Czapnik, Peter Harper, Kevin Jones, Nigel Jones, Timothy Loughhead, Hartej Matharoo, Tim Mulkern, Max Rutherford, Sian Tempest, Richard Ward, Carol Warmsley, Adam Willis.

The authors wish to record their thanks for the assistance given by the staff of Orbis Publishing Ltd, in particular Peter Butler, art editor, and Mia Stewart-Wilson, picture researcher.

INDEX